FROM THE SKIES OF PARADISE

OAHU

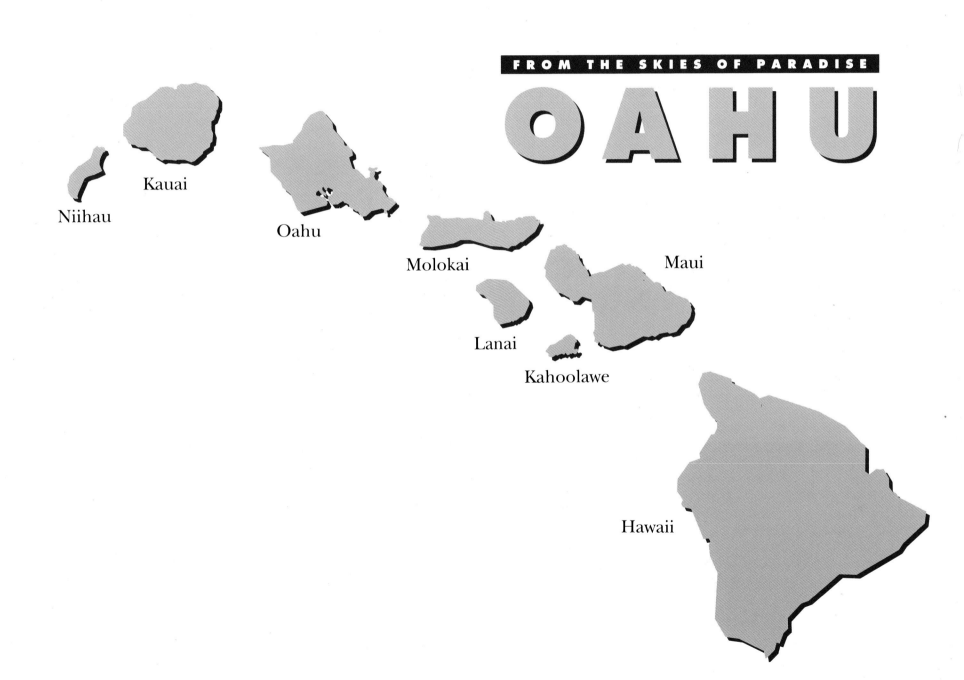

Niihau

Kauai

Oahu

Molokai

Maui

Lanai

Kahoolawe

Hawaii

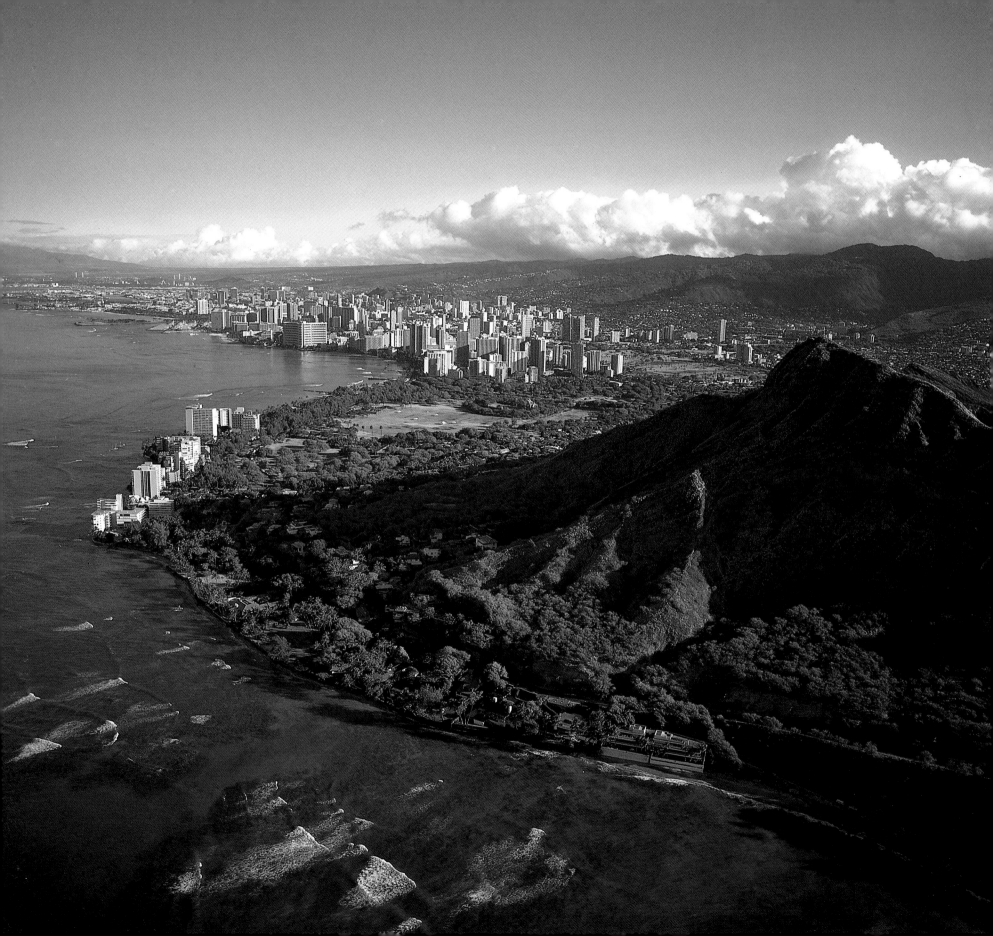

FROM THE SKIES OF PARADISE

OAHU

Aerial Photography by Douglas Peebles

Text by Glen Grant

Mutual Publishing

PREVIOUS PAGE: *Leahi or Diamond Head Crater rises 760 feet above world famous Waikiki beach, providing a dramatic backdrop to the popular visitor resort. A national natural landmark, Diamond Head was formed 350,000 years ago in a single trememdous explosion after seawater came into contact with lava seeping out of a fissure. The last volcanic activity at the extinct crater was possibly 200,000 years ago.*

FRONT COVER: *Hanauma Bay continues to lure visitors into its clear-blue waters to show-off hundreds of Hawai'i's unique sea creatures.* INSET: *Ka'ena Point, a Natural Area Reserve reachable only on foot. The white "golf balls" at the crest of Wai'anae Range are plane and satellite-tracking stations. The Kawailoa Girl Home and the adjacent Hawai'i Youth Correctional Facilities are on the verdant Kailua plains beneath Mt. Olomana. The* Arizona *Memorial, Pearl Harbor.*

ISBN 1-56647-728-X

First Printing (softcover), June 2005
1 2 3 4 5 6 7 8 9

Mutual Publishing, LLC
1215 Center Street, Suite 210
Honolulu, Hawai'i 96816
Ph: (808) 732-1709
Fax: (808) 734-4094
email: mutual@mutualpublishing.com
www.mutualpublishing.com

Printed in Taiwan

CONTENTS

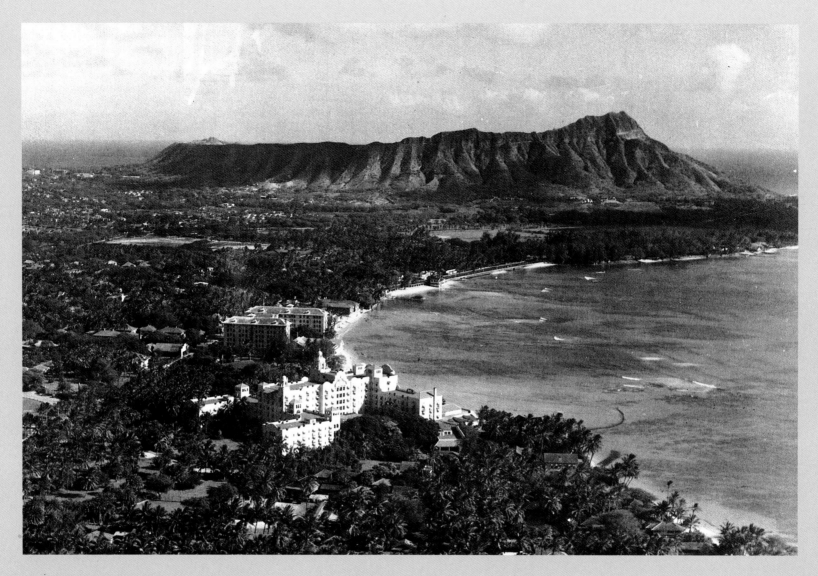

The tropical beauty of old Waikiki was still evident in this aerial photograph of the famous tourist destination taken in the 1930's. The new Royal Hawaiian Hotel and the nearby Moana Hotel were the only major landmarks on the beach next to stately Diamond Head whose view in those days was wholly unobstructed.

The first truly aerial view of O'ahu, "gem of the seas," was briefly enjoyed on November 2, 1889 by Joe Van Tassell, one of the Van Tassell Brothers team of balloonists—"Acknowledged Premier Aeronauts of the World." Lifting off from Punchbowl Crater, Professor Van Tassell rose within three minutes to 2,000 feet in his 80-foot hot-air balloon to pause directly above Richards and King Streets. As he prepared to parachute from the balloon into 'Iolani Palace grounds for a prearranged greeting from King Kalakaua, the crowd watched horrified as the tradewinds swept the aeronaut and his flying gadgetry out beyond the reef, finally dumping them into a wild sea. Hawai'i's first authentic flight, a "Grand Sensational Daring Attraction!" had ended in ten minutes and 18 seconds. Poor Professor Van Tassell's body was never recovered.

In the next century, other far more successful flights over Honolulu were made in balloons, airplanes, helicopters and spacecraft. Successive generations of photographer-aviators captured images of our paradise in its metamorphosis from a minor Pacific port to a major metropolis. The empty beaches across which Van Tassell was blown to his doom today are packed with sun worshippers.

With a total area of barely 600 square miles, O'ahu's physical environment has changed drastically since the first aerial views became available, not surprising as the island's population approaches one million people.

O'ahu's fame for attracting people from around the world to visit and live on its shores is reflected in its being called "The Gathering Place." What is truly extraordinary is not just the island's capacity to receive more and more people of all races, cultures and backgrounds, but its resilient natural beauty.

O'ahu,
ka 'onohi o na kai.
"O'ahu,
gem of the seas."

In spite of modern developments, the ancient volcanic terrain and O'ahu's more than 100 miles of coastline still have a dramatic, spellbinding effect when seen from the air.

Ancient Hawaiians understood the many faces of O'ahu through close association with land, sea and sky. The original *moku'aina,* or major land divisions, corresponded with the island's physical characteristics. *Honolulu* or *Kona* was the southern leeward district with a dry climate, well-watered valleys, and open coastlines that supported both fishermen and farmers. *'Ewa* was the expansive open plain encompassing the great inland lochs and rivers we know today as Pearl Harbor. Wai'anae was the drier, mountainous region of unique geographic features and tradition of independence from the rest of O'ahu. *Waialua* on the northern shore was lush with fertile lands but noted for rough seas and high surf. *Ko'olauloa* was the gentle land at the northeastern corner of the island, protected by offshore reefs, never without water and always heavily populated. *Ko'olaupoko,* the southern end of the Windward side, was remarkable for towering fluted cliffs in a cloak of velvet green that formed the perfect backdrop to paradise. Together they comprised, *ka 'onohi o na kai,* "O'ahu, gem of the seas."

This photographic study of O'ahu is based upon these older divisions. From this perspective, the modern viewer is reminded that the precious beauty of O'ahu is best understood as a link between *mauka,* "to the mountains," and *makai,* "to the sea." The fragility of our natural environment cannot be appreciated when concern is only over a single real estate or beach development. What the ancient people knew from living on the earth, modern civilization seems to discover only from space: the land and sea are finite.

He ali'i ka 'aina; he kauwa ke kanaka. " The land is a chief; man is its servant."

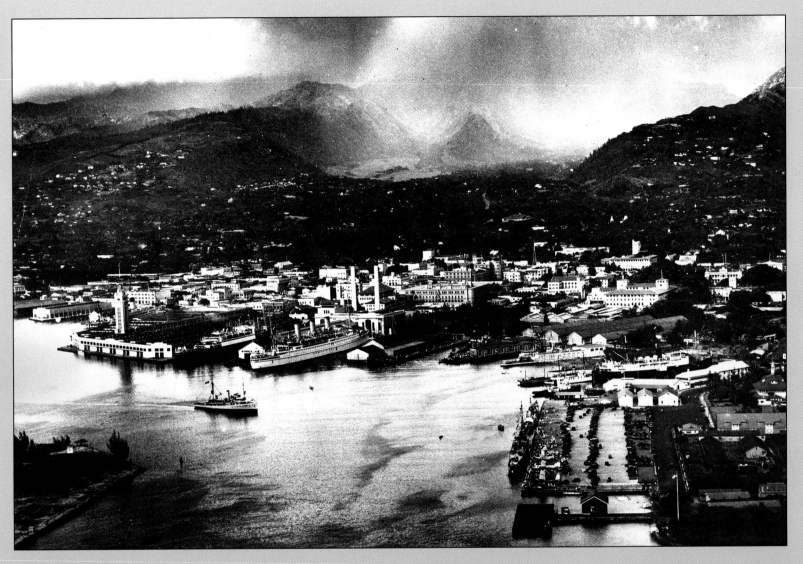

Honolulu in the 1930's was a
multicultural Pacific port with
graceful, low-rise buildings
neatly nestled between the
greenish-blue waters of the
harbor and the dramatic,
verdant Ko'olau mountains.
The tallest building in town
was Aloha Tower, a ten-story
structure rising from Honolulu
Harbor that was built in 1926
to welcome ships from around
the world with its distinctive
Hawaiian greeting.

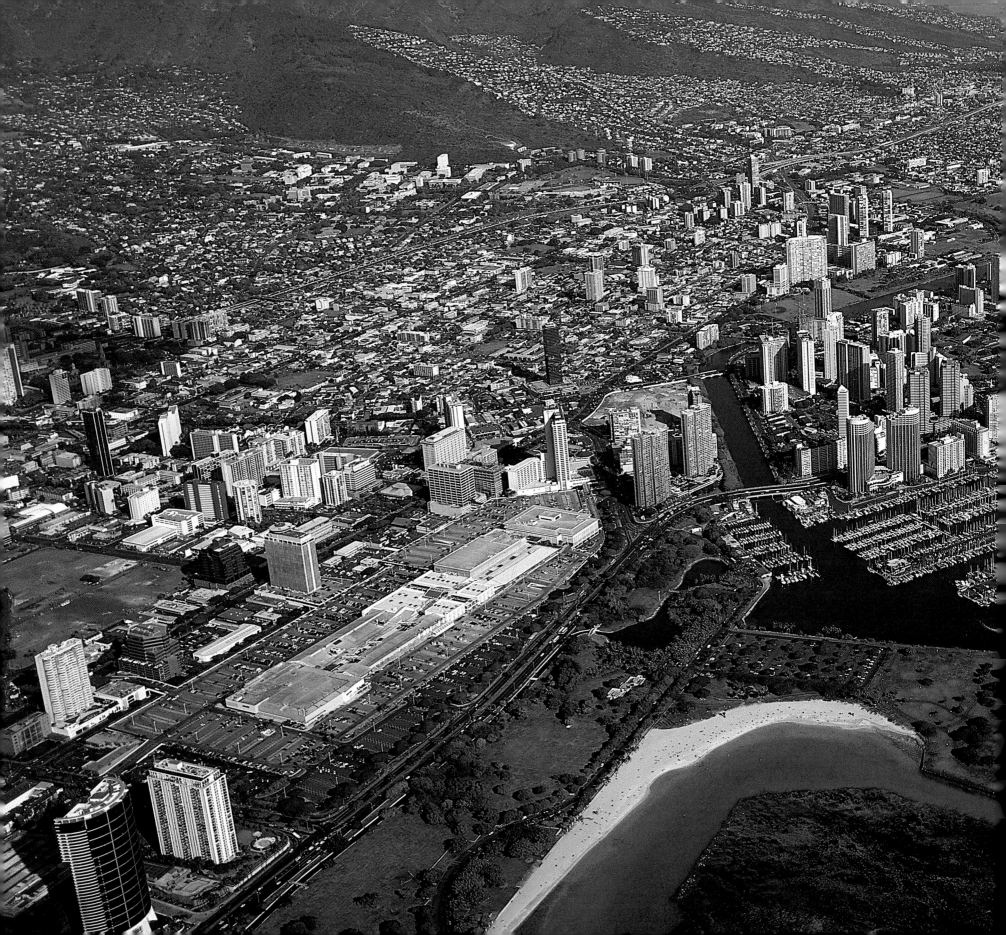

HONOLULU

THE HAWAIIAN METROPOLIS

The further I traveled through the town," wrote Samuel Clemens ["Mark Twain"] after visiting Honolulu in 1866, "the better I liked it. Every step revealed a new contrast–disclosed something I was unaccustomed to."

While the neatly laid-out streets, exotic grass huts, coral-block homes, polite residents, ample lawns, expansive shade trees, and multitudes of cats impressed the author, the setting of Honolulu between mountain and sea made the strongest impression.

"I saw on the one side a framework of tall, precipitous mountains close at hand, clad in refreshing green, and cleft by deep, cool, chasm-like valleys—and in front the grand sweep of the ocean: a brilliant, transparent green near the shore, bound and bordered by a long white line of foamy water of the deep sea, flecked with 'white caps' ..." rhapsodized America's beloved author. "I moved in the midst of a Summer calm, as tranquil as dawn in the Garden of Eden."

Honolulu may have lost the tranquility that earned it a comparison with the Garden of Eden. Its population stretches the city to near maximum capacity. Yet no other American metropolis of equal size can offer the exotic setting, diversity of ethnicity, mildness of climate, or spirit of "small town" living that Honolulu does. Where else can you walk four short city blocks to buy a *lei* of ginger blossoms, drink a cup of French-style coffee at a Vietnamese cafe, choose *dim sum* dumplings from among a dozen Chinese bakeries, visit a medicinal herb shop, pick up fresh noodles where the expert is tossing the dough in his shop window, bow respectfully at a Japanese shrine, visit a Korean senior citizen center, purchase a handmade shirt from a Filipino

PREVIOUS PAGES: *Waikiki's fabulous climate, multicultural life styles and teeming beaches annually attract millions from around the world, substantiating O'ahu's reputation as "the gathering place." Between Ala Moana Beach Park and Magic Island (foreground) and Diamond Head, more than a quarter-million people daily find their paradise.*

OPPOSITE: *Seen from the air, Koko Head and southern O'ahu are indeed "gems of the ocean." Although it is the most heavily populated of the Hawaiian islands, O'ahu retains its captivating natural beauty.*

13

Hui aku na maka i Kou.

"The faces will meet in Kou.
[We will all meet
in Honolulu, for the
games and watching.]"

tailor, and then relax with an American beer in an old saloon upgraded to a fashionable after-hours watering hole? Where else, as you walk into an out-of-the-way luncheonette, do you run into not only the mayor but half a dozen of your scuba-diving buddies from the other side of the island?

When the first Westerners arrived, Oʻahu's population center was Waikiki, in the shadow of Diamond Head. But shallow reefs and exposure to shifting currents made it desirable to sail a couple of miles westward to anchor off the smaller village of Kou. There a deep lagoon was protected by a shallow sandbar and reef, through which a precarious passage was found. Soon the chiefs and commoners followed the newcomers to what was being called Fair Haven (*honolulu* in Hawaiian) and Waikiki lost its prominence. As Kou/Fair Haven/Honolulu grew and Hawaiʻi became an important nineteenth century port-of-call for merchants and whalers, in 1859 it was renamed Honolulu. At the same time the boundaries were redrawn. The town now stretched from the southeastern Halona and Hanauma beaches to Moanalua Valley on the north. Oʻahu was indeed "the gathering place" as Honolulu became the capital of the Hawaiian Kingdom.

From a cluster of Hawaiian and foreigners' shacks by the harbor near the present site of Aloha Tower, Queen, Merchant and Fort streets, the village quickly expanded inland to the foot of the Punchbowl hill. Then in the mid-nineteenth century royalty and wealthy foreigners built up Nuʻuanu Valley toward the Pali Lookout. Soon other areas—Kalihi Valley, Makiki and Manoa Valley, Kaimuki and Moʻiliʻili—filled as Chinese and Japanese immigrants joined the rising *haole,* or foreign, tide seeking living space away from the bustle of downtown. Ironically, Waikiki was one of the last to develop into a residential district. Rice fields and taro farms persisted through World War I.

Today, seen from the air, Honolulu is nonstop development. The quiet

beach community of Waikiki has been transformed into Hawai'i's busiest population center with nearly 87,000 visitors a day from around the world packing its hotels, playing on its beaches, and filling its shopping centers. In the past two decades the fastest growth has been in east Honolulu where Hawai'i Kai and adjacent Kalama Valley continue to attract moderately affluent residents.

The projected growth rates for Honolulu and O'ahu in general remain high. Hawai'i anticipates 10 million visitors a year by the end of the century, with most staying in or near Waikiki. O'ahu's permanent population already tops 850,000. Aerial views of Honolulu in 2020 will certainly substantiate the Hawaiian prediction that "we will all meet in Honolulu." In the face of such population density, new highways, fixed-rail systems, accelerated tourism, and heated tempers, will Honolulu retain the special qualities, the startling contrasts and the scenic beauty that once prompted a young journalist to nominate it as a Garden of Eden in the Pacific?

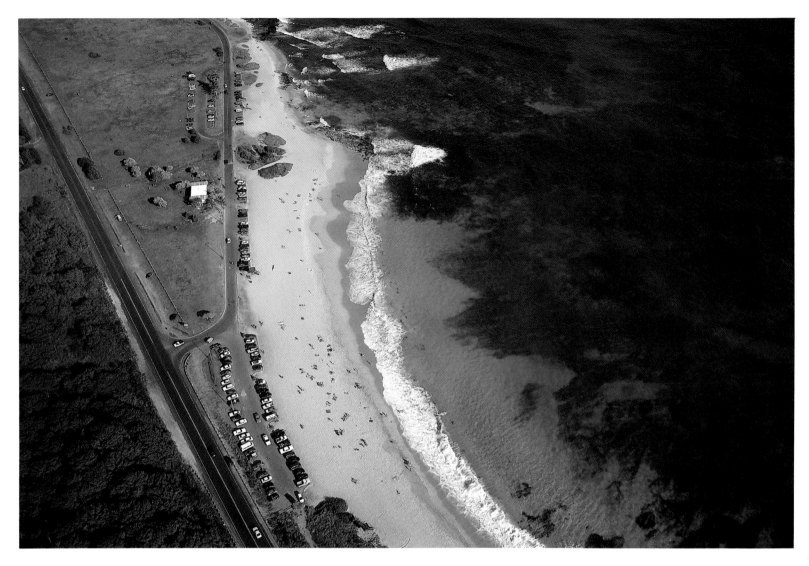

ABOVE: *Quarter-mile-long Sandy Beach, a popular body-surfing spot, usually is crowded with youthful sun worshippers and "boogie boarders." From the air, the water's color reveals the ocean bottom's abrupt drop that creates the fast, steep surf "breaks" for which Sandy Beach is famous—and often feared.*

Currents produce powerful tiderips and backwashes that can trap the veteran surfer as well as the unwary visitor. As at many other of O'ahu's spectacular beaches, survival at "Sandy" demands healthy caution.

OPPOSITE: *Plans to develop Kalama Valley in the early 1970s stirred a storm of community protests against its conversion into another Honolulu suburb. Although the effort to "save" Kalama Valley failed, the collective*

action of Native Hawaiian activists, environmentalists, and concerned islanders helped to ignite a renewed cultural pride and preservation ethic.

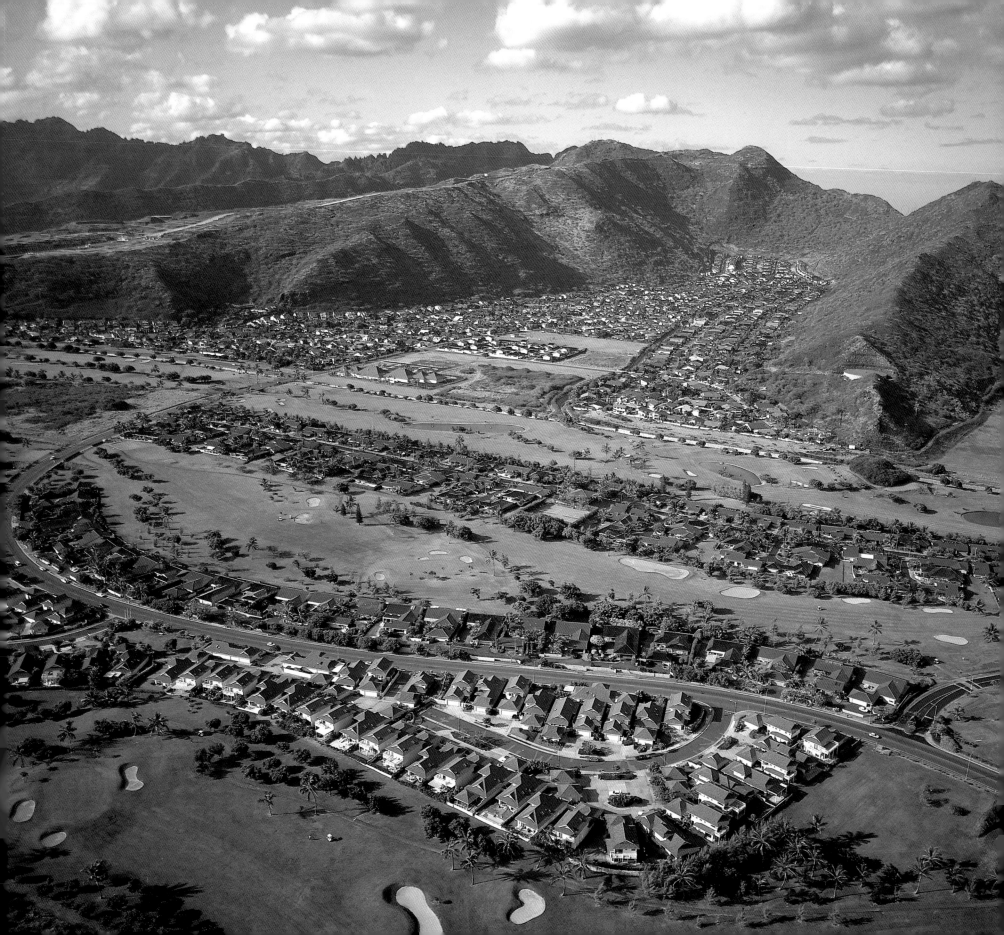

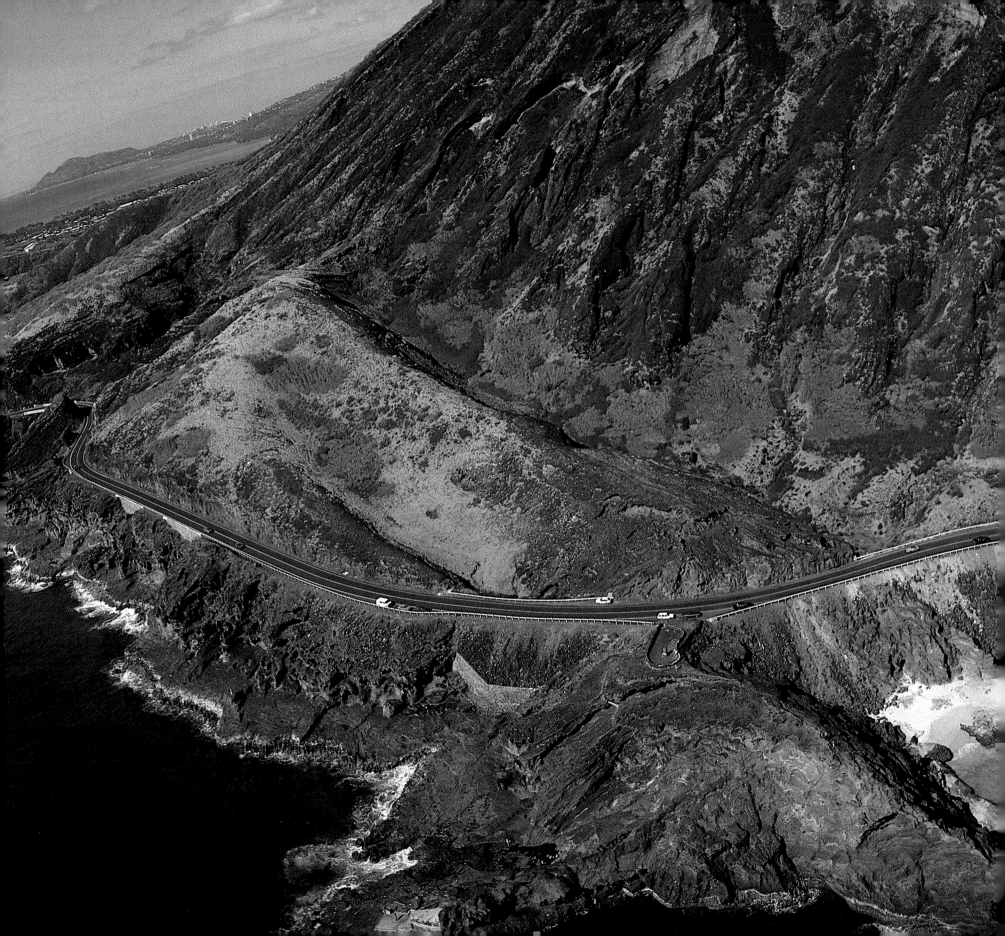

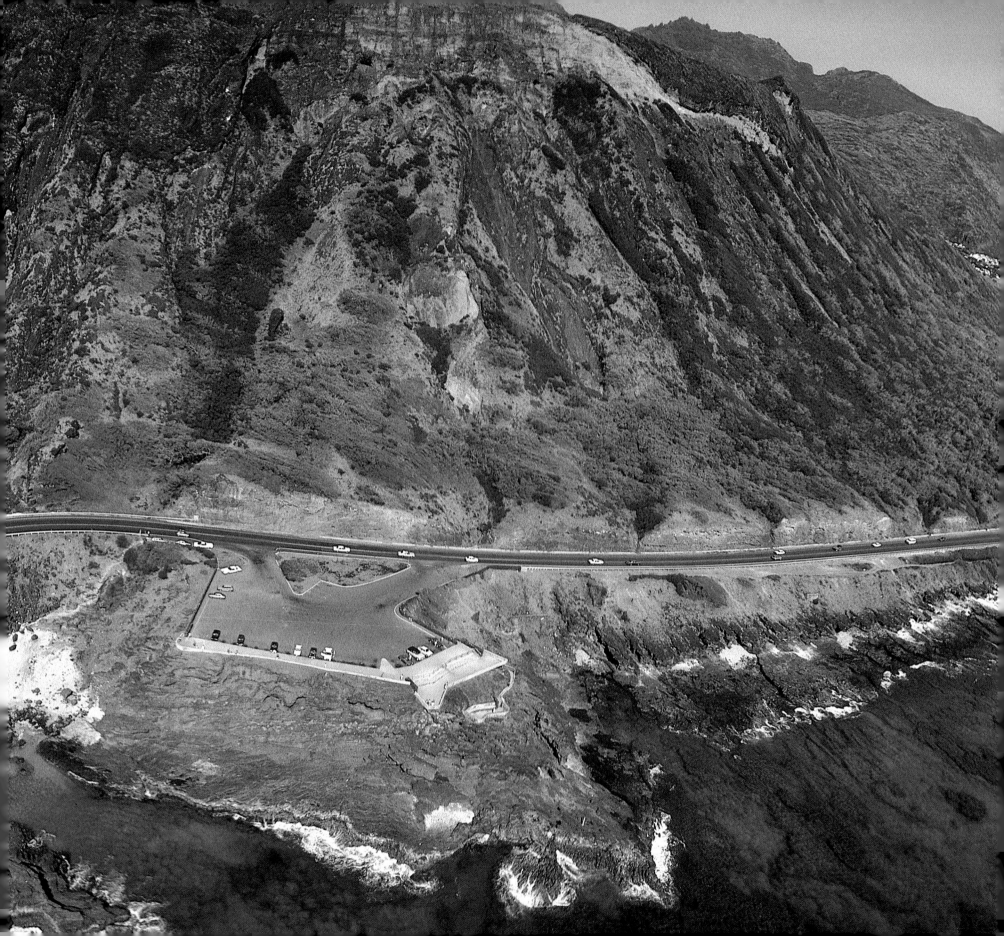

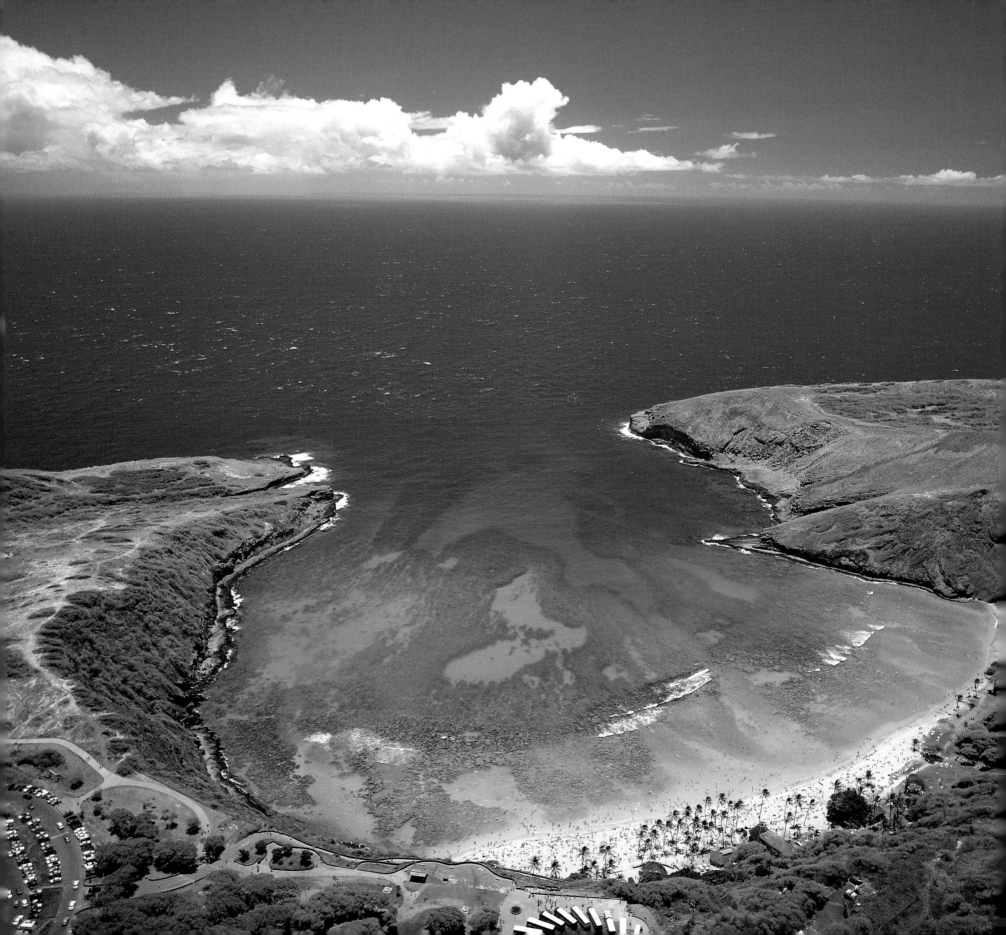

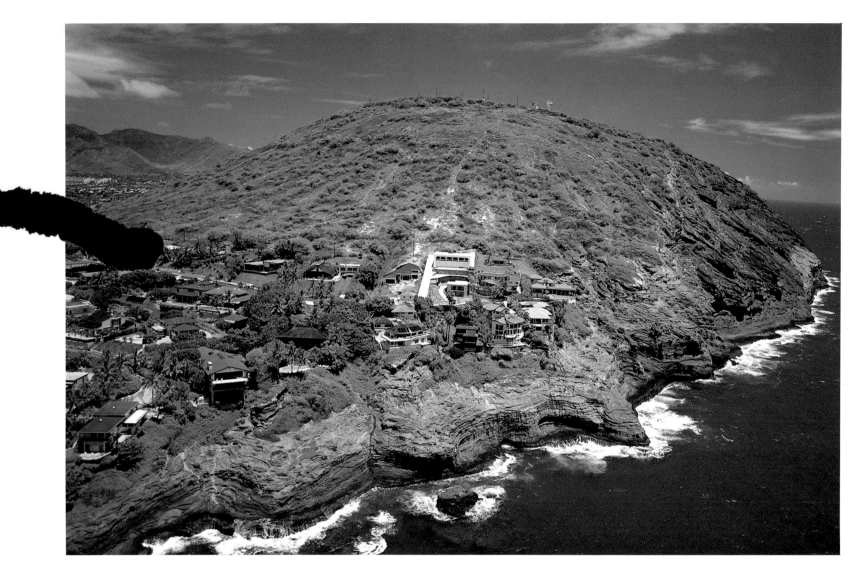

PREVIOUS PAGES: *Koko Crater is rimmed by a busy two-lane stretch of Kalanianaole Highway leading to O'ahu's popular southeastern beaches. Halona Point, the "secret" white sands of Halona Cove, and the famous Halona Blowhole are in the left foreground.* Halona *means "the peering place."*

OPPOSITE: *Hanauma Bay is internationally famous as a spectacular marine sanctuary. The meaning of* hanauma *is obscure, but it possibly refers to the ancient sport of* uma *said to have been played on the beach. The park's immense popularity has required an effort to limit the number of visitors.*

ABOVE: *Honolulu's Koko Head, a tuff cone, was known as* Mookua-o-Kaneapua, *"the backbone of Kaneapua." According to legend, the younger brother of the gods Kane and Kanaloa, Kaneapua had been sent by his brothers to fetch fresh water. When he disobeyed, he was transformed into this hill. Along the coastline is Portlock.*

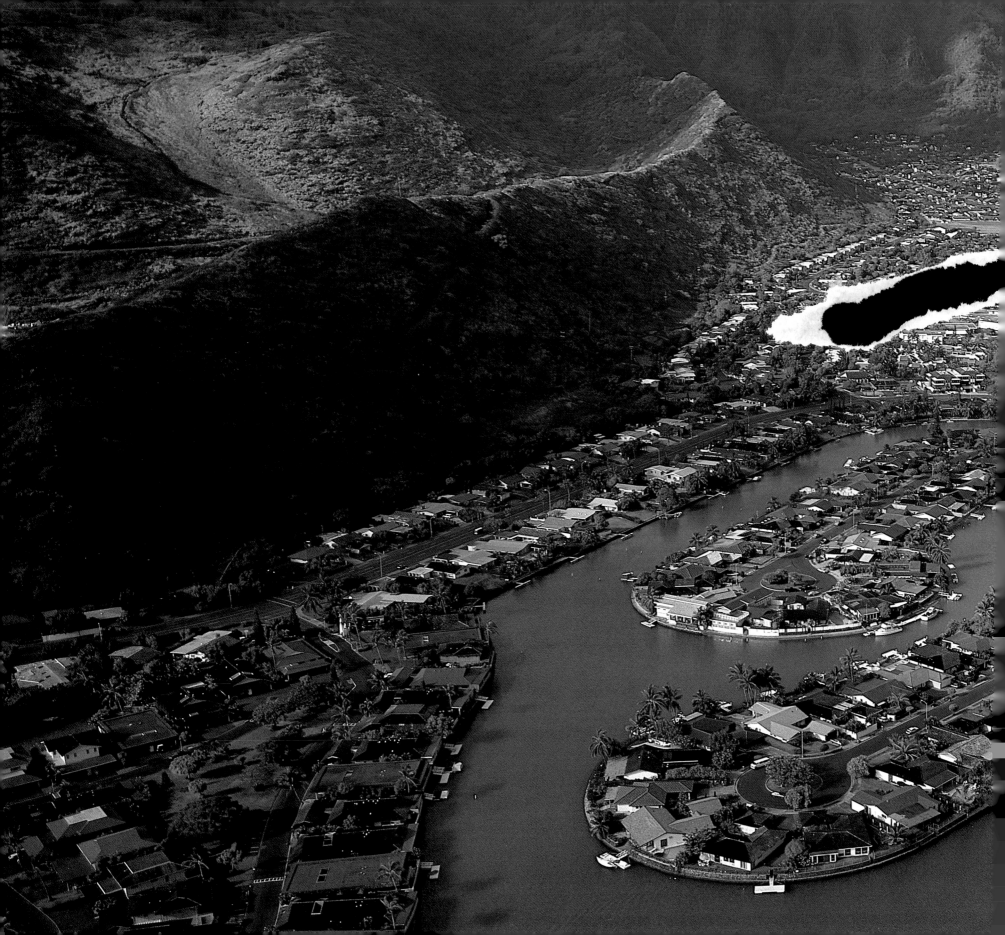

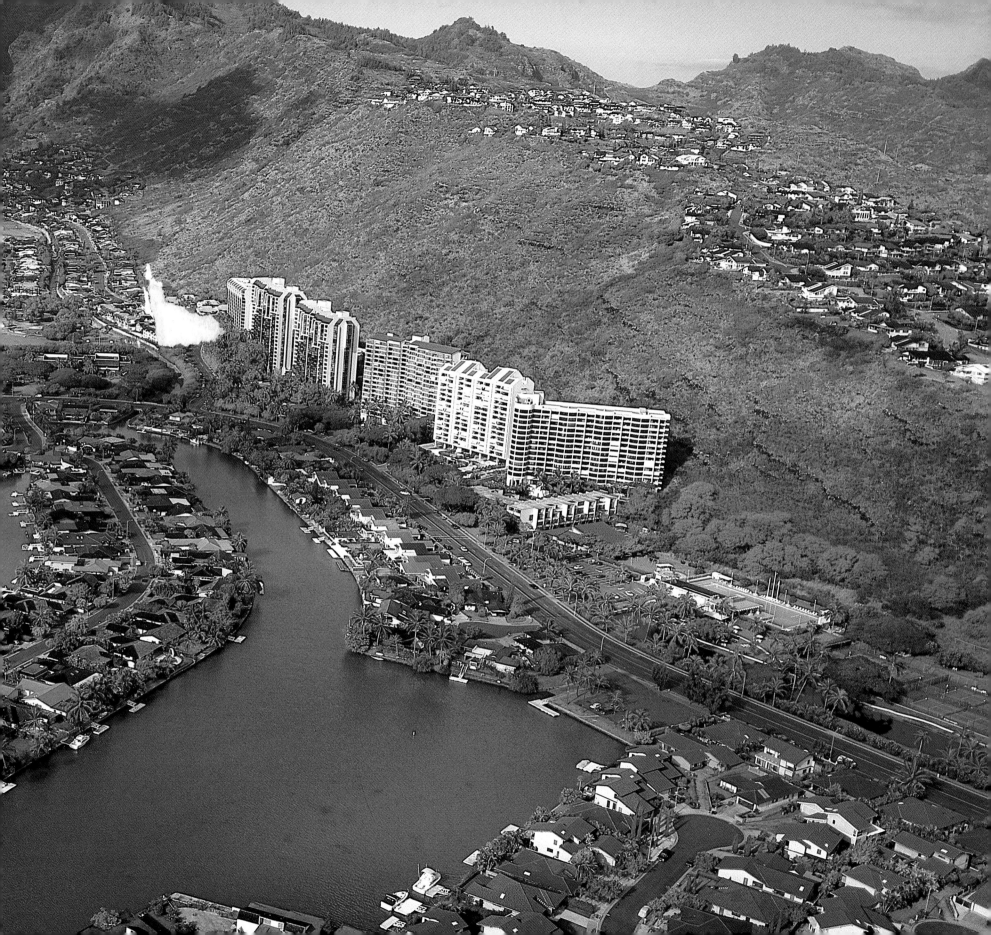

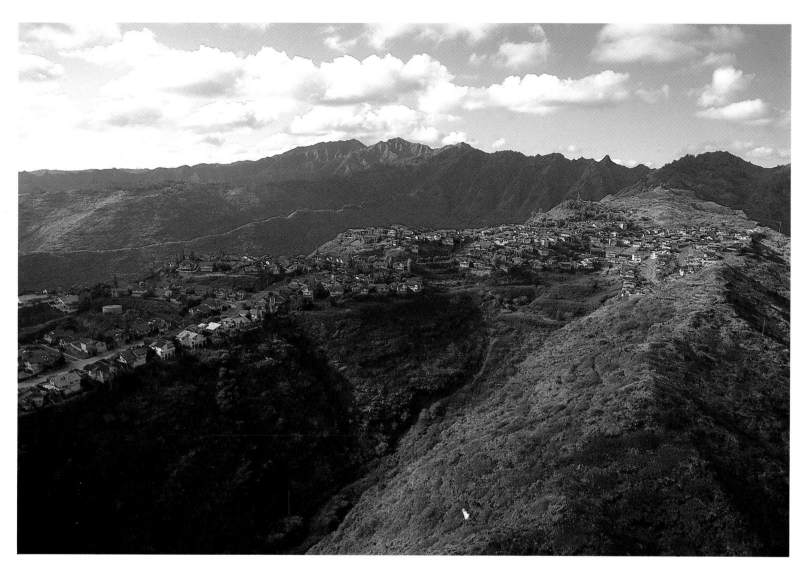

PREVIOUS PAGES: *Hawaii Kai Marina is on the site of an old Hawaiian fish pond, said to have covered 520 acres. Legend adds that the final section of the pond wall was constructed in a single night by the* menehune, *Hawai'i's "little people." Supposedly a tunnel connected this pond with Ka'elepulu pond (today's Enchanted Lake) on the* opposite shore of O'ahu, permitting mullet to disappear from one and quickly reappear in the other. Like many O'ahu neighborhoods, in Hawaii Kai ancient legends, early history and archeological sites mingle with convenience stores, townhouses and marinas.

ABOVE: *Hawaii Kai's development as a Honolulu suburb was begun in the fifties by aluminum magnate Henry J. Kaiser. Today it nears the crest of Kaluanui Ridge. Upscale residential complexes amid the commanding beauty of the south end of the Ko'olau Range are the hallmark of fast-growing Hawaii Kai.*

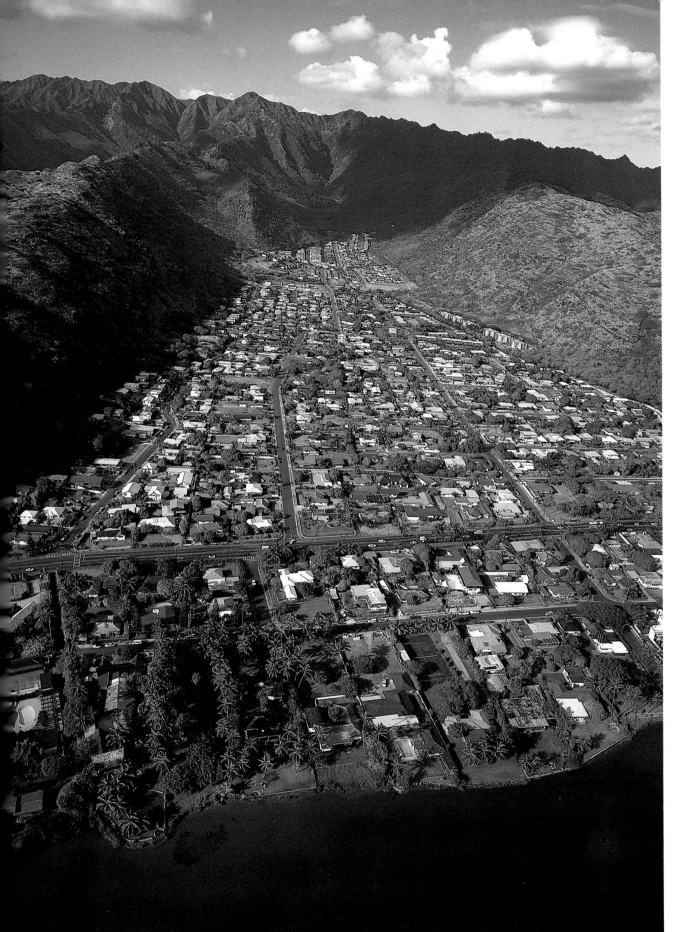

Archeologists in 1950 discovered
a remarkable lava-tube shelter
in Kuli'ou'ou Valley. Stone tools
carbon-dated to approximately
A.D. 500 were similar to those
found in Tahiti and the
Marquesan islands 2,700 to
3,000 miles away across the
South Pacific.

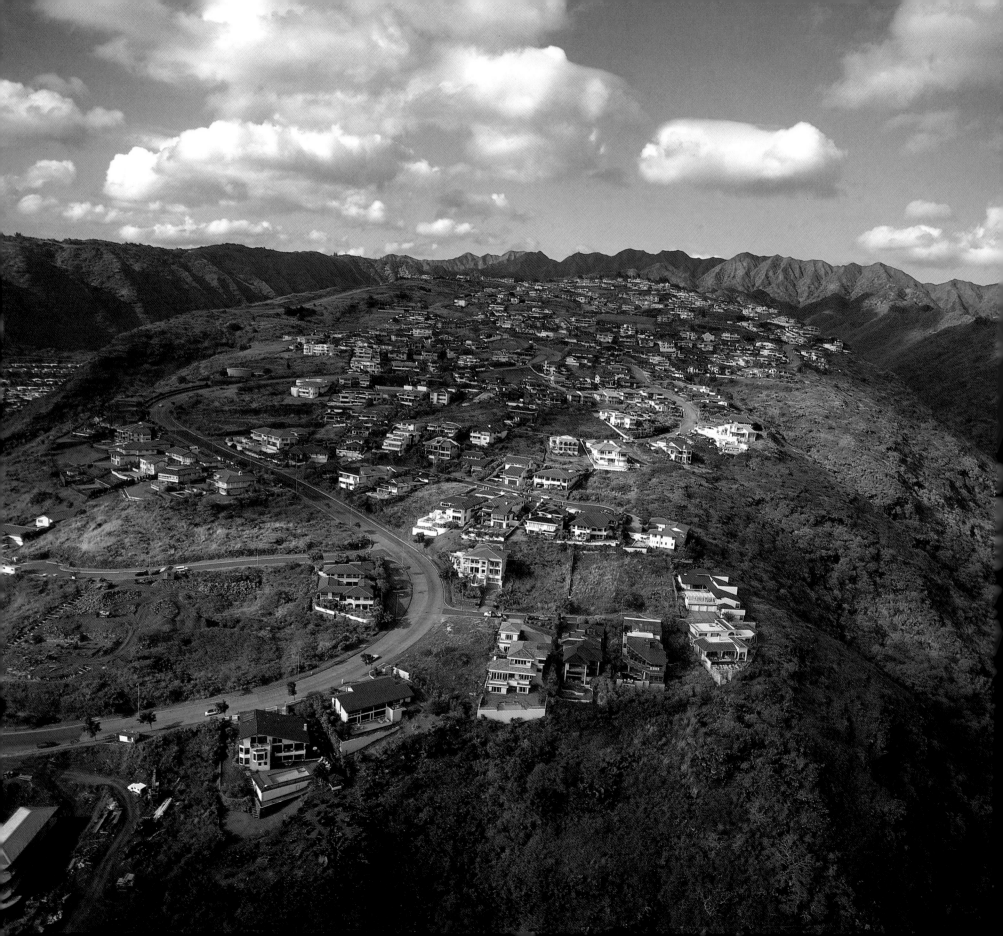

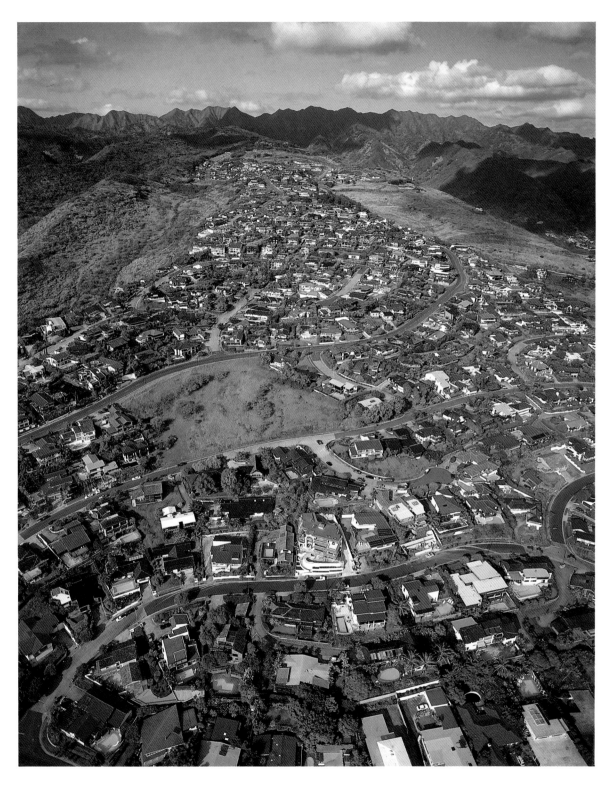

OPPOSITE: *Hawai'i-loa Ridge offers high-priced housing on a hill that Hawaiians call* **Kulepeamoa**, *"the flapping of a chicken." Honolulu's continued growth has pushed housing almost to the summit of the Ko'olau Range, providing spectacular views for those who can afford it.*

LEFT: *The Wai'alae Iki residential district was probably as densely populated in ancient times as it is today. Irrigated from a stone-encased spring named* Wai'alae, *"mudhen ponds," Wai'alae Iki and adjacent Wai'alae Nui were heavily terraced to grow taro, sweet potatoes, bananas and sugar cane.*

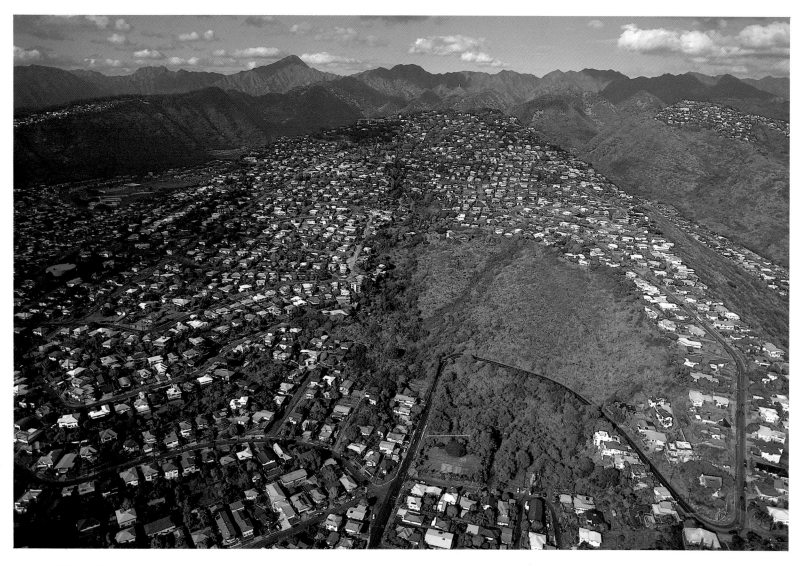

ABOVE: *Many Chinese and Japanese "graduates" from plantation work obtained homes for their growing families at Palolo Valley in the 1920s. Three generations later, this modest-income in-town suburb retains the spirit of its ethnic origins, with many small "mama-san and papa-san" shops, Buddhist temples,*

Japanese obon *folk-dance festivals, and the Palolo Home for elderly Chinese . Rising above the valley floor are Maunalani ("heavenly mountain") Heights and Wilhelmina Rise, the latter named for a daughter of a long-time president of the Castle & Cooke mercantile firm.*

OPPOSITE: *Kahala Mandarin Oriental has spelled "luxury" in Honolulu for thirty years. The equally exclusive (and expensive) adjacent Waialae Country Club hosts the annual big-purse Hawaiian Open Invitational Golf Tournament. The course was laid out originally in the 1920s for guests at the Royal Hawaiian Hotel in Waikiki*

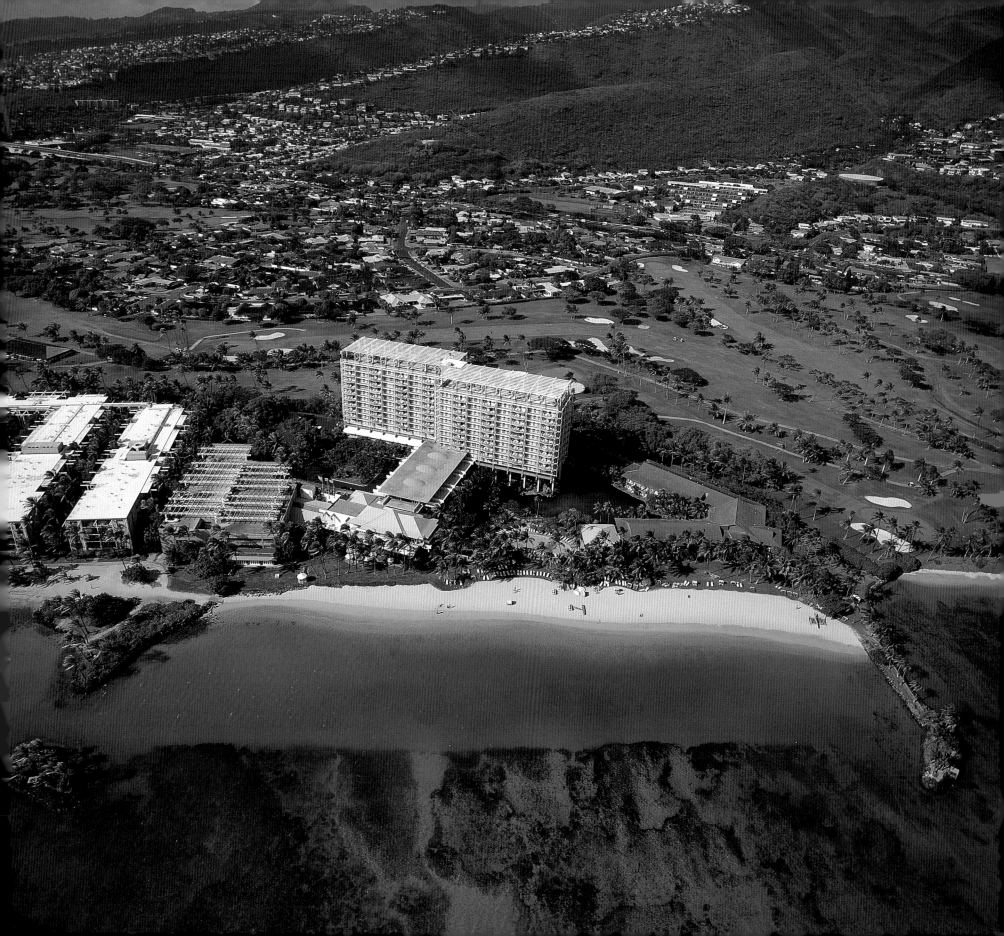

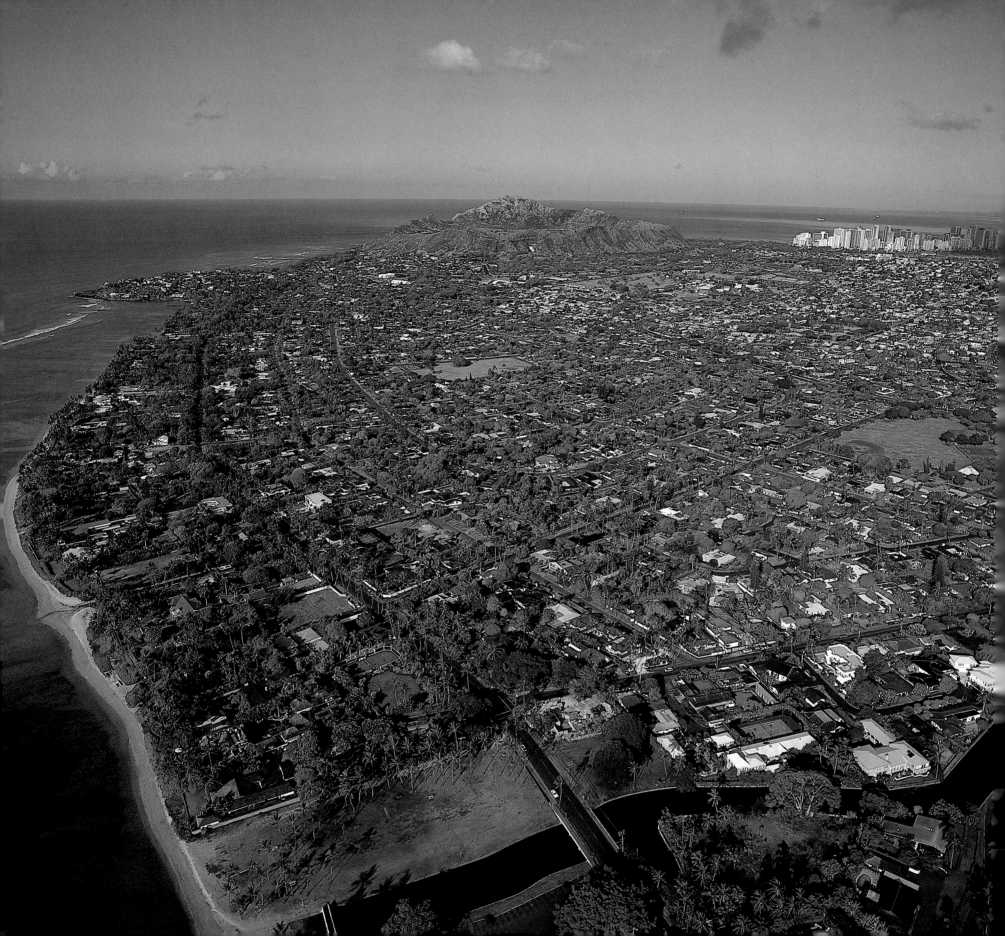

OPPOSITE: *In recent years, Kahala Beach and the adjacent Wai'alae-Kahala "gold coast" stretching to Black Point and Diamond Head have been the most expensive residential real estate in Hawai'i. The assessed value of homes here has skyrocketed.*

ABOVE: *After Maui the Polynesian trickster god accidentally raised the Hawaiian islands from the bottom of the Pacific with his magic hook of heaven,* Manaiakalani, *he attempted to pull the separate islands together. Standing on Ka'ena Point, at the northwestern corner of Oahu, he fastened his hook securely to Kaua'i island, over the horizon to the west, and pulled. Unfortunately, a corner of Kaua'i broke off, sailed across the Kauai Channel, and splashed down at his feet. The hook itself flew over his head across O'ahu, landing at the top of Palolo Valley where Ka'au Crater marks the spot.*

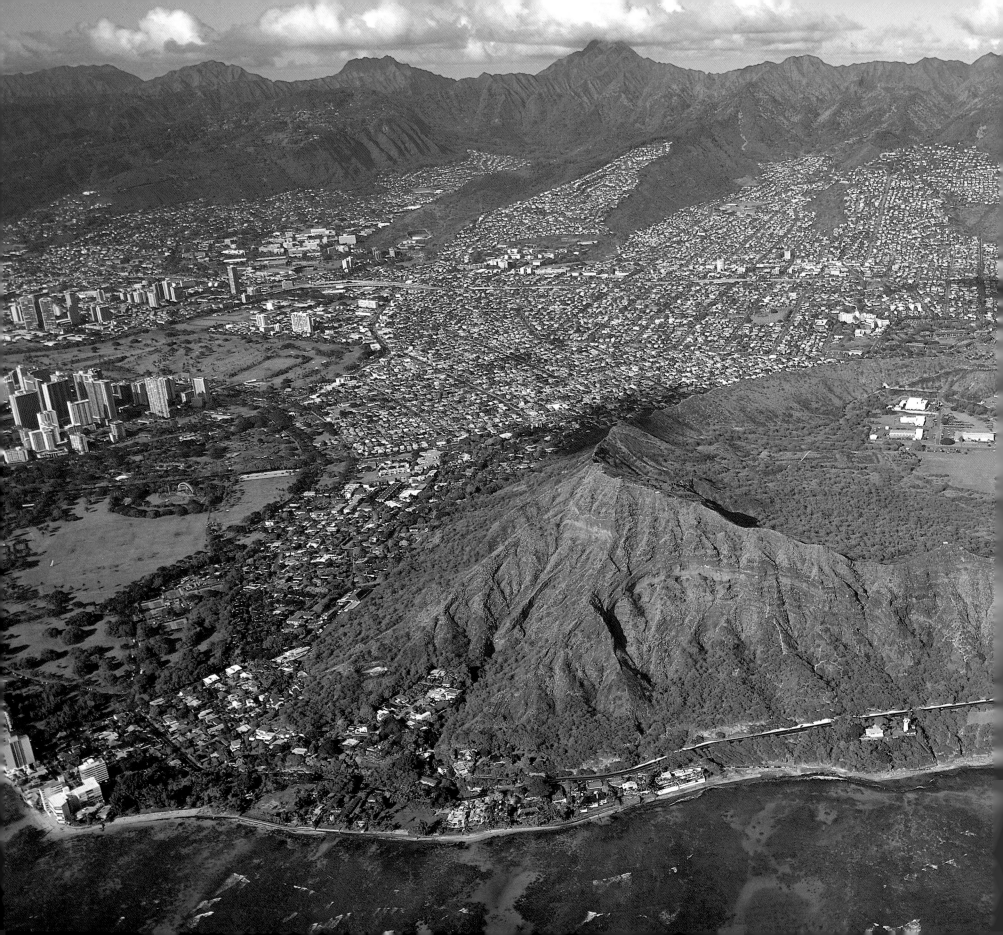

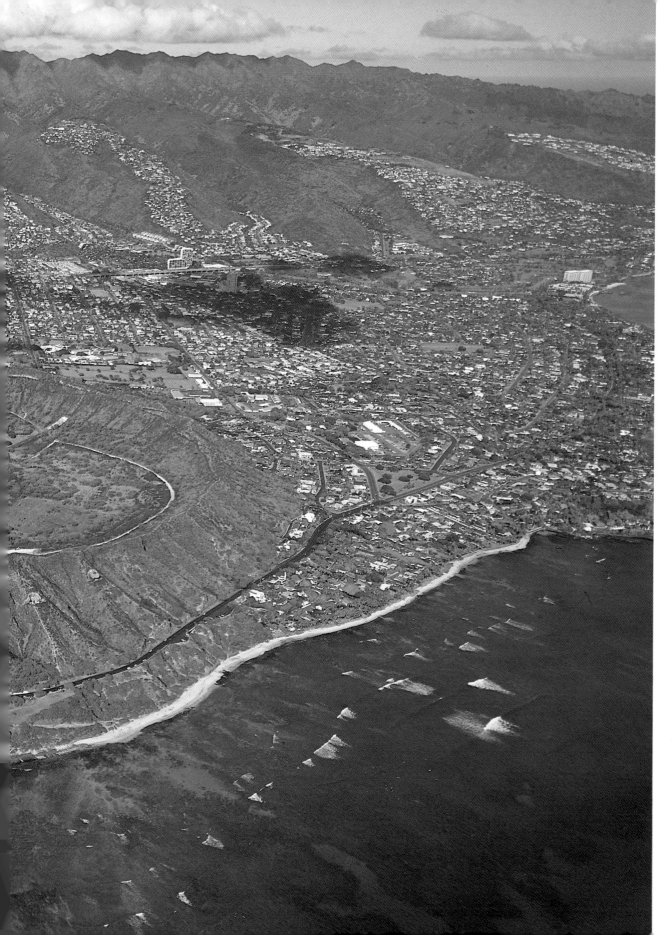

Diamond Head is Hawai'i's most famous natural landmark, inspiring voyagers, artists, poets, songwriters, naturalists, hikers, and tourism publicists. Le'ahi, "brow of the yellowfin tuna" to the Hawaiians, was once speckled with calcite crystals mistaken by early sailors for diamonds. The 200,000-year-old cone remnant looms 760 feet over Waikiki. Nani Le'ahi, he maka no Kahiki, say the Hawaiians. "Beautiful Le'ahi, object of the eyes from Tahiti."

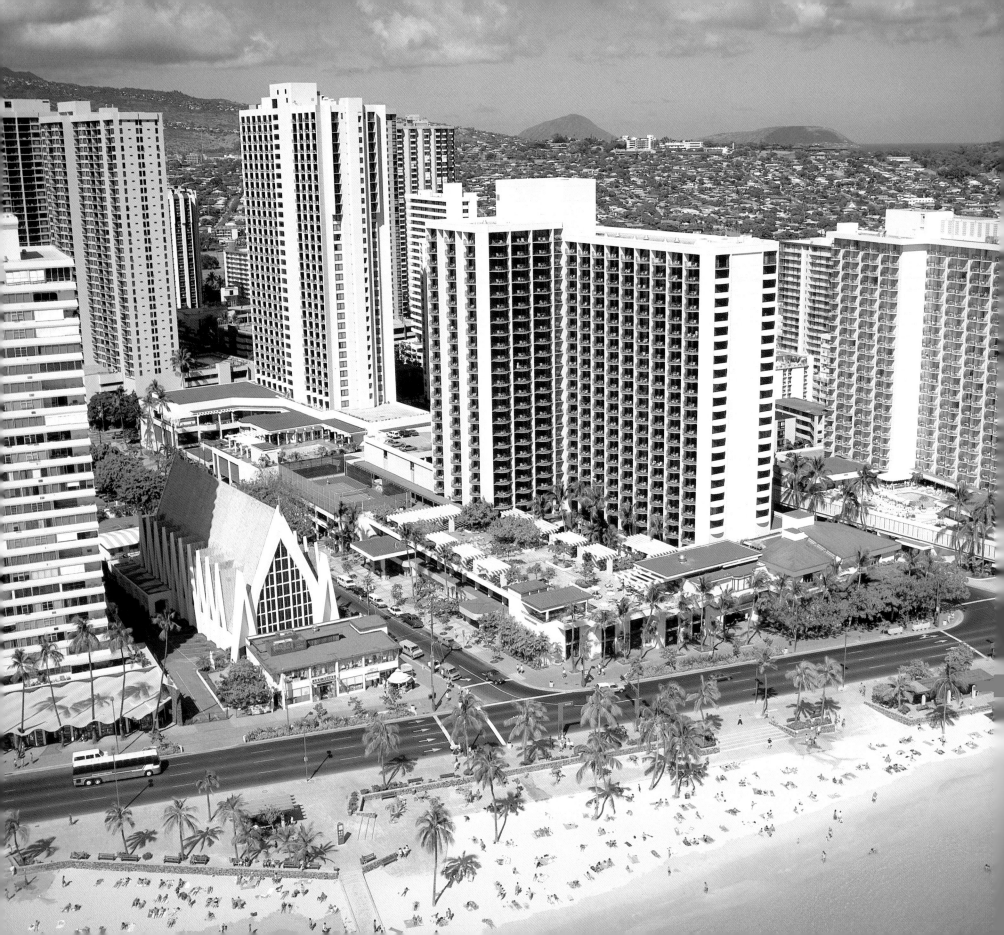

In one of the earliest aerial views of Waikiki, taken on September 9, 1920, the Moana Hotel, with massive new concrete wings added to the original 1901 wooden structure, dominates the beach. Nearby, Victorian homes nestle under huge shade trees and tropical palms on Kalakaua Avenue along what today is Kuhio Beach Park. The old electric Waikiki Trolley traverses Waikiki to Kapiolani Park, passing a popular watering hole, the Waikiki Tavern and Inn. Behind Waikiki Beach Hawaiian, Chinese and Japanese cultivate extensive rice and taro farms. Several rivers flowing from the Koʻolau Range water the rice paddies and feed the swamps that bred mosquitoes, giving the area its distinctive name, Waikiki, or "spouting waters."

A few members of Hawaiʻi's royalty were still in Waikiki in 1920, when that aerial photo was taken. Princess Kaʻiulani, King Kalakaua and Queen Liliʻuokalani all were gone, their estates subdivided and sold, but Prince Jonah Kalanianaʻole Kuhio still had his home on Kalakaua Avenue near the foot of Liliʻuokalani Street. As Hawaiʻi's delegate to the United States Congress, Prince Kuhio had been instrumental in securing passage of the Hawaiian Homesteads Commission Act and frequently used his Waikiki grounds and beach for large *luau*, or picnics. His residence was one of the last vestiges of the time when Waikiki was the preferred retreat for the great chiefs, including Kukuihewa, Kame-

hameha the Great, and Kamehameha V.

Arrivals in Hawaiʻi by ship in the twenties often sought out a new kind of royalty in Waikiki—the world's fastest swimmer, Duke Paoa Kahanamoku. As a 21-year-old, this Waikiki resident had taken the gold in the 100-meter freestyle race at the 1912 Stockholm Olympics. (In 1920 he again competed in Antwerp, once again winning a gold medal.) Out of gratitude and pride, the people of Honolulu bought him a Waikiki house near where he grew up. Fame and Hollywood stardom, however, never went to the head of this quiet, self-effacing gentleman who preferred to eat and speak Hawaiian and to spend his days in the sea or with his boyhood "beach boy" friends.

These were the old days of Waikiki, before the farms were drained into the newly dredged Ala Wai Canal, before the World War II mass influx of fighting men, and before the postwar boom filled Waikiki with concrete high rises. Pre-World War II Waikiki was a community of Hawaiians, Japanese, Chinese and *haoles* enjoying a simple, quiet life together, sharing with visitors the lovely nights, the mellow *ukulele* and Hawaiian steel guitar music, and the falsetto voices of Hawaiʻi's great entertainers. To this day, when a full moon rises above Diamond Head and a gentle breeze blows across a deserted late-night beach, the old ghosts can still be evoked with the words of musician Andy Cummings, "… the magic of Waikiki."

Facing Kuhio Beach in the center of Waikiki, St. Augustine's Catholic Church seems an anomaly on crowded high-rise Kalakaua Avenue. Founded in 1854, it became a landmark half a century later with a distinctive "Polynesian Gothic" structure to serve the growing community. Another half century later, as Waikiki became an international visitor destination, that building was replaced, too. Despite multi-million-dollar offers for the land as a hotel site, St. Augustine's remains steadfast as Waikiki's religious center.

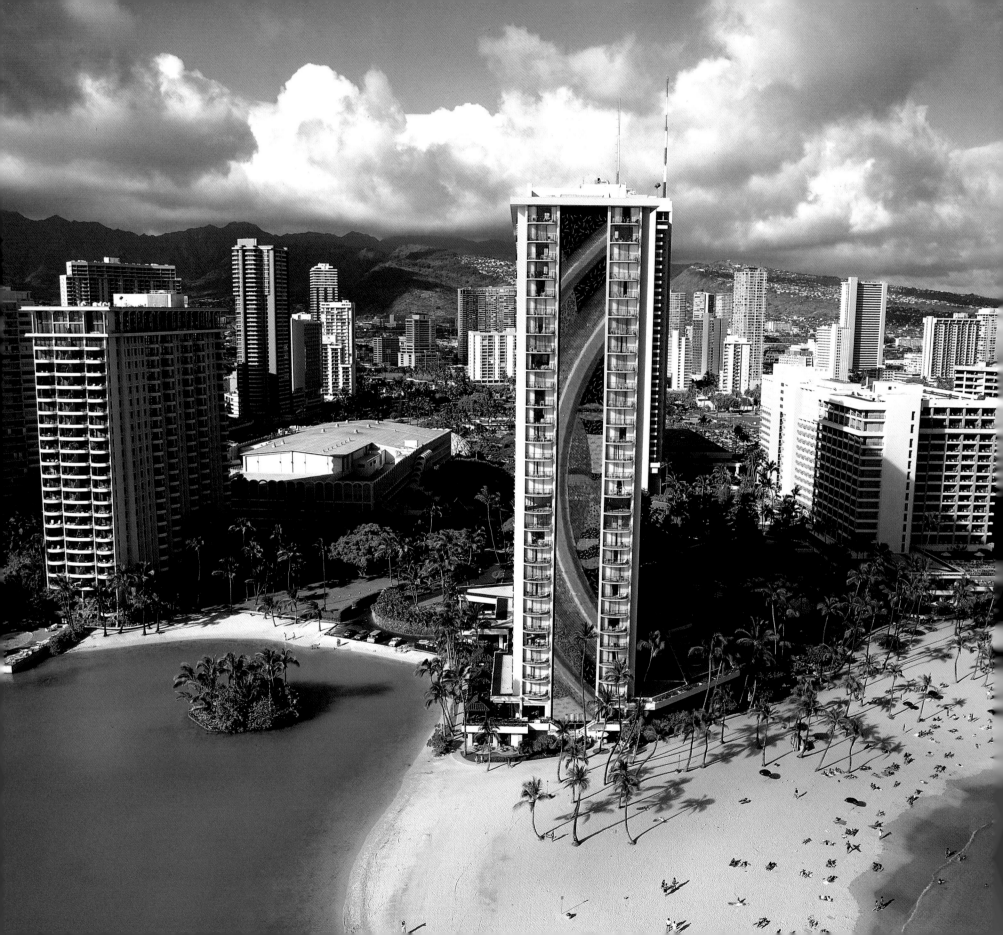

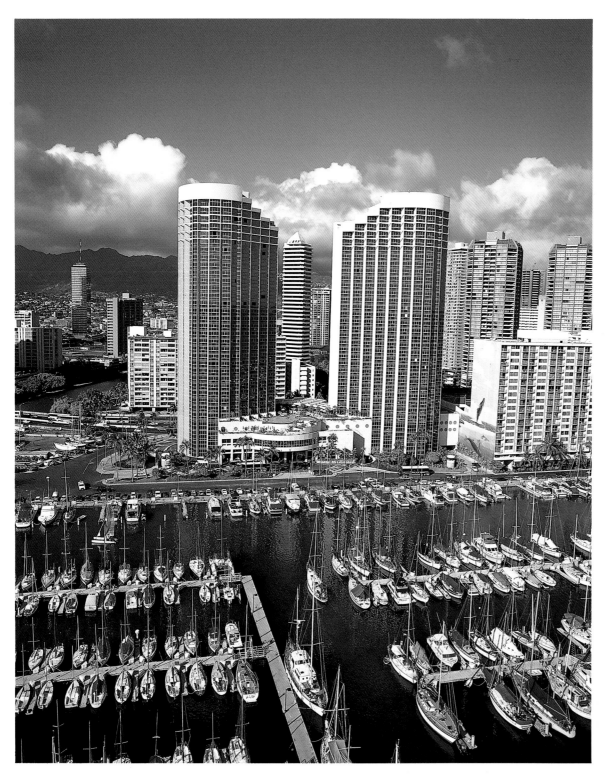

OPPOSITE: *Hilton Hawaiian Village's Rainbow Tower dominates its end of Waikiki with the world's tallest ceramic-tile mosaic. Constructed on the one-time John Ena estate in 1954 by developers Fritz Burns and Henry Kaiser, the hotel completed a six-year, 100-million-dollar facelift in 1988. The beautiful white-sand beach and lagoon are named for Hawai'i's great Olympic swimming champion and surfing idol, Duke Paoa Kahanamoku, who grew up in the neighborhood.*

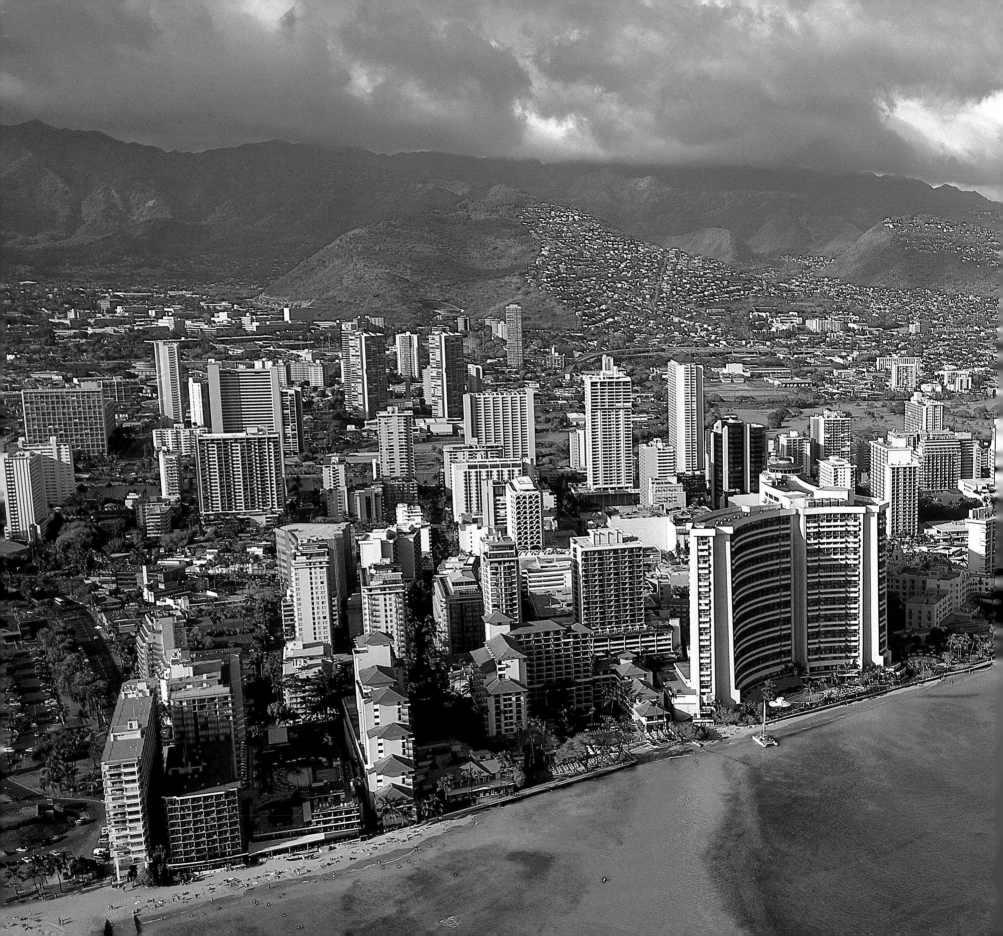

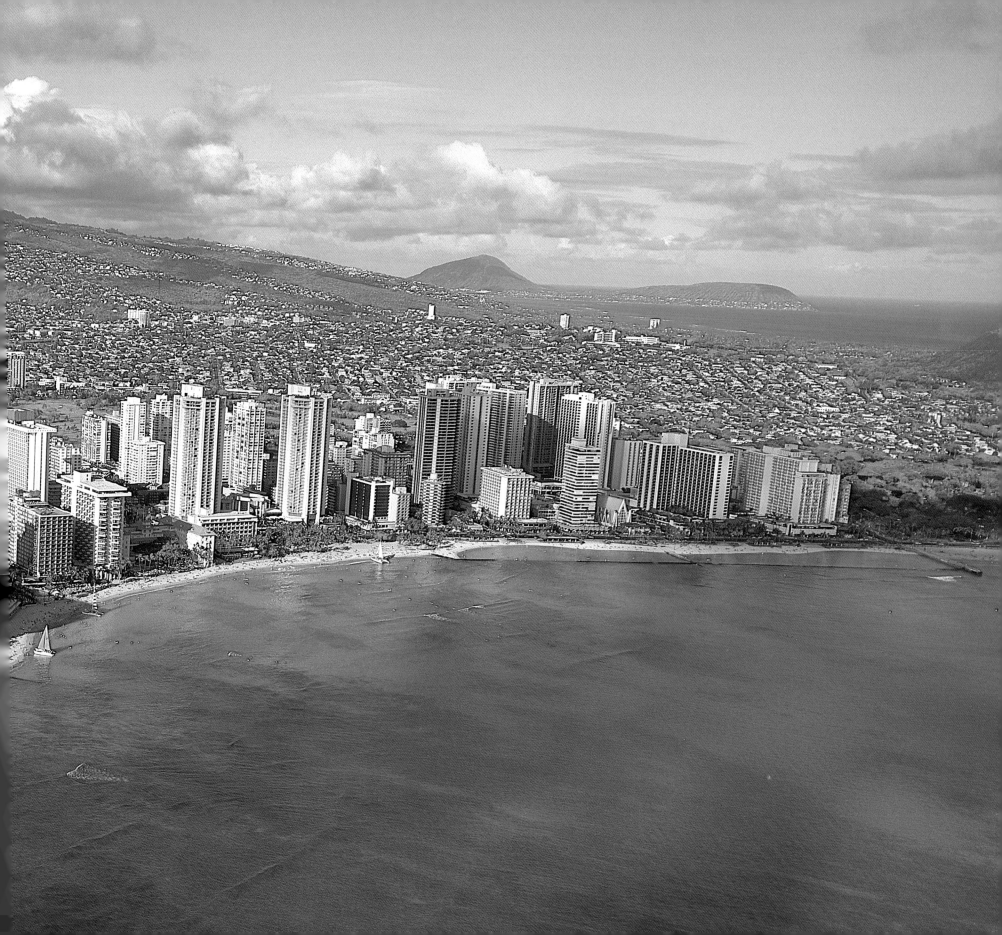

PREVIOUS PAGES: *Waikiki today, with its bustling beach center, tree-rimmed Kapiʻolani Park (right), and densely built-up residential neighborhoods reaching halfway up the Koʻolau Range, bears little resemblance to what it was 90 years ago. Then it was almost endless taro farms, rice fields, duck ponds, swamps, clusters of coconut trees behind an empty beach, a scattering of residences and weekend bungalows, and some of the world's best surfing.*

RIGHT: *Yachts set spinnakers flying off Waikiki as modern islanders continue Hawaiʻi's ancient maritime tradition. ʻAu i ke kai me he manu ala, says an old poem. "Cross the sea as a bird." There is no better way to appreciate the islands.*

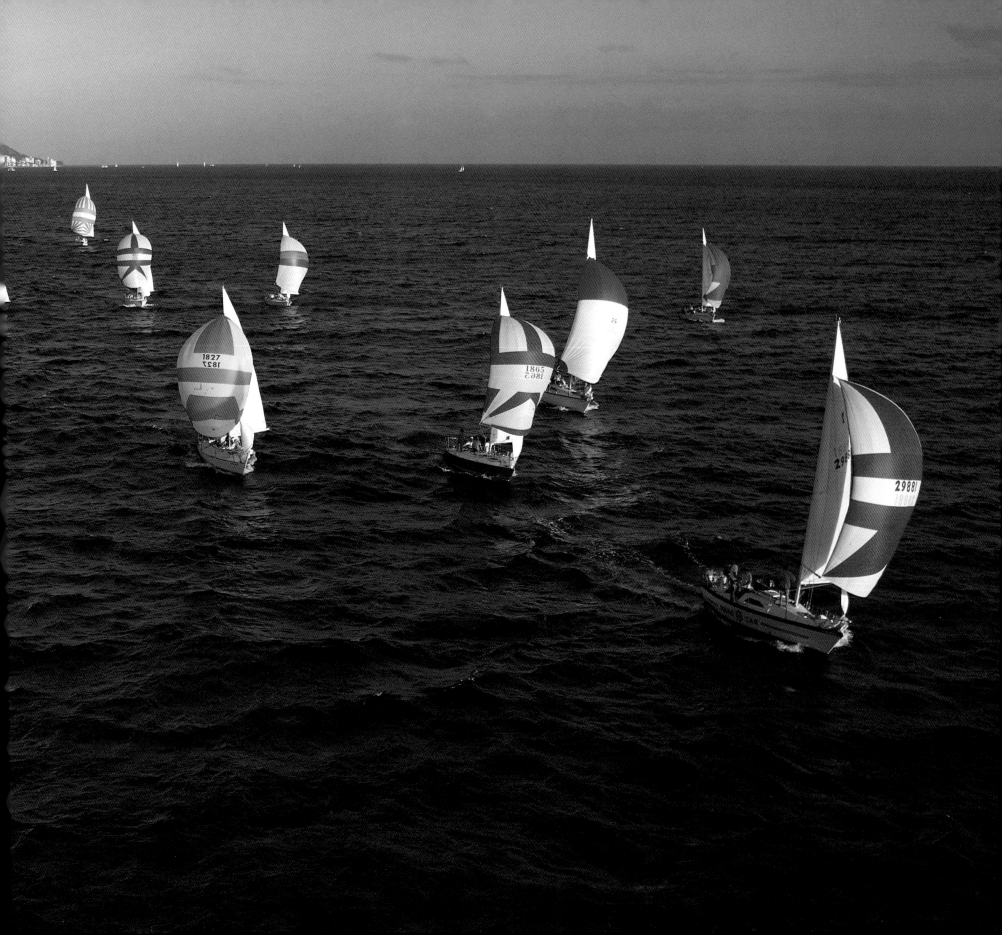

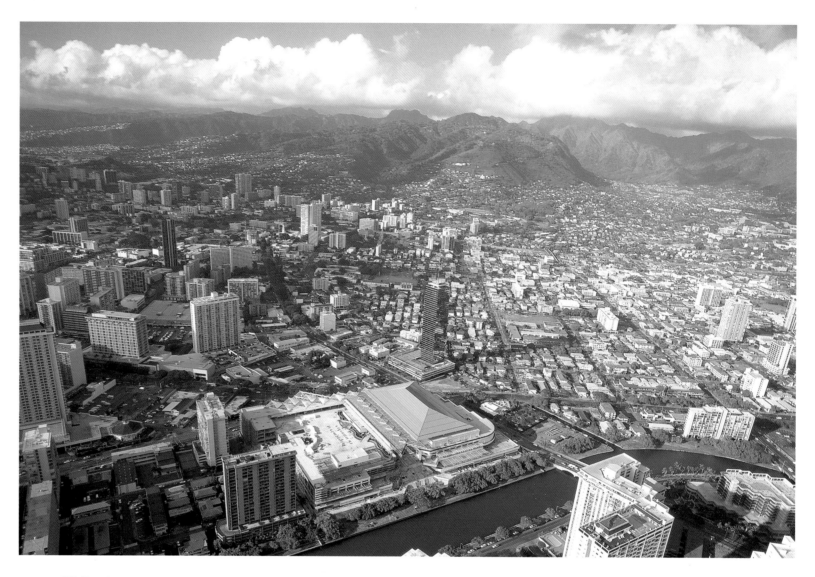

ABOVE: *Waikiki's traditional core is now extended to the Kapi'olani boundary with the July 1, 1998 opening of the Hawai'i Convention Center. Equipped with state-of-the-art technology, this landmark architecturally pleasing edifice will make O'ahu a gathering place for people from across the globe.*

OPPOSITE: *When fifty-acre Ala Moana Shopping Center opened in the 1960s, it was billed as the world's largest. Although it has lost that distinction, the center remains a maelstrom of activity. In recent years Ala Moana Center has upscaled its shops and clientele with designer stores and an exclusive third-level showcase, Palm Boulevard. In 1998, Neiman Marcus joined the prestigious ranks opening it's doors to offer not only popular designer products, but also integrated space for Hawai'i's gifted local artists.*

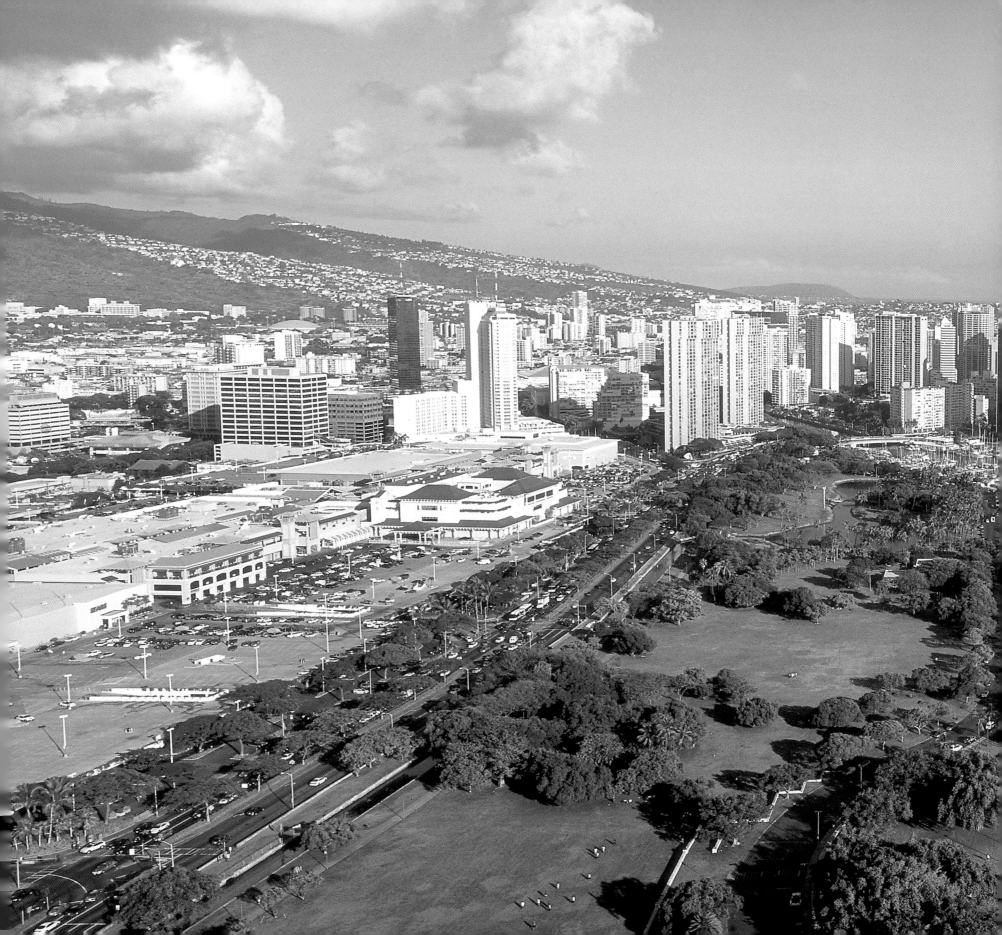

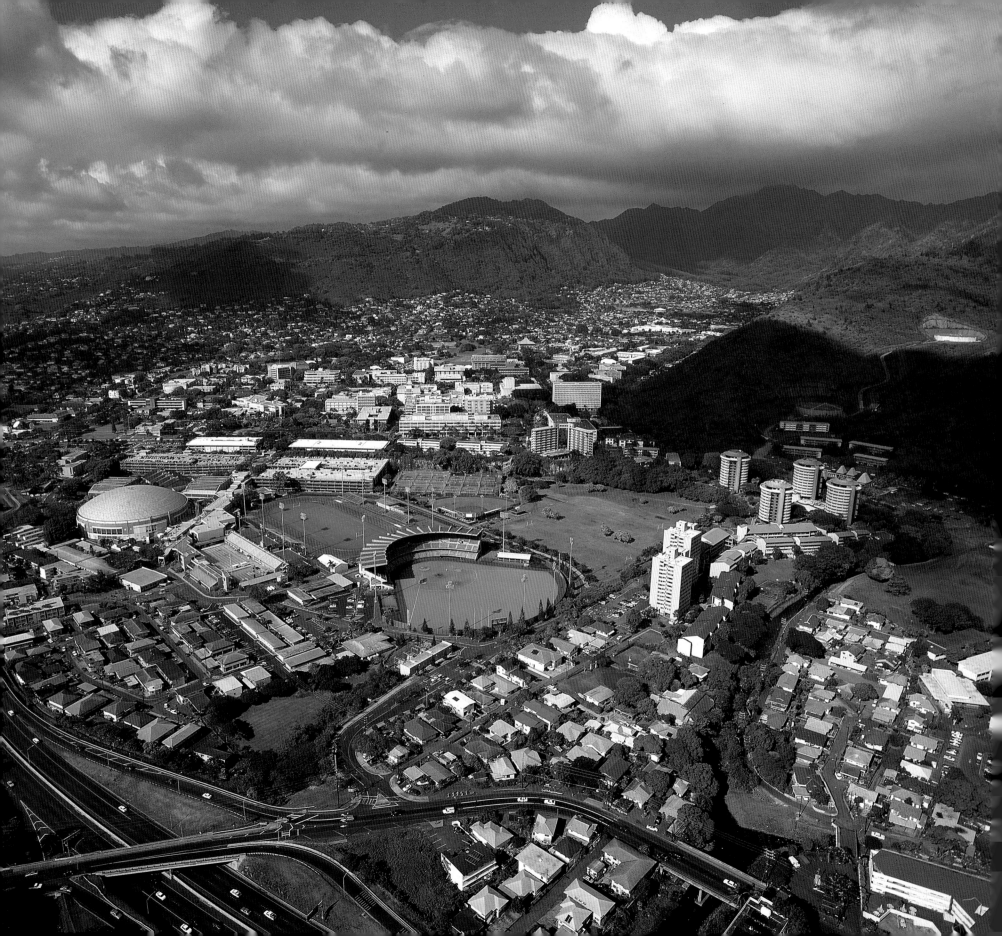

The University of Hawaii's Duke Kahanamoku Pool, Rainbow Stadium and Cooke Field are at the lower end of a campus that reaches far up Manoa Valley. Founded in 1905 as a mainly agricultural college, it moved to lush Manoa Valley in 1911. The University of Hawai'i at Manoa—today the flagship of a nine-campus statewide system—offers its more than 20,000 students baccalaureates in ninety fields. The distant Manoa Valley residential neighborhood retains much of the charm of older Honolulu with quiet streets, enormous shade trees, graceful island-style homes with broad lawns, and the cool mists and wind for which the valley is noted.

No legend of ancient Hawai'i seems to endure so beautifully as that of Kahalaopuna, the "rainbow maiden of Manoa." Honolulu's most beloved valley, noted for elegant old homes, a picturesque Chinese cemetery, the University of Hawai'i campus, and cool misty breezes, Manoa over the generations has attracted chiefs, the wealthy elite of island society, and middle-class residents representing all of Hawai'i's races. As Japanese and Chinese immigrants and their children began to climb the social and economic ladders, they often displaced Manoa's older taro farms and dairies with elegant new homes.

Despite Manoa's growth, one feature has remained dominant—Mount Akaaka, the tallest peak overlooking the valley. Akaaka, according to the legend, originally was a chief of high rank residing in Manoa with his wife, Hinaakaaka, and their children. It was his granddaughter Kahalaopuna, however, whom Akaaka loved the most. Acknowledged to be the most beautiful woman in the Hawaiian islands, she grew up in Manoa Valley in the care of her grandfather who placed upon her a *kapu*, or taboo, so that no man could ever look upon her.

When she came of age, Kauhi, a high-ranking chief who resided in Waikiki, was selected to be her mate. Before he met the beautiful Kahalaopuna, this arrogant and jealous chief heard untrue rumors that she had consorted with men of far lesser rank than he. Choosing to believe, Kauhi lured Kahalaopuna away from her grandfather and, despite her protestations of chastity, murdered and buried her. Kauhi's act was observed, however, by Kahalaopuna's owl *'aumakua*, or guardian spirit, who exhumed her body and restored her to life. Again Kauhi murdered Kahalaopuna, and again the owl restored her to life. Finally after several more attempts to hide the body, Kauhi successfully buried Kahalaopuna under a great *koa* tree, the roots of which prevented the owl from recovering the body.

Only after Kahalaopuna was rescued from the other world by a young chief named Mahana could she be fully restored. When Kauhi finally was confronted with his crimes, he was punished with death in the open ovens of Waikiki and transformed into a shark, his *'aumakua*. Two years later, despite warnings not to go into the surf at Waikiki, Kahalaopuna was attacked and eaten by Kauhi. Broken-hearted, old chief Akaaka became the mountain peak overlooking Manoa Valley. His wife now is the ferns that grow at its base, and his children can be felt in the wind and mist for which Manoa is famous.

As for Kahalaopuna, say the old Hawaiian story tellers, you can see her at times in the valley. For when the rainbow appears, then disappears and then reappears, that is Kahalaopuna dying and returning to life, dying and coming to life again.

ABOVE: *Puʻu ʻOhiʻa, the hill of the ʻohiʻa trees, was dubbed Tantalus a century ago supposedly by hill-climbing students from Honolulu's now-famous Punahou School. They went on to rename two other landmarks of the valley—Round Top for* Puʻu ʻUalakaʻa *and Sugar Loaf for* Puʻu Kakea.

OPPOSITE: Pu-o-waina, *"hill of sacrifice," better known today as the Punchbowl, has been the site of an important ancient Hawaiian temple of human sacrifice, a fort from which a battery of cannons might defend Honolulu (and salute ships entering or leaving the harbor), a stage for spectacular fireworks, and a place where thousands* gathered *to welcome the Easter sunrise. In 1949 the bowl of this 500-foot tuff cone was dedicated as the U.S.National Memorial Cemetery of the Pacific. More than 25,000 men and women who fought for the nation from the Spanish-American War through Vietnam are buried there.*

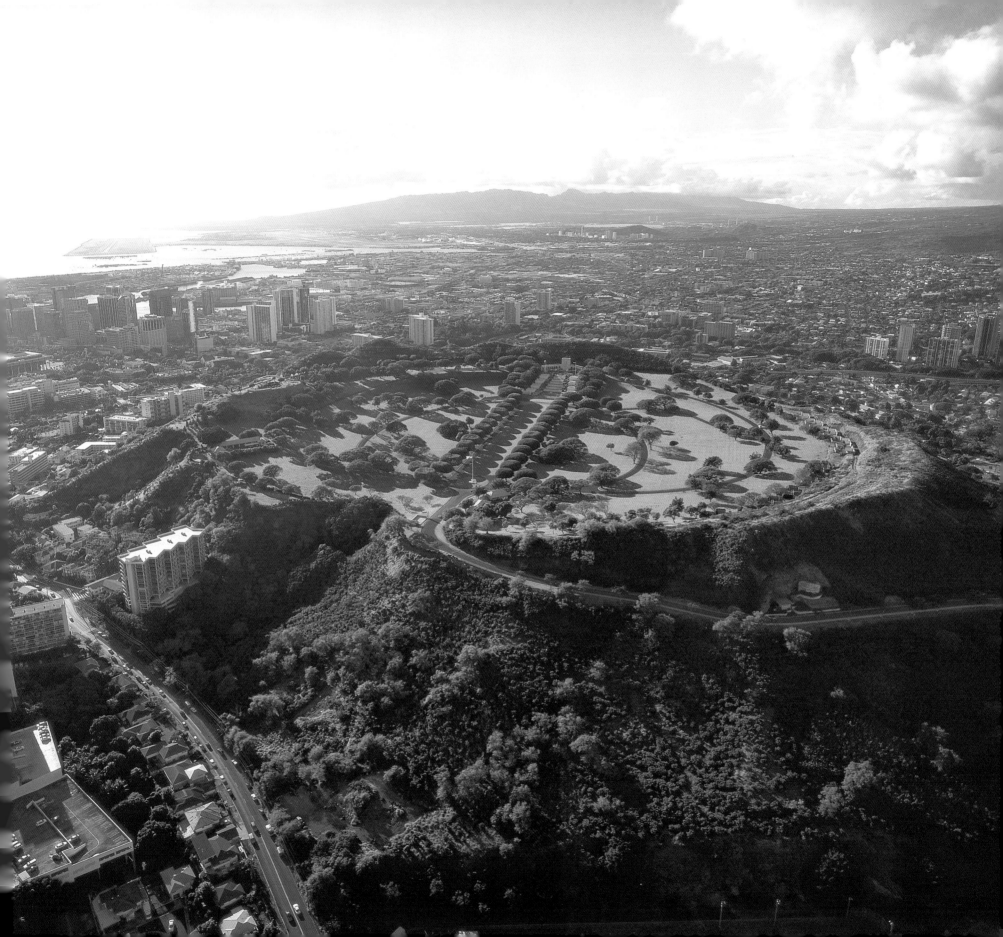

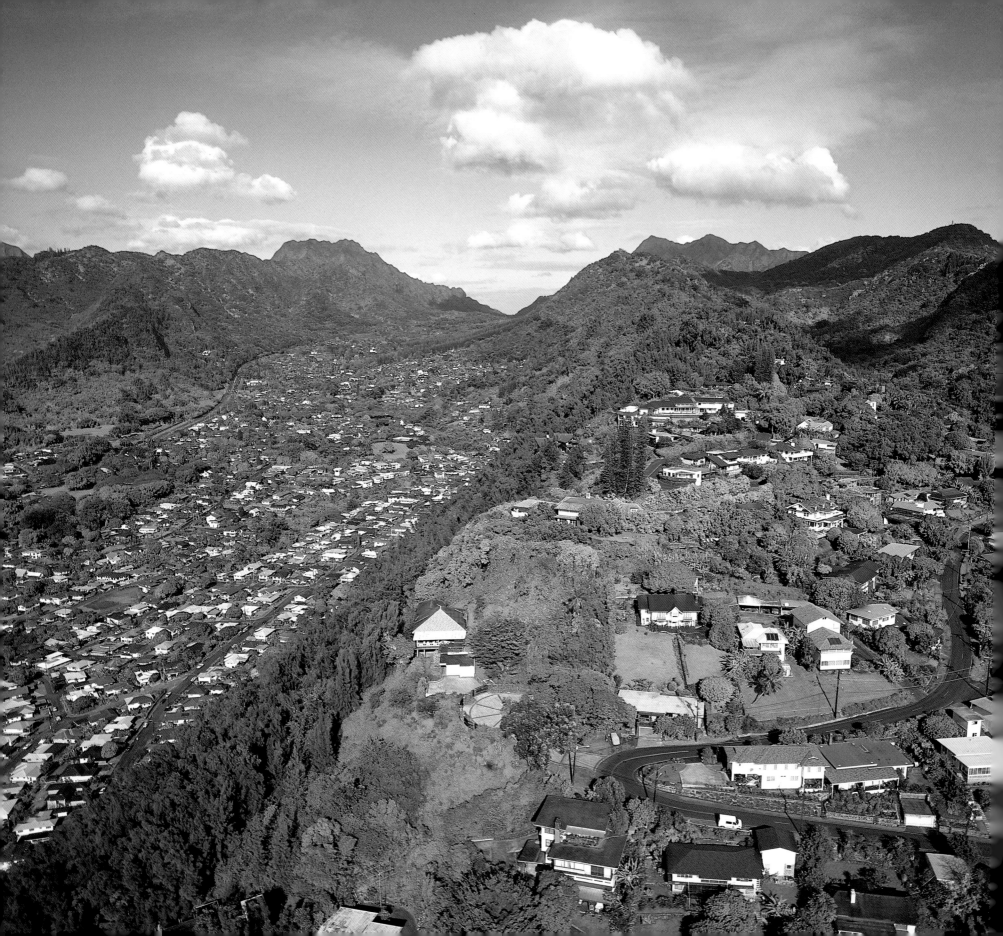

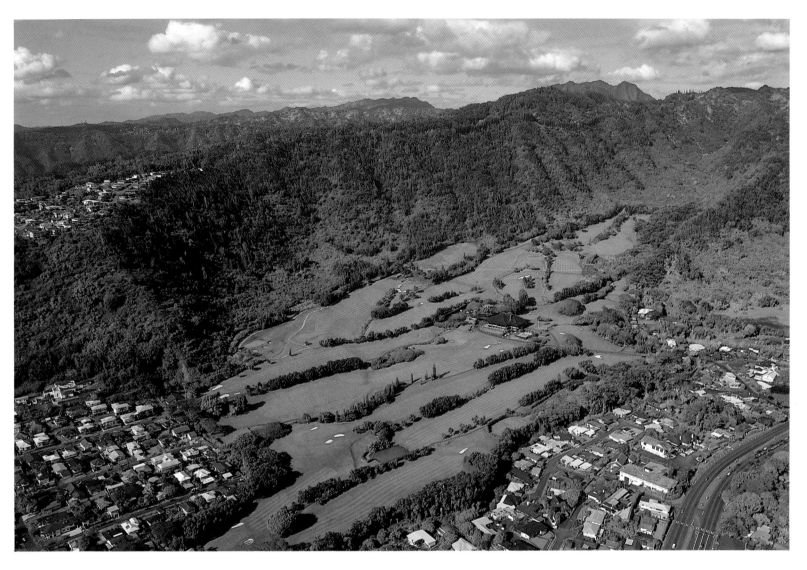

OPPOSITE: *The most desirable homesites for Hawaiian royalty and foreign merchants during the nineteenth century were in Nuʻuanu Valley. Later many moved to nearby Pacific Heights where in 1901 an electric cable car was installed to carry residents 1,000 feet up to their homes. The cooling trade winds and frequent rains of Nuʻuanu were a welcome relief from hot, arid and often mosquito-infested Honolulu.* Kahiko i Nuʻuanu ka ua Waʻahila, *"Adorned is Nuʻuanu by the Waʻahila rain."*

ABOVE: *One of Oʻahu's oldest golf courses is today's Oahu Country Club in Nuʻuanu Valley, an area that Hawaiians call Waolani. Tradition says Hawaiʻi's first* heiau, temple, *built in the time of Papa and Wakea, legendary founders of the Hawaiian race, was in this area. Remnants of the ancient site are occasionally found.*

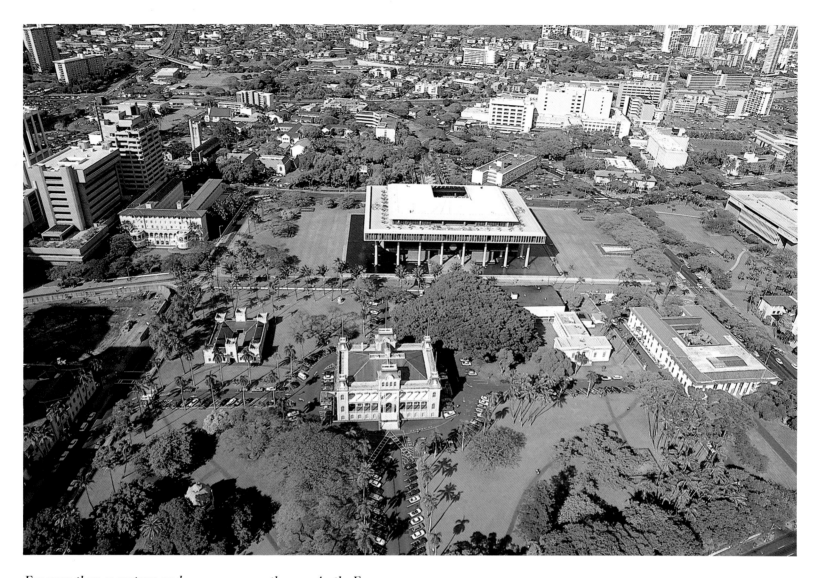

For more than a century and a half Pohukaina, today's State Capitol District, has been the heart of Hawai'i's politics. King Kalakaua's ornate 'Iolani Palace, completed here in 1882, was the royal residence until 1893 when the last Hawaiian monarch, Queen Lili'uokalani, was overthrown. As the Executive Building, the former palace was home to the Governor and Legislature from 1900 until the new Hawai'i State Capitol (toward the rear) was dedicated in 1969.

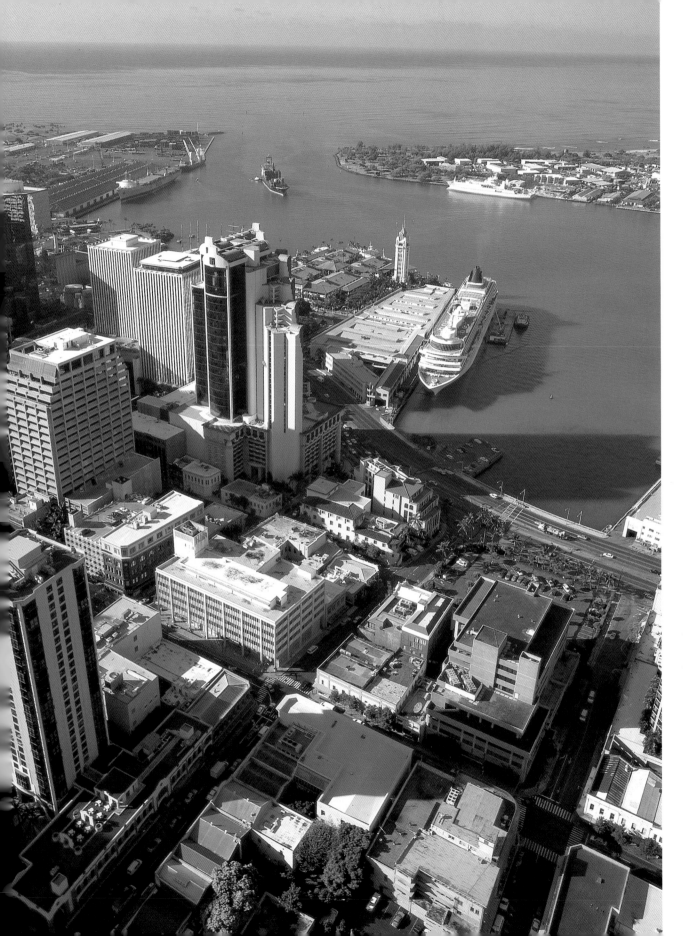

A cruise ship appears to be parked on a Honolulu street when it is tied up in port. In pre-jumbo jet days ship arrivals or departures brought out lei sellers, the Royal Hawaiian Band, hundreds of well wishers, and an avalanche of streamers and confetti. "Boat Days" were the epitome or Hawaiian hospitality.

51

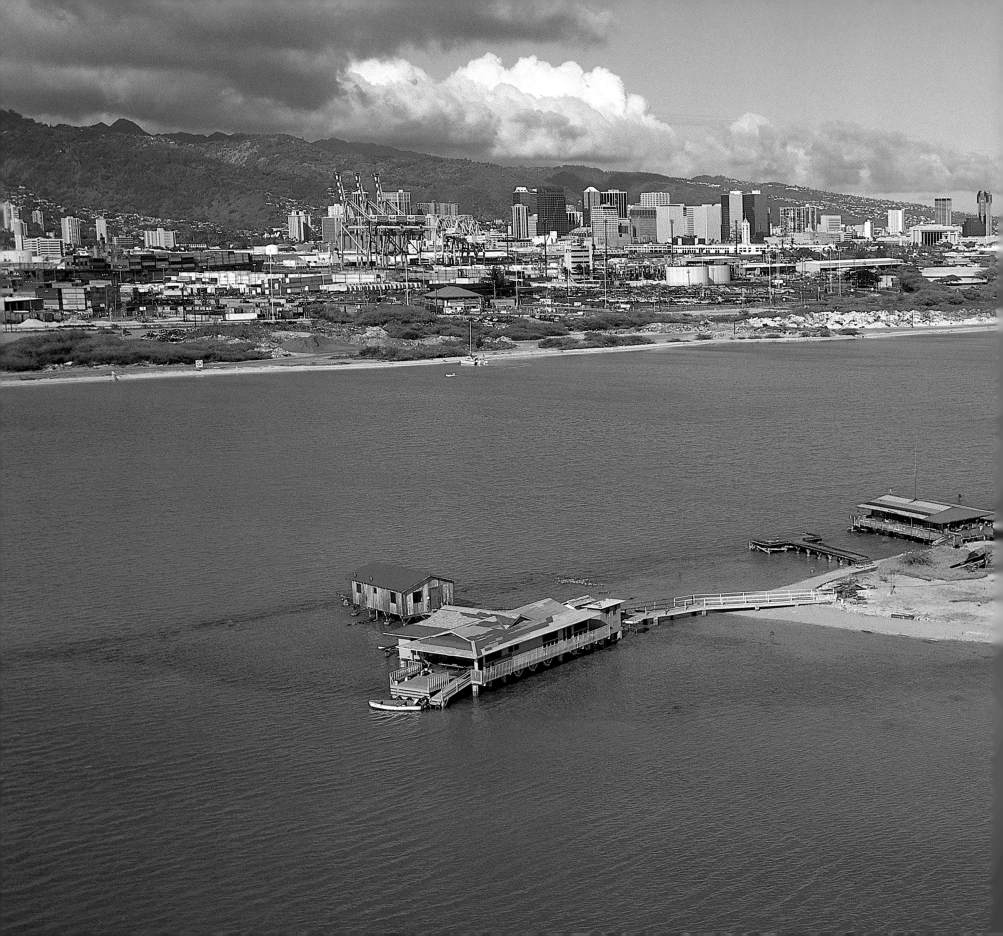

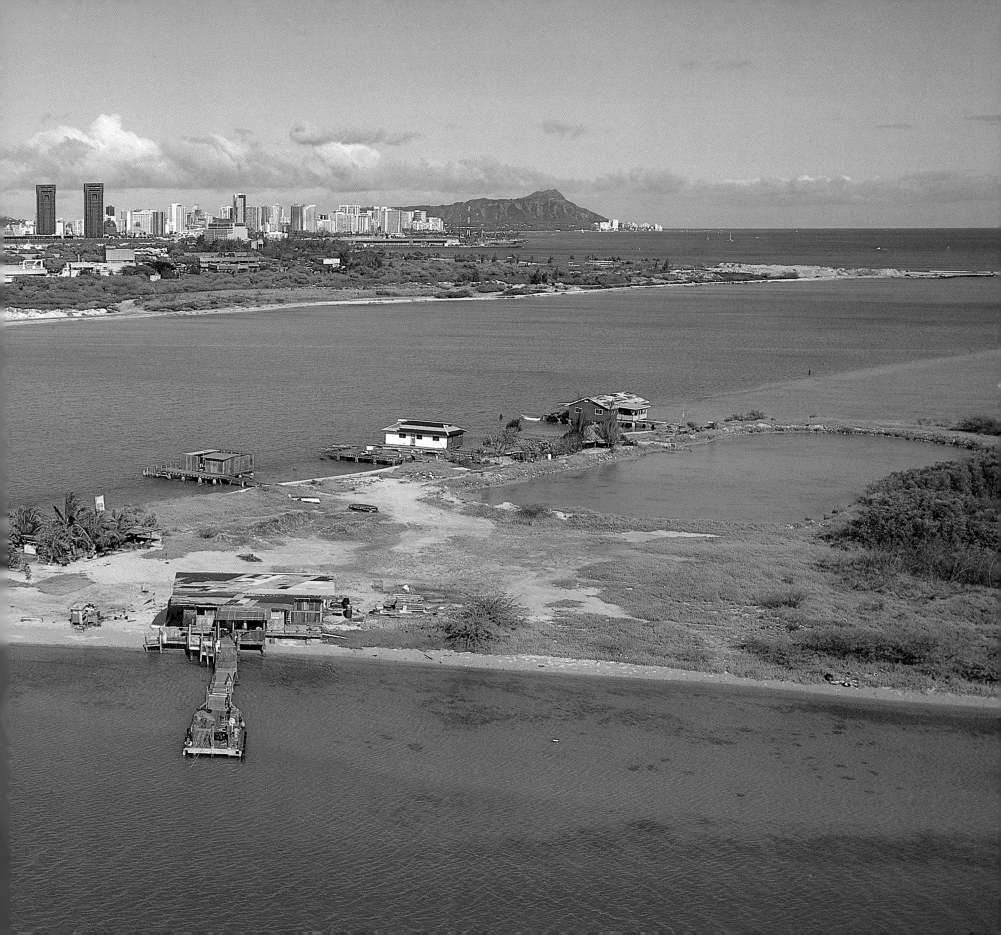

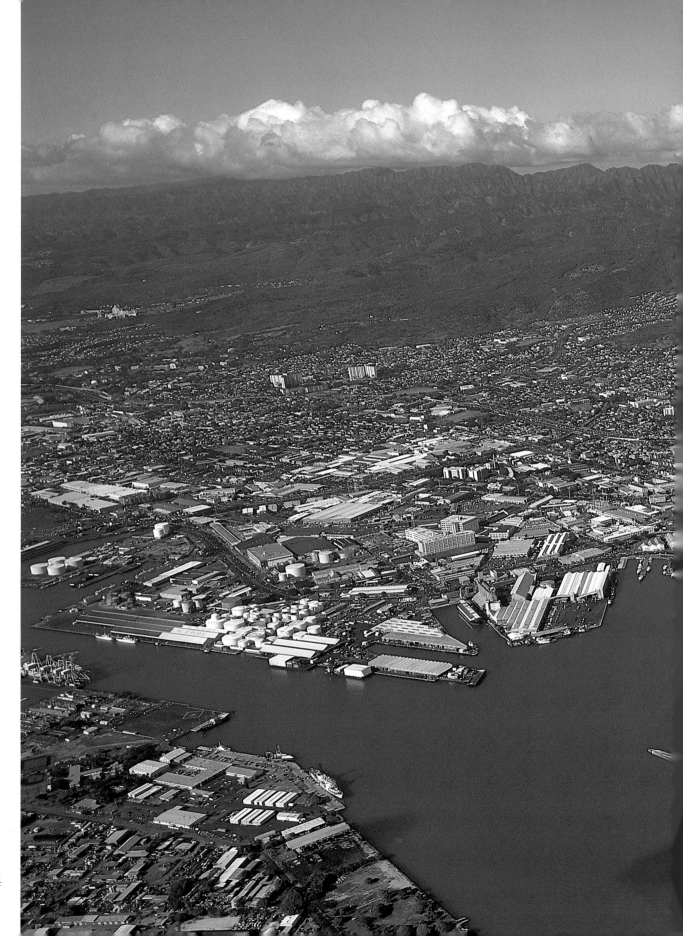

PREVIOUS PAGES: *Mokauea Island dotted with boat-landing piers and shanty-like homes, lies peacefully in Ke'ehi Lagoon, a major boating area near downtown Honolulu. In the early days of trans-Pacific aviation, Ke'ehi Lagoon was used as a landing area for the old "flying boats" or Clipper ships. Sand Island, a 500 acre man-made extension of two old sandbars used for industrial purposes as well as recreation, lies on the opposite side of the Ke'ehi channel.*

RIGHT: *Over the centuries, freshwater Nu'uanu Stream from the Ko'olau Range cut through the coral reef to open a channel for ocean-going ships into today's Honolulu Harbor. Whalers and merchant ships during the early nineteenth century eased their way through the Malama entrance (foreground) to anchor just to the left of the Aloha Tower complex. Continued dredging and the expansion of harbor facilities have greatly changed the shoreline. Sand Island is to the left of the channel.*

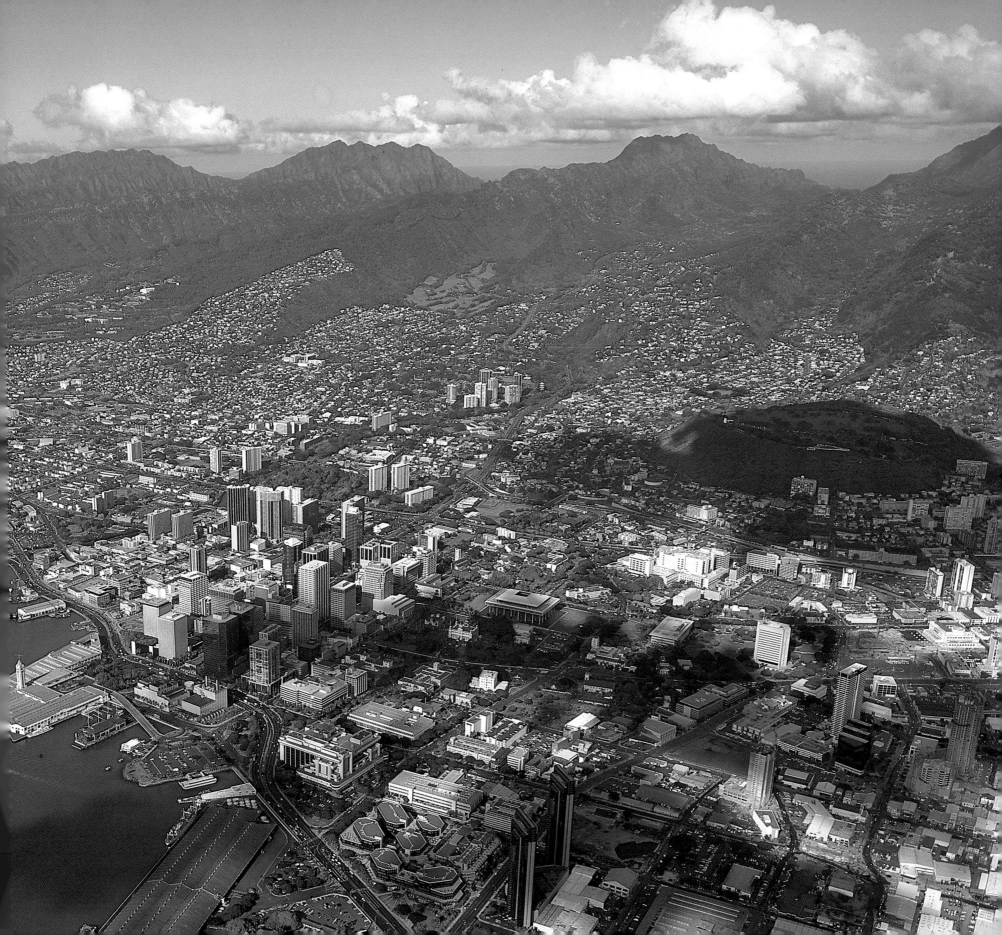

RIGHT: *Visitors now arrive in Hawai'i by jumbo jet, but nearly everything on the store counters comes by ship. At Sand Island Container Terminal huge cranes unload containerized products from around the world. Also on 500-acre manmade Sand Island are the U.S. Coast Guard base and an expansive Sand Island State Park, as well as considerable light industry.*

OPPOSITE: *The Kamehameha Schools stand proudly on Kapalama Heights overlooking Kalihi Valley in Central Honolulu. Founded by Princess Bernice Pauahi Bishop, last of the Kamehameha royal line, in 1887 for children of Hawaiian ancestry, the schools are beneficiaries of a trust that owns nearly 10 percent of the land in the state and that is regarded as one of the wealthiest in the world.*

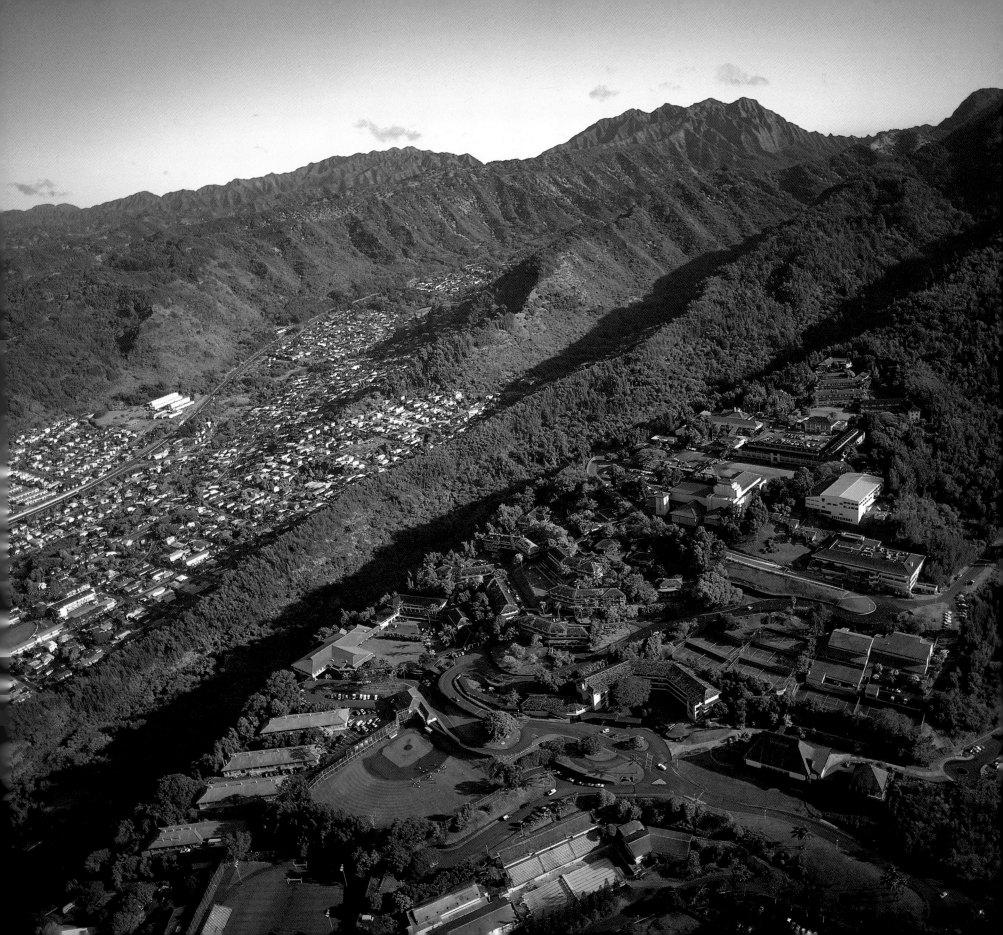

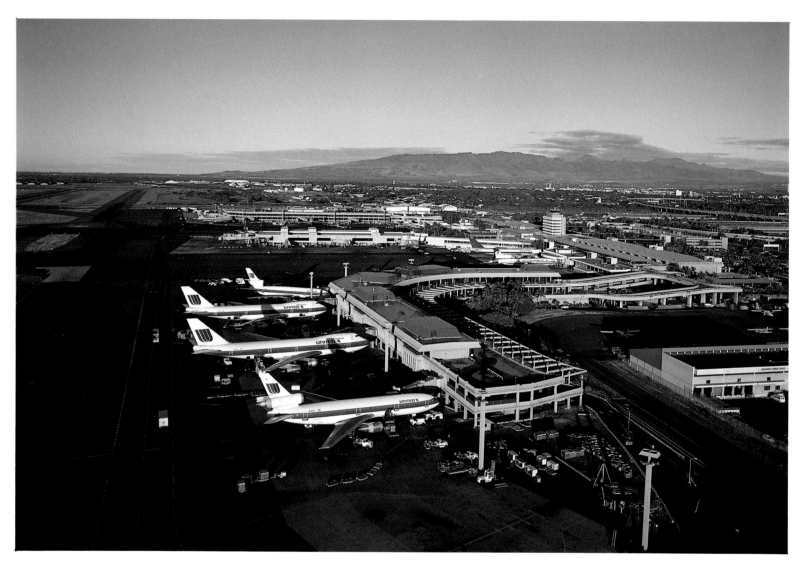

PREVIOUS PAGES: *Hawai'i's first "interstate" freeway, H-1, cuts through the Kalihi section of Honolulu. The neighborhood was given its name in 1856 by Prince Lot Kamehameha. Since 1900, Kalihi has been home to waves of new arrivals to Honolulu. Their influence is still visible throughout the neighborhood.*

ABOVE: *Honolulu International Airport handles more than 20 million passengers a year. Nine-tenths of them are traveling for pleasure either seeking to fulfill a dream, or having already sampled the islands are returning for more.*

OPPOSITE: *Straddling Maunalani Ridge, fourteen-story 1,500-bed U.S. Army Tripler General Hospital was built when Pearl Harbor made the need for a major military hospital to serve the Pacific obvious. Only 300 hospital beds were available 1941. One mystery remains, however: Why was Tripler Hospital painted pink?*

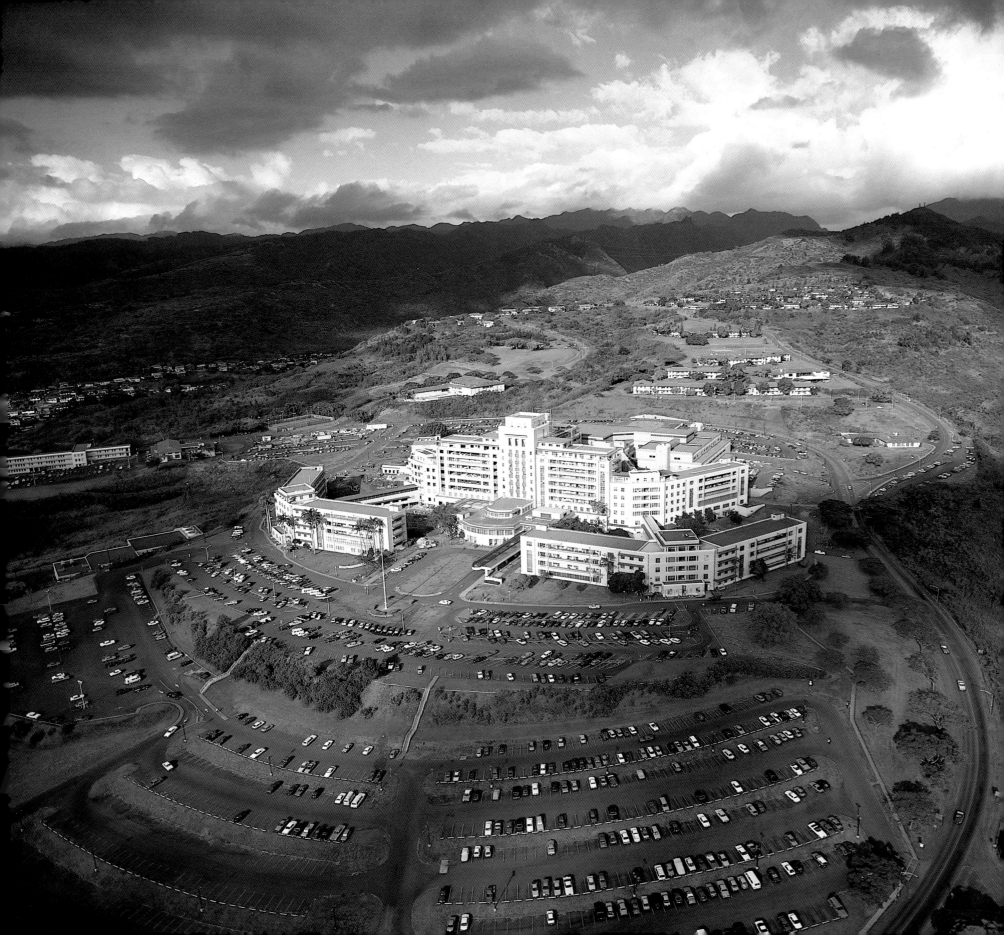

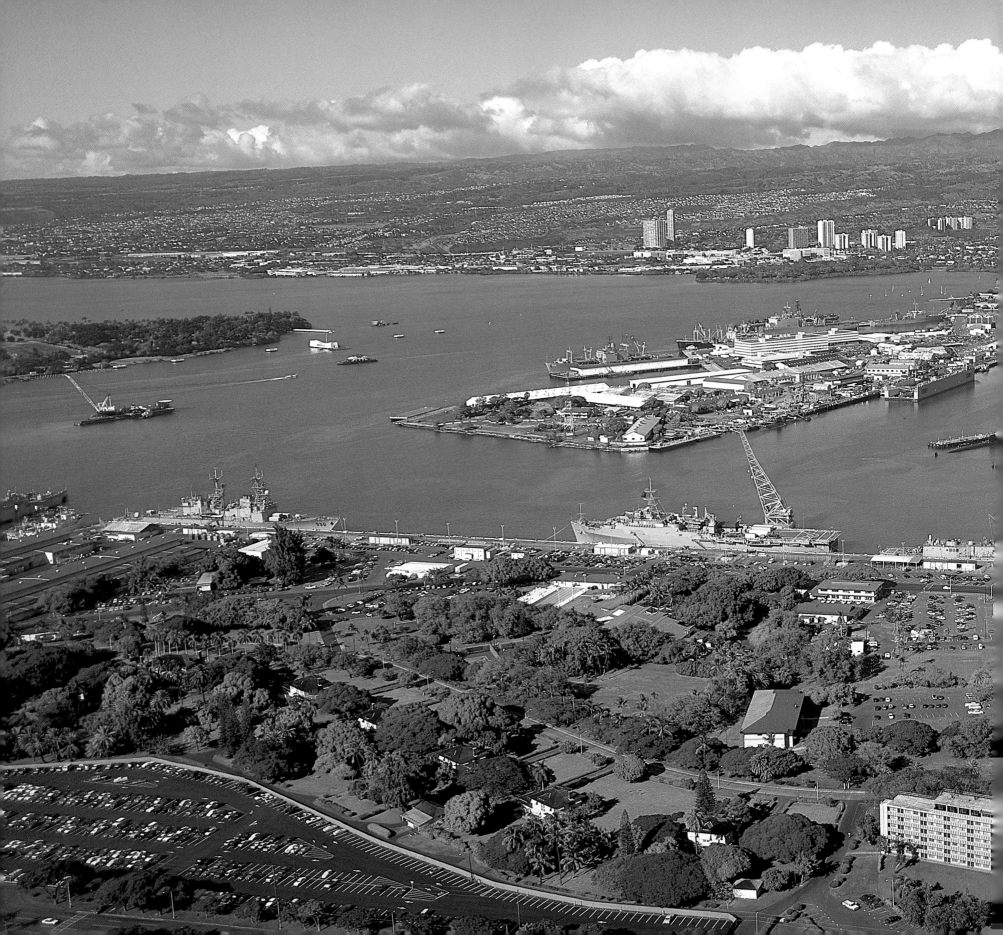

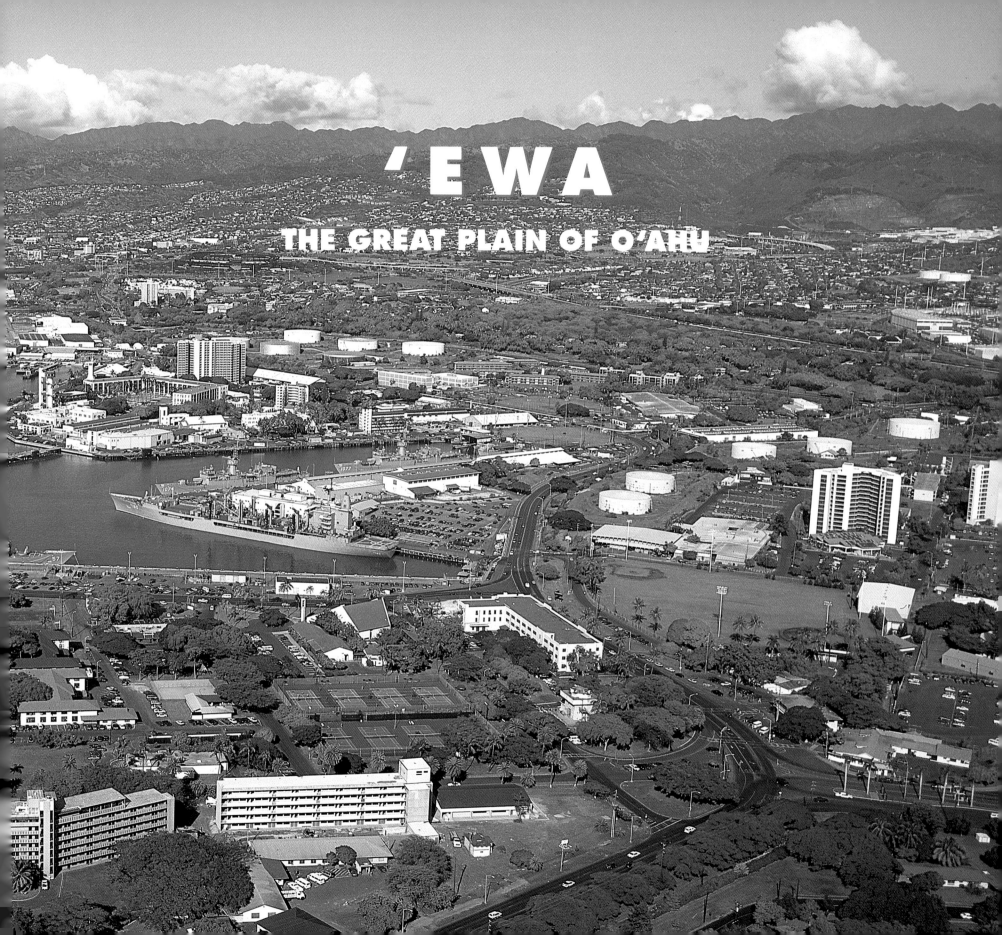

'EWA
THE GREAT PLAIN OF O'AHU

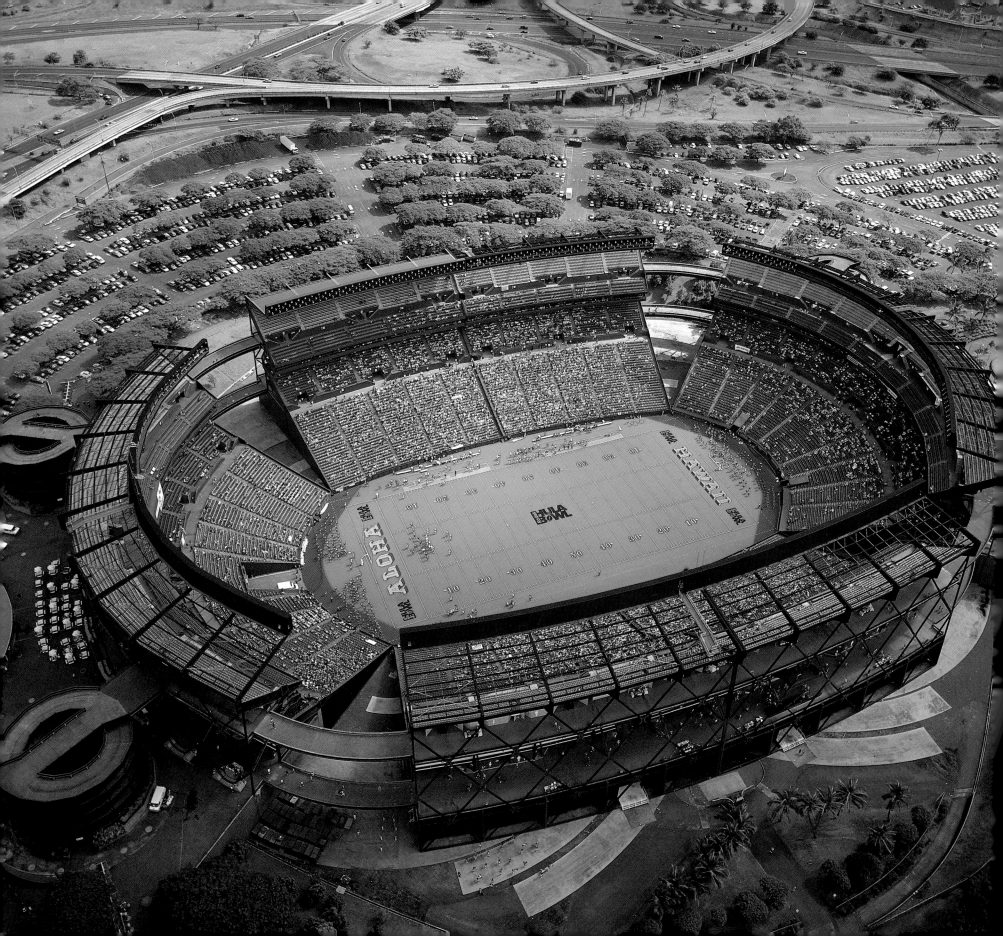

Kane and Kanaloa, the brother gods who frequently took human forms to live among mortals, testing them for their hospitality and open-heartedness, were standing at Red Hill on Oʻahu, marking the district boundaries of the island. They looked across the flat plains stretching to the Waiʻanae mountains and determined that this beautiful, abundantly watered land should be as large as possible. Hurling a stone with all their might, they decided that wherever the stone fell should be the opposite boundary. Underestimating their own strength, they sent the rock sailing to land somewhere near Kahe Point, the southernmost part of Oʻahu. When Kane and Kanaloa later tried to find the stone, they failed. The boundary, however, was fixed a little west of Barbers Point and the district was given the name ʻEwa, or "strayed," for the stone that somehow had escaped the gods' watchful eyes.

Even as Kane and Kanaloa were naming ʻEwa, in Waimalu a man named Maihea was growing taro, sweet potatoes and *awa,* a mildly narcotic root, in his terraces. The *awa* was fermented into a drink that he would always offer to the gods before his meals. At that time, however, the gods had not yet revealed themselves to mortals so Maihea would pray "Oh, unknown gods of mine, here is *awa,* taro greens and sweet potatoes I have raised. Grant health to me, to my wife, and to my son. Grant us *mana,* knowledge and skill." So faithful was Maihea in his devotions and offerings to his unknown gods that Kane and Kanaloa sent a great fish to the shore at Waimalu. When the fish appeared, Maihea's son climbed onto its back and was taken away to Kahiki, the legendary land of mystery, to be trained in priestly knowledge by the gods themselves.

PREVIOUS PAGES: Ke awa lau o Puʻuloa, *"the many-harbored sea of Puʻuloa, as Hawaiians called the extensive saltwater lochs we know as Pearl Harbor, was famed in the nineteenth century for its* pipi, *pearl oysters. By the twentieth century the United States Navy had acquired the area, constructing dry docks (foreground) and mooring the Pacific Fleet along Battleship Row at Ford Island (left). The U.S.S.* Arizona *Memorial is visible off the tip of Ford Island.*

OPPOSITE: *Although Aloha Stadium is host to football and baseball games, an occasional rock concert, and lively weekly flea markets, it is best known for its tailgate parties. Fans gather early at the stadium parking lot for pregame socializing, impromptu jam sessions, good food, and tons of island-style camaraderie.*

O *'Ewa, 'aina kai*
'ula i ka lepo.
　"Ewa, land of the sea
reddened by earth."

Not knowing what had happened to his son, Maihea was praying to his unknown gods for the boy's safe return when two strangers appeared at his home. They listened as the father called out to the unnamed deities. When he finished they told him, " We are they upon whom you call. I am Kane and this is Kanaloa. Call us by these names after this." Thus did the gods first reveal themselves to humans. When Maihea's son returned from Kahiki with the knowledge of *mana,* or divine power, he taught his father. Together they were the first in Hawai'i to practice the craft of the *kahuna.*

Eventually the 'Ewa plains became a most productive and profitable sugar plantation. The 'Ewa Plantation quickly gained a reputation as having the "ideal" system where the often-vicious *luna,* or supervisor, was replaced with more paternalistic leadership. 'Ewa Plantation pioneered hospital care for its workers, and improved living conditions and education for its children. It also adopted the first laborers' profit-sharing plan . The paternalism evidently paid healthy dividends; 'Ewa Plantation workers were reputed to be the most loyal and hardworking on O'ahu. From an initial harvest of 3,000 tons in 1892, 'Ewa was producing 60,000 tons a year by 1920 and calling its 6,500 acres "the most productive in the world."

Some who came to work on the Waipahu, 'Ewa and Aiea sugar plantations soon sought independent employment. After the U.S. annexation of Hawai'i, the lochs of neighboring Pearl Harbor were largely taken over by the Navy for the Pacific fleet. Japanese, released from the plantations, initiated Hawai'i's sampan fishing industry, using the nearby Oahu Railway to take their fresh catch into Honolulu for the early morning fishmarkets.

The Japanese attack on Pearl Harbor abruptly halted the sampan fishing as 'Ewa became the focus of a mighty construction job— to rebuild the United States Navy. Twenty-four hours a day, while the rest of Honolulu lived under a blackout, 'Ewa blazed with lights as thousands of workers lifted

sunken warships out of the mud, and refitted and rearmed a fighting armada that secured the safety of the Hawaiian Islands and the ultimate defeat of Japan.

Looking across modern 'Ewa from the skies of paradise, one is aware of these memories. The Hawaiian past remains in sacred sites and burial caves still being uncovered near West Beach, now being developed as Ko'Olina Resort. The 'Ewa Plantation closed a decade ago, although its sugarcane is still harvested, but Pearl Harbor remains as home of the U.S.Pacific Fleet. Yet the next decade seems certain to bring more change to 'Ewa. Honolulu's new "dormitory" subdivisions at Makakilo, Waipio Gentry and Mililani have brought thousands of young commuting families. Ko 'Olina at West Beach plans two-million-dollar condominiums, golf courses, and a marina in an area once noted for inexpensive plantation housing. At Kapolei, a municipally inspired "second city" economic center is being developed for those who live on the Leeward Coast of O'ahu. On the 'Ewa plain, where the gods first revealed themselves to humans, much of O'ahu's future is certain to unfold as islanders struggle for a balance among growth, their love for rural living, and their respect for history.

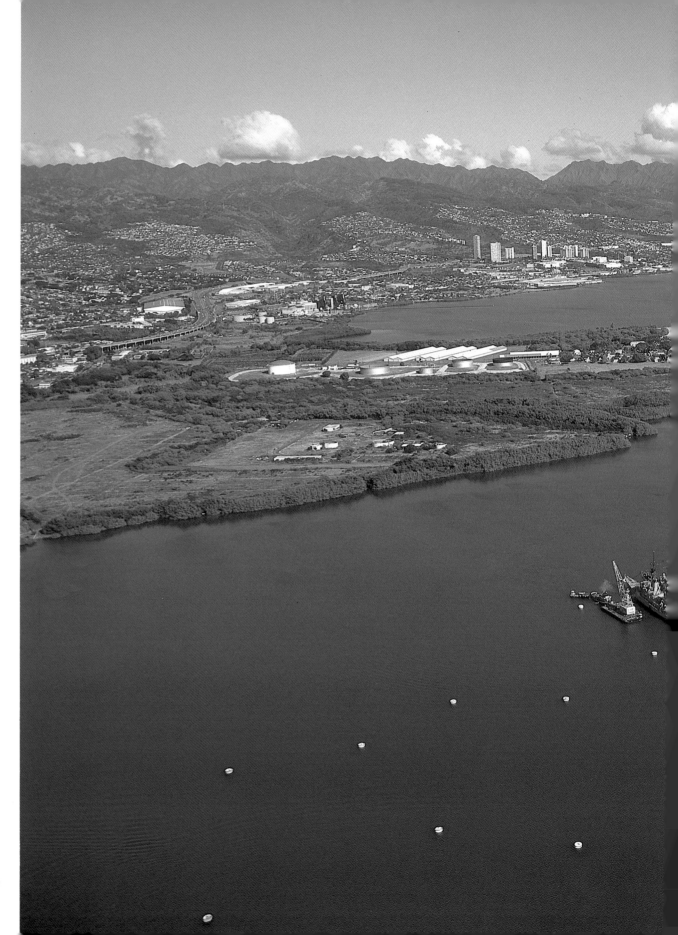

Pearl Harbor's Middle Loch harbors mothballed ships these days. Before World War II, Middle Loch was popular for fishing. Shoals of mullet were said to migrate in October or November from Pearl Harbor to Makapuʻu Point at the eastern tip of Oʻahu, then to Laʻie at the northern end of the island. The mullet would return to Pearl Harbor in March or April.

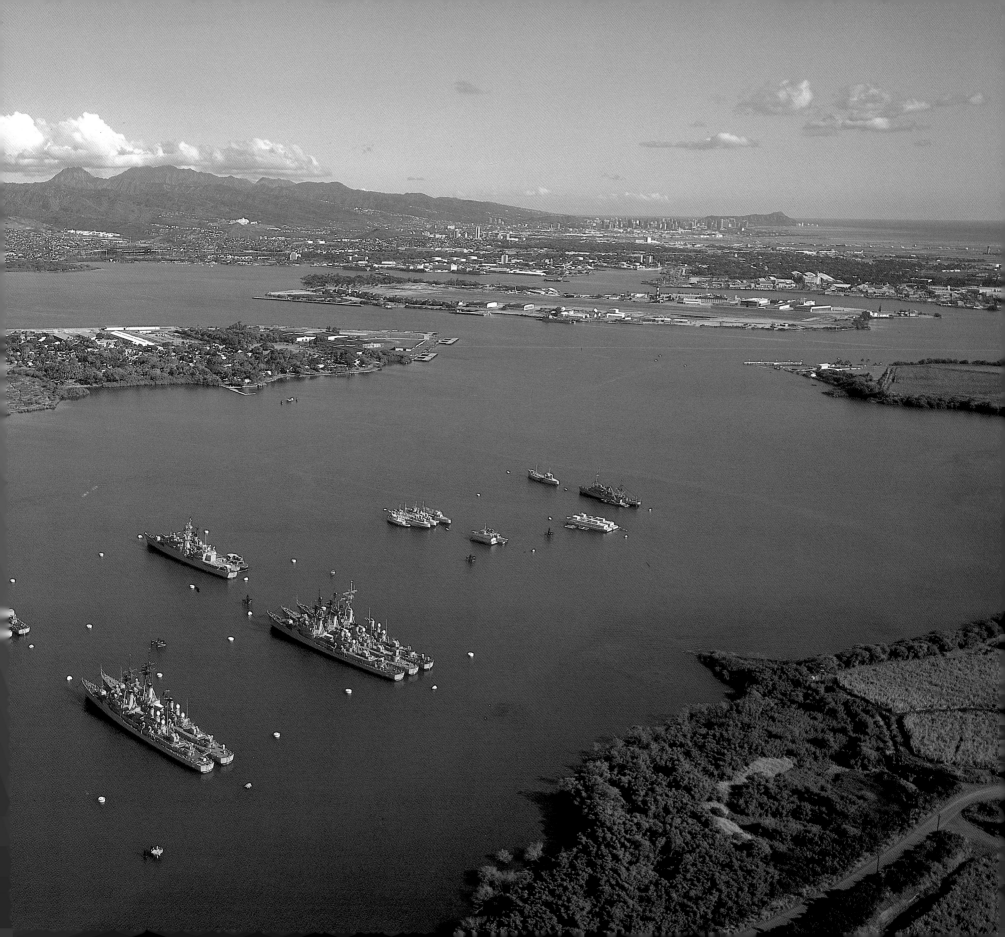

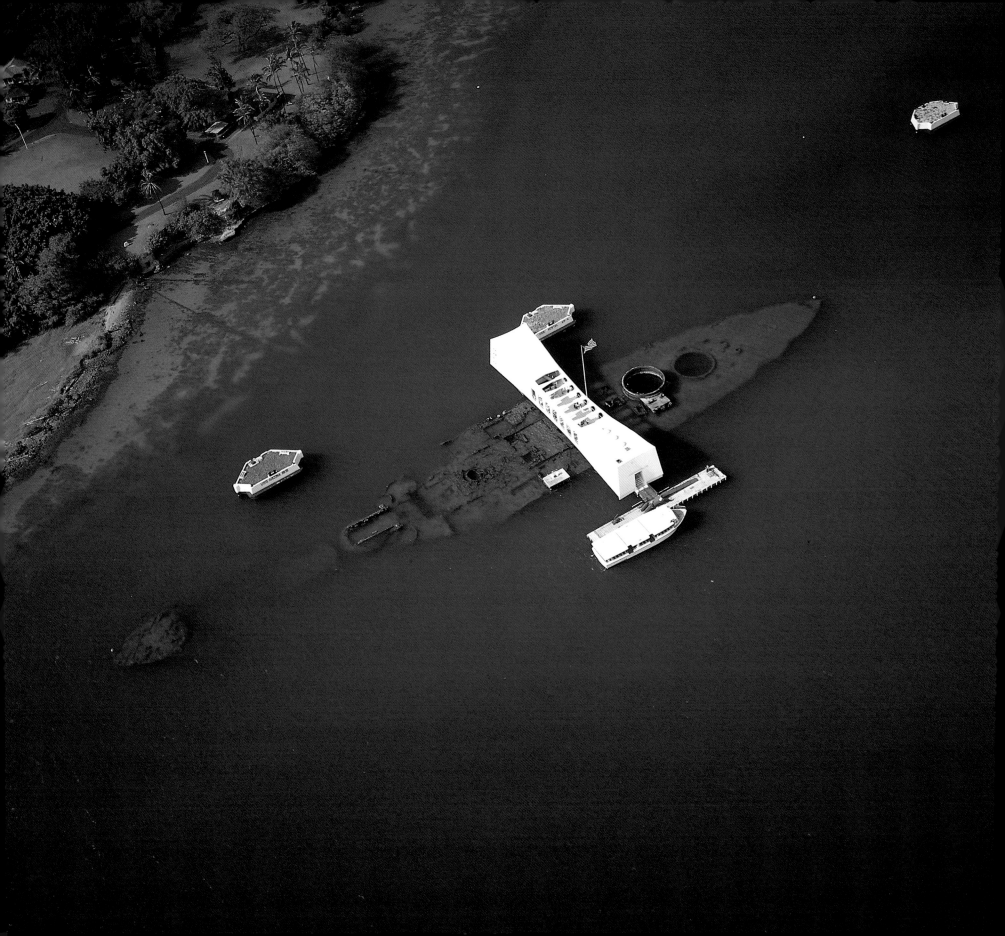

KGBQ to car 20," called Honolulu Police Dispatcher Jimmy Wong that Sunday morning. "KGBQ to car 20. Proceed to 610E Damon Drive. Complainant reported a bomb fell through his house while he was having breakfast. KGBQ to Car 30, car 30. Proceed immediately to Lewers and Kalakaua [streets], Lewers and Kalakaua. Someone, an unknown woman, reported a bomb fell near this address."

Throughout the city of Honolulu telephone calls were beginning to come into the police switchboard. What were those explosives falling from the sky? As police cars reported from the scenes of the disturbances, the magnitude of what was really occurring took on unbelievable proportions.

While war in the Pacific was not unlikely, a Japanese assault on the Hawaiian Islands seemed an impossibility to both civilians and military. Air maneuvers above Pearl Harbor had become customary in the weeks before December 7, 1941 and some island residents in the first unreal moments of the Japanese air attack were convinced this was some kind of Navy practice.

Hundreds who had gathered on Aiea Heights and Mount Tantalus to watch the "maneuvers" as if it were a carnival soon realized that the billowing black smoke above Ford Island and the exploding Iwilei fuel tanks were part of no mock exercise.

A squadron of Japanese dive bombers and Zeros roared over Diamond Head en route from the Kaneohe Air Station to Pearl Harbor, the bright-red "meatballs" on fuselages and wings clearly visible. Fifty-one of the bombs that fell on Honolulu were actually "friendly fire"—U.S. antiaircraft shells falling back on the city. At least 60 civilians died that morning, in addition to 2,341 military and naval personnel killed at Pearl Harbor.

By 11:30 a.m. on December 7, 1941, Governor Joseph Poindexter, after phone consultation with President Roosevelt in Washington, had declared martial law in effect. The Territory of Hawai'i was now under military control. Hawai'i and the United States were thus thrust into the largest, most terrifying and deadliest conflict the human race had ever endured.

The war effort of the next four years touched all aspects of daily life in Hawai'i. It ranged from victory gardens, newspaper, rubber and tin drives, Red Cross volunteer services, gas masks, blackouts, and curfews, to combat service. Hawai'i's people knew that they sat on the stage of the Pacific theater of war. They had sustained the first foreign bombing of American soil since the War of 1812, and more than 800 island residents were to give their lives in their country's service. The attack on Pearl Harbor is etched in the islands' memory as the day Hawai'i was turned upside down.

The ghostly outline of the USS Arizona is visible beneath the 184-foot-long memorial for the 1,177 crew members who perished when the battleship was sunk on the morning of December 7, 1941. More than 900 men are still entombed within the wreck. Fifty years later drops of oil from her fuel tanks—filled to the brim just before the attack—rise as silent reminders of the gallant men below.

RIGHT: *The U.S. Navy has been using Pearl Harbor since 1887 when the Kingdom of Hawai'i granted permission for its development as a coaling station. By the 1980s, over 20,000 Navy personnel were stationed on O'ahu, mostly at Pearl Harbor. One hundred thousand acres, 26 percent of O'ahu's land, are today controlled by the military. In 1998, Pearl Harbor welcomed a new addition. More than 25,000 people lined the shoreline as the* Missouri *rounded Diamond Head and continued past Waikiki, Ala Moana and Aloha Tower. On the morning of June 21, 1998, The* Missouri *was towed into Pearl Harbor and moored at Ford Island's Pier F-5. It will eventually move down the channel to a permanent site on Battleship Row.*

OPPOSITE: *The Pearlridge shopping center is West O'ahu's largest mall, serving the growing Aiea, Pearl City and 'Ewa communities. The green adjacent to the shopping center is the Sumida Watercress Farm, a three-generation-family business. In the 'Ewa district, farms and sugar cane coexist with freeways and urban development.*

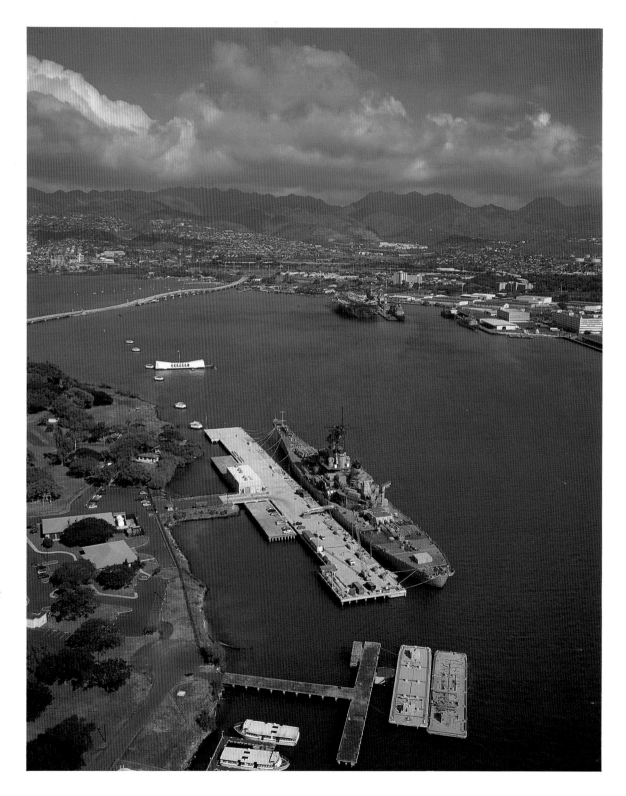

72

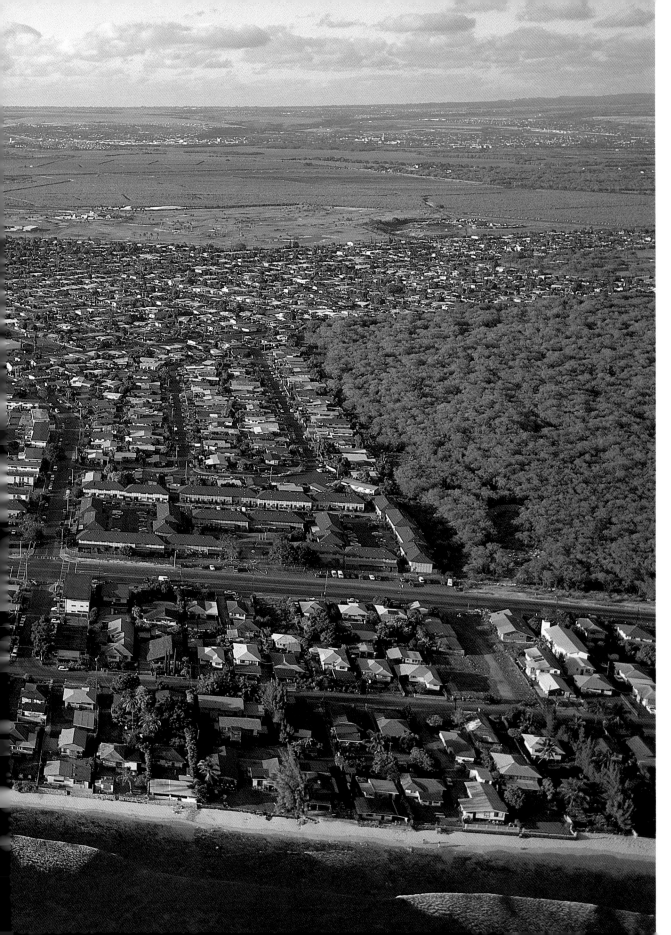

'Ewa Beach, Kupaka to Hawaiians, once was a source of excellent limu, or seaweed, popular as a relish. Fanciers still come from throughout O'ahu especially to gather ogo, a zesty seaweed often mixed with raw fish or octopus.

75

RIGHT: *In the 1970's, the 'Ewa district experienced over a 70% increase in residential housing as Makakilo City, Mililani Town and 'Ewa Beach experienced new construction of single-family dwellings, townhouses and condominiums. In this view of Makakilo, new subdivisions are seen being built on the slopes of the Wai'anae Mountain range.*

OPPOSITE: *Kapolei, O'ahu's "second city" is being created like swirling geometric patterns in the midst of the former fertile sugar fields of the 'Ewa plains. When completed, this new community is designed to be West O'ahu's major population center with housing, employment, schools, hospitals and recreation all provided conveniently within Kapolei's borders.*

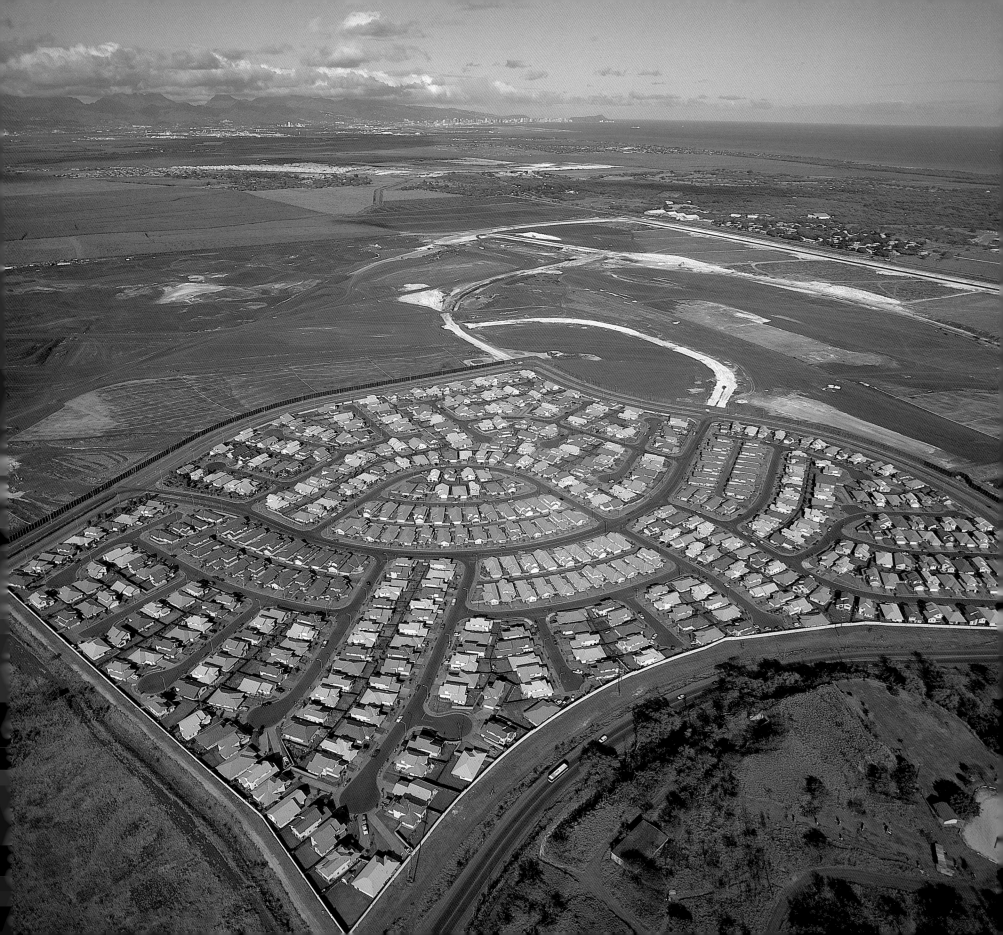

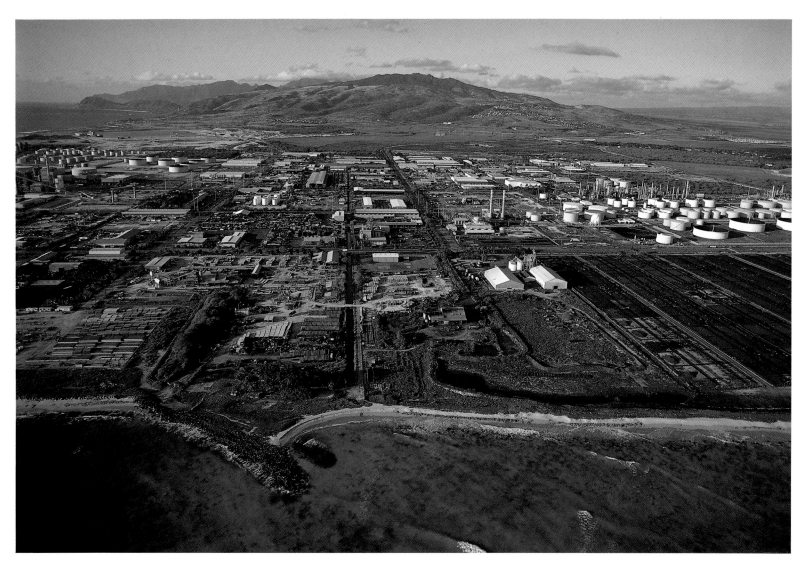

*After the Campbell Industrial
Park opened at the southwestern
corner of Oʻahu in the early
1960s, new industries and jobs
came to the depressed Leeward
Coast. Two petroleum refineries,
a steel fabricating plant,
fertilizer mills, cement and
concrete-product industries,
cattle feed pens, dairies, and
small businesses revitalized a
local economy long dominated
by sugar. New housing
developments such as Makakilo,
visible on the slopes of the
Waiʻanae Range in the
distance, serve this "Second
City."*

Ko ʻOlina, "the place of joy," is Oʻahu's newest and largest westside resort development. Future plans for this "Second Waikiki" include up to six multistory apartments and hotels, and centers serving both visitors and residents. A golf course, restaurant and interpretive center already are open at Ko ʻOlina as the formerly quiet ʻEwa and Waiʻanae districts prepare for the impact of urbanization.

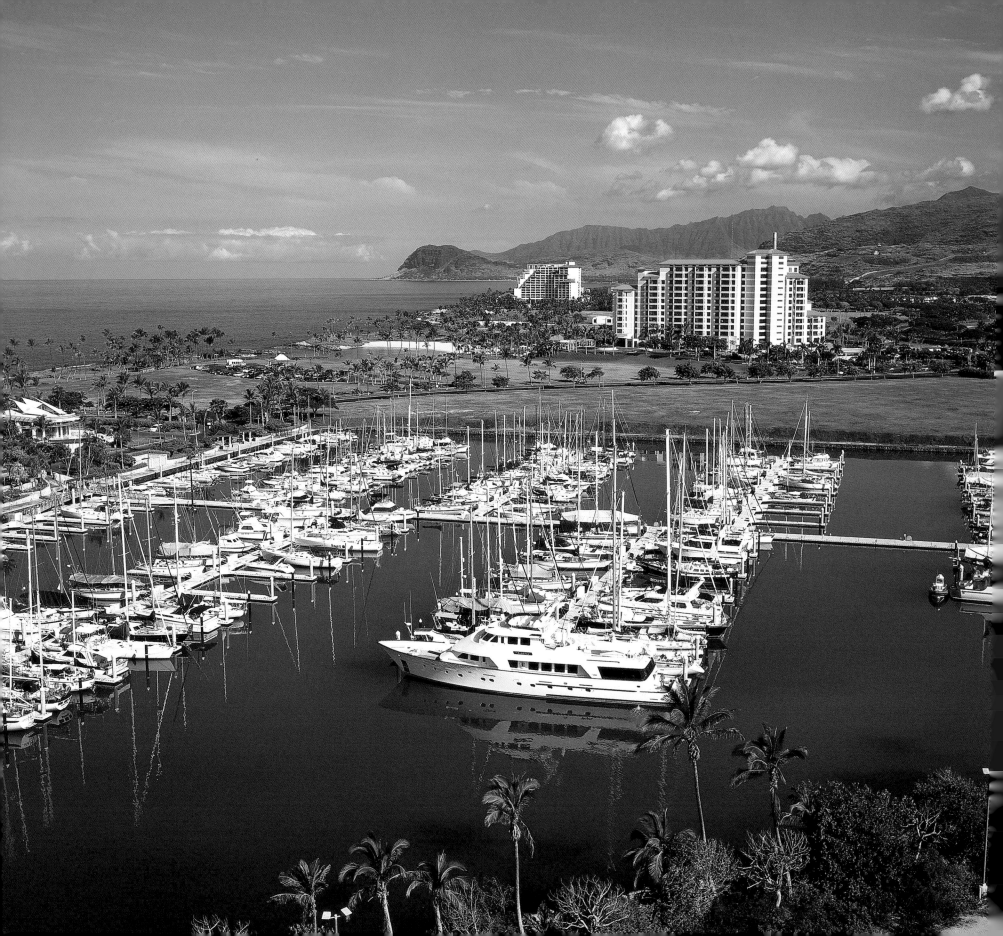

No creature instills fear in the land lubber like *mano*, the shark. A midnight swim in some peaceful lagoon becomes an imagined date with a creature with razor-sharp teeth and an appetite for flesh. *Jaws* not only horrified millions of moviegoers, but sobered scores of surfers, swimmers and divers in Hawaiian waters.

In ancient Hawai'i, however not everyone had a fear of *mano*. In fact, some claimed an ancestral link to sharks through the mating of family members with dieties such as Kamohoali'i, a shark god and older brother of Pele. Having no fear of their own relatives, these individuals could swim freely among *aikanaka*, or man-eating, sharks. Somewhere on their bodies, it was said, was a birthmark shaped like either a shark's dorsal fin or its gaping mouth.

In the waters around Barbers Point on O'ahu, even riding the backs of sharks was reported. Ko 'Olina Resort, a beautiful stretch of coastline being heralded as the "Second Waikiki," is the traditional home of a variety of sharks. Mid-nineteenth century visitors reported seeing Hawaiians dive into the water, lasso a sleeping shark and ride it to the surface like a bucking bronco. Another story tells how two Hawaiians in 1854 deserted from a whaling ship about 30 miles off Barbers Point. They grabbed the fins of two mano in the area and held on while the creatures carried them to shore.

As one travels about O'ahu, discovering Hawaiian lore in the stones, land formations and historic sites, the mysterious relationship between humans and sharks is evident over and over again. At Kahana Bay on the Windward Coast, for example, a large stone shaped like a shark rests on the beach. Many years ago, an elderly Kahana resident became ill while visiting Kauai'i island. Unable to return home on his own, he prayed to his ancestors who sent him a shark as a companion. Riding on its back across a hundred miles of ocean to Kahana, the old man was able to die on his native soil. The shark waited in the bay until broken hearted, it also perished. For its devotion to its human friend, the shark was turned to stone.

What makes Hawai'i truly unique among the fifty states is not only its tropical climate and scenery. It is this Hawaiian heritage of lore and wisdom, found in unexpected places like West Beach.

The 43-acre Ko Olina Marina, the first built in Hawaii in thirty years, caters to both sport fishermen and pleasure boaters. It is also home to water activity tours, including catamaran tours and a variety of snorkeling outings. The private marina offers easy access to JW Marriott's renowned Ihilani Resort & Spa, Ted Robinson's championship golf course, and blue lagoons.

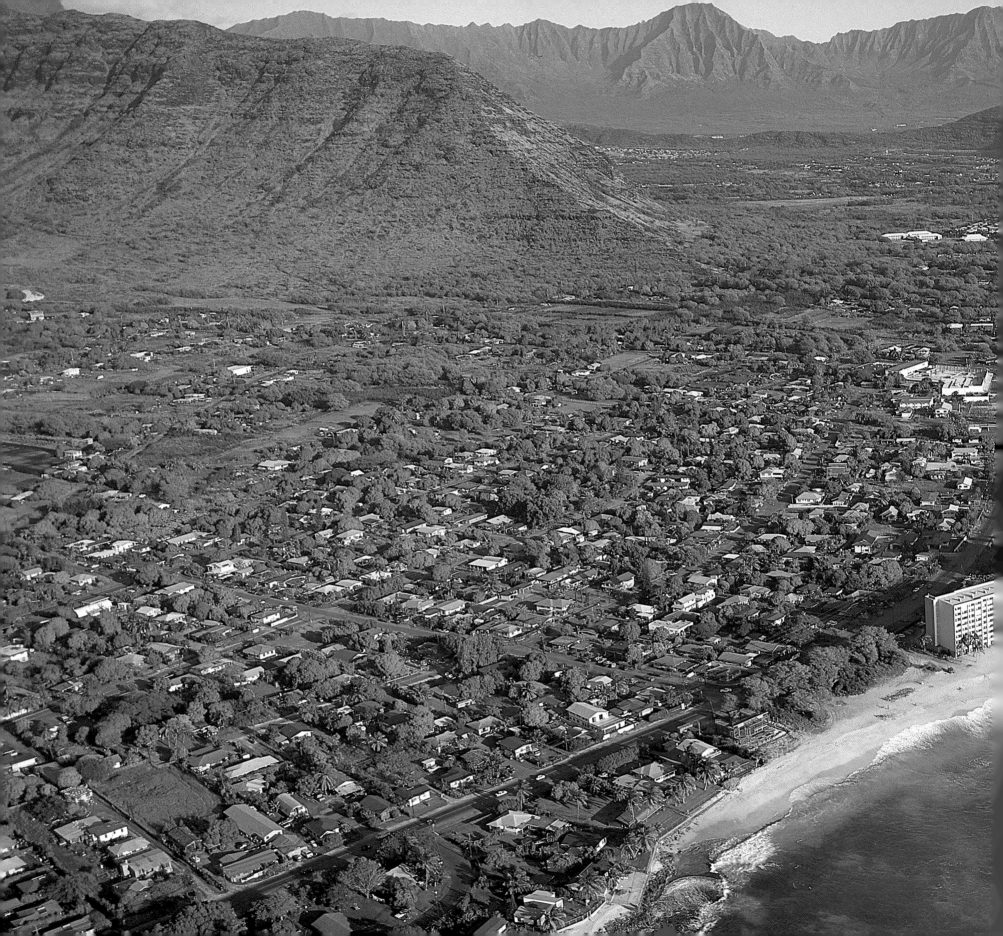

WAI'ANAE

THE HAWAIIAN WAY OF O'AHU

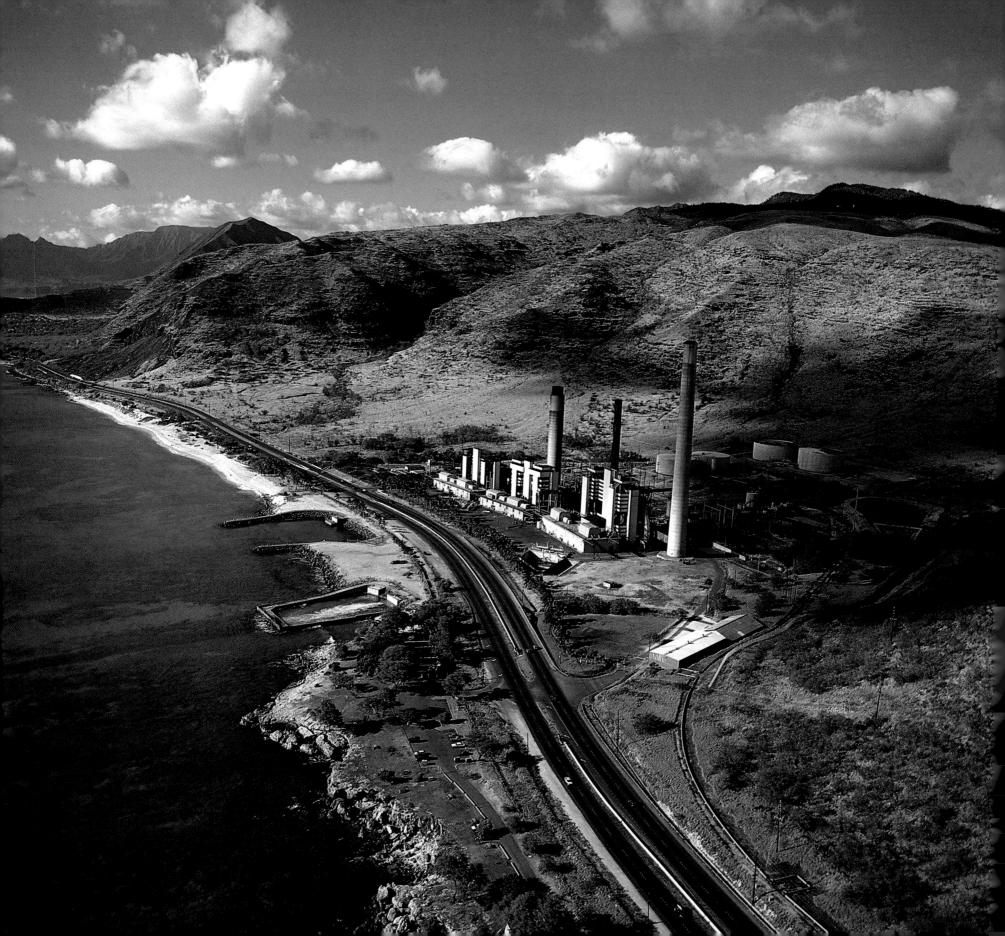

Wai'anae is a separate realm, made distinct from the rest of O'ahu by its geography and the independent spirit of its people. In ancient times, walking into Wai'anae required either climbing over the Wai'anae range at Kolekole Pass or crossing dry rugged terrain to the north or south. This geographic barrier allowed those who lived on the Wai'anae Coast to shut themselves off when they desired, and to maintain their own customs and traditions. An easily navigated channel separated them from independent-minded Kaua'i island to the west, with which the people of Wai'anae often found themselves linked more closely than with their own cousins on O'ahu. After Kamehameha the Great conquered O'ahu in 1795, followed by the island's Christianization, the Wai'anae district drifted even further out of the cultural and political mainstream.

This separation was a mixed blessing for Wai'anae. On the one hand it meant less intrusion in its life. Church workers were never as successful in Wai'anae as in Honolulu. Such Wai'anae leaders as Governor Boki and his wife Liliha were traditionalists who offered an alternative to the rapid assimilation of Christian mores. Even rebellious foreigners found their way to Wai'anae where, far from church-going Honolulu, they could do with their private lives what they came to Hawai'i to do. In 1869, missionary-son Samuel Andrews "escaped" to spend most of the rest of his life with a common-law Hawaiian wife in remote Makua Valley.

The drawback to this isolation was that Wai'anae's contribution to Hawaiian civilization was never taken seriously. The Polynesian god Maui, for example, usually has been associated with the island of Maui. Actually, he probably lived with his mother Hina at Wai'anae. A mountain in the land

PREVIOUS PAGES: *From the white sands of Papaoneone Beach and dramatic Mauna Lahilahi, or "thin mountain," to the curve of the Wai'anae range in the distance, the Wai'anae moku'aina, or land division, can be distinguished from the rest of O'ahu by its geology, proud cultural heritage and independent spirit.*

OPPOSITE: *The Kahe Power Plant supplying much of O'ahu's electrical energy is the visitor's introduction to modern Wai'anae. The dryness of this side of the island is apparent from the vivid yellow-auburn vegetation of the Wai'anae hills. Trade-wind clouds usually empty their moisture on the wet Wahiawa side of the ancient Wai'anae volcano, leaving little for the Leeward Coast.*

division of Nanakuli called Heleakala, or "snare the sun," is near a stone said to have been used by Hina in beating kapa. When the great trickster god Maui lassoed the sun to slow it down so that Hina could dry her tapa properly, he probably was standing near his Wai'anae home, not atop Haleakala on Maui. Rarely, though, were the independent, rebellious folk of Wai'anae acknowledged for their history and lore.

Wai'anae proudly bears its decades of neglect with remarkable resilience. The community suffered in the past century from a dramatic shift in agriculture that left once-well-watered taro fields dry while thirsty sugar plantations flourished. The early Nanakuli homesteads provided to Native Hawaiians under federal jurisdiction through the Hawaiian Homestead Commission Act were without roads or infrastructure of any sort, most importantly water. When the Wai'anae Sugar Company closed in 1946, extensive Makaha Valley and Wai'anae acreage was purchased by investor Chinn Ho of Honolulu, who brought limited tourism. As the economy slipped, so too did the well-being of the district's families. Increased juvenile delinquency, drug and alcohol abuse, crime, and educational problems became community issues. Outsiders once again called the people of Wai'anae "troublemakers." While the U.S. Navy and Air Force were being pressed to stop bombing Kaho'olawe island, few even remembered that Makua Valley in Wai'anae was being continually bombed by the U.S. Army even though its historic and archeological sites were as important as those on Kaho'olawe.

Yet the seeds of change are taking root in Wai'anae. Educators and community leaders are re-establishing links to the wisdom of their forbears. On a small piece of property in Wai'anae, a group of Native Hawaiians and their friends have cleared some ancient taro terraces, irrigating their crops from old water channels and instructing youths in the value of work, respect

MAKAHA
WAIANAE
MAILI
NANAKULI

for the land, and reverence to their *'aumakua*.

When Papa and Wakea, the earth's first parents, had their first child, legends say it was stillborn. Where they buried the infant a taro plant sprouted. The second child born to Papa and Wakea was human. Thus, say the Hawaiians, taro and humans are siblings. Watching the taro shoots grow, one feels the communality of all life, animate and inanimate. Wai'anae searches for wisdom to revitalize the community, to restore Hawaiian sovereignty, and to provide for future generations the blessings found through a love of the land.

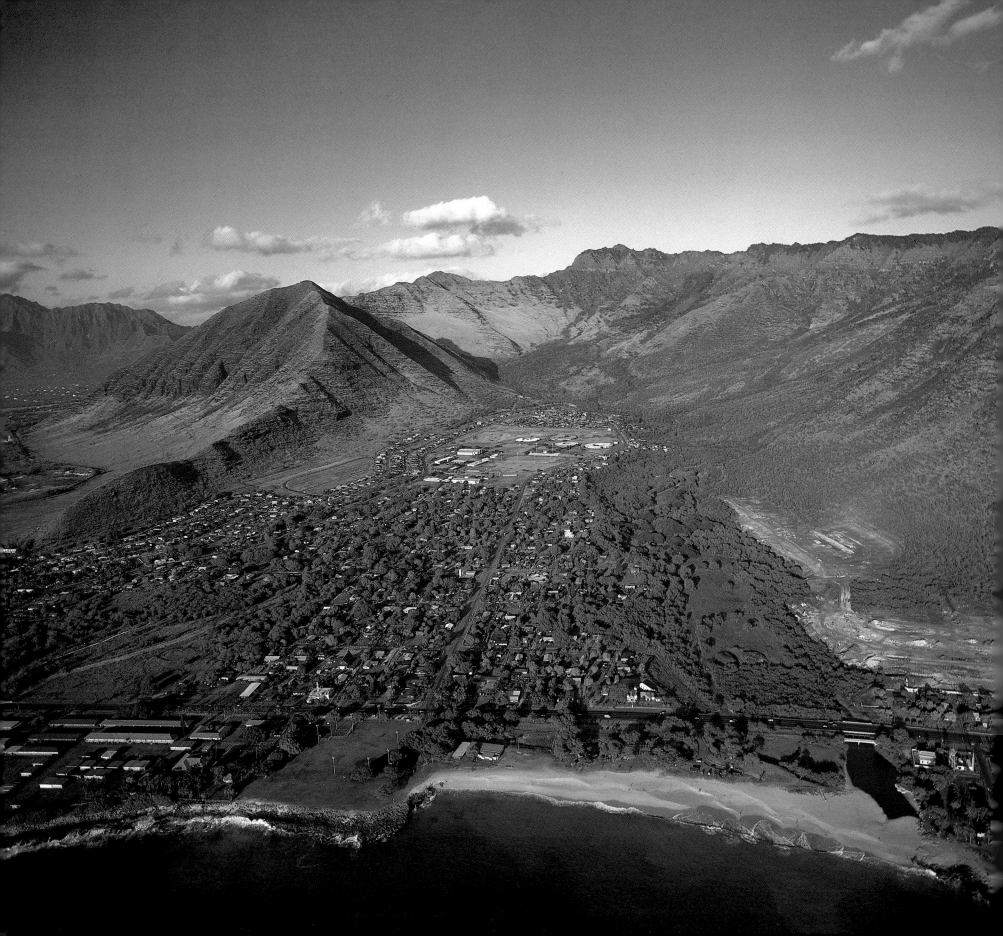

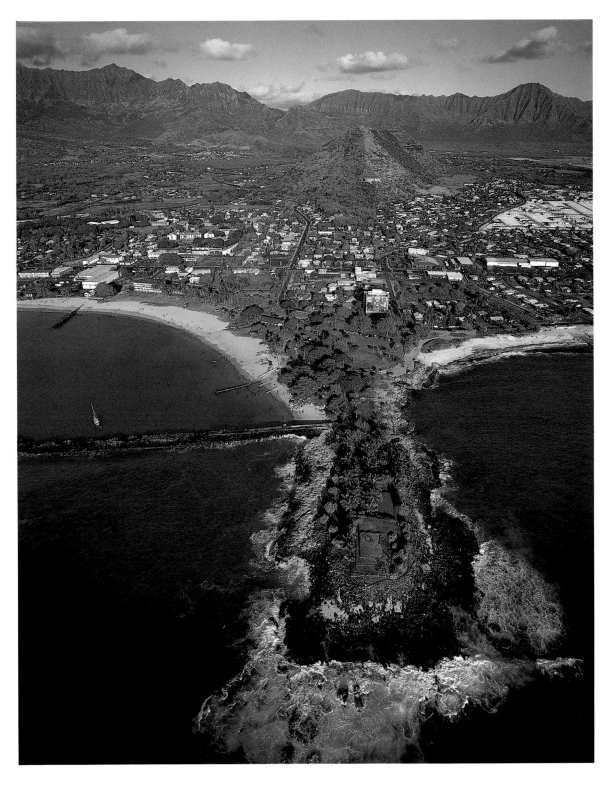

OPPOSITE: *The homestead lands of Nanakuli at the base of dramatic Heleakala Hill reach to the water at Nanakuli Beach Park. One translation of* nanakuli *is "to look deaf." Residents were said to be so poor that they had nothing to offer passersby. Thus, when a traveler called to them, they stared back as if deaf.*

LEFT: *The stunning deep-blue ocean off Wai'anae, "the mullet water," has some of O'ahu's very best fishing. A spring at the foot of the pyramidal Kamaile'unu hill provided fresh water while nearby Kukaauau cave offered shelter. Expanding from Kamaile, early Hawaiians settled, irrigated and cultivated the Makaha and Wai'anae Valleys while harvesting the sea.*

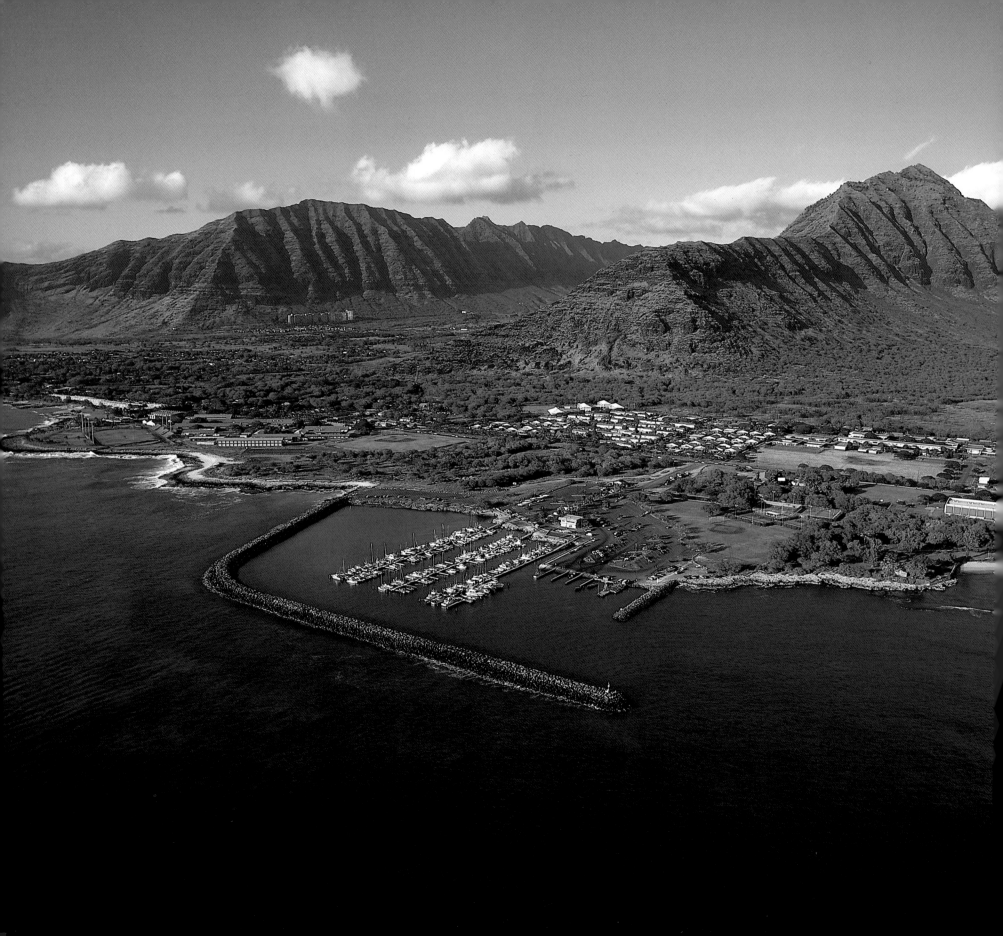

Water was precious to the people of old. Without great freshwater lakes, they learned to tap freshwater springs, cultivate taro in terraces beside the streams, and build *auwai*, or irrigation ditches, that sometimes transported water half way across the island to drier districts. The water rights of common people were guarded by the *konohiki*, or district caretaker, who made sure that the gift from the gods sustained all levels of society. Wealth in ancient Hawai'i was measured by water; the word for wealth was *waiwai*, literally "plentiful water."

The people of Wai'anae long had been conscious of the value of water, for their district received less rainfall than did other areas. Although springs and streams flowed in Wai'anae, the cultivation of taro required an advanced conservation ethic. When Herman Widemann in 1878 founded the Wai'anae Sugar Company, traditional farming communities quickly learned that sugar needed water—thousands of tons daily. The older concept of sharing was suddenly redefined. The notion of private water rights and ownership transformed Wai'anae into lush canefields. The taro farms dried up.

The Wai'anae Sugar Company tapped freshwater springs in the Wai'anae Range. A hydroelectric generating plant diverted more millions of tons of water from the upper slopes of Mt. Ka'ala. Finally, at Nanakuli in 1879 the brothers John, James and Lincoln McCandless dug the first successful artesian well in Hawai'i, to provide 2,400 gallons of water an hour.

Water seemed everywhere in Wai'anae, but it was not for direct human use. When Nanakuli lands were opened in the 1920s as Hawaiian Homestead lots, a two-inch pipe was laid to the sites. Wai'anae Sugar Company, which grew cane with the upcountry water, resisted any diversion. The Territory of Hawai'i finally bought water for Nanakuli homesteaders, but it was not enough to supply many homes. During the 1930s angry Wai'anae residents fought in the courts, in Washington, D.C., and along the pipelines to get water to their dried-out homesteads. As late as the 1950s, Nanakuli youngsters were fetching drinking water in buckets from springs and bathing in the ocean.

Naha ka huewai a ua kahe ka wai, says the old proverb. "The gourd water-bottle is broken and the water has run out." Without it, life has fled.

Ka malu niu o Poka'i, *"the sheltering palms of Poka'i," once the largest and best-known coconut grove on O'ahu, was planted from the first coconuts brought to Hawai'i by the legendary voyaging chief Poka'i. Poka'i Bay is also distinguished for Kane'ilio Point where a* heiau, *or temple, is surrounded on three sides by water.*

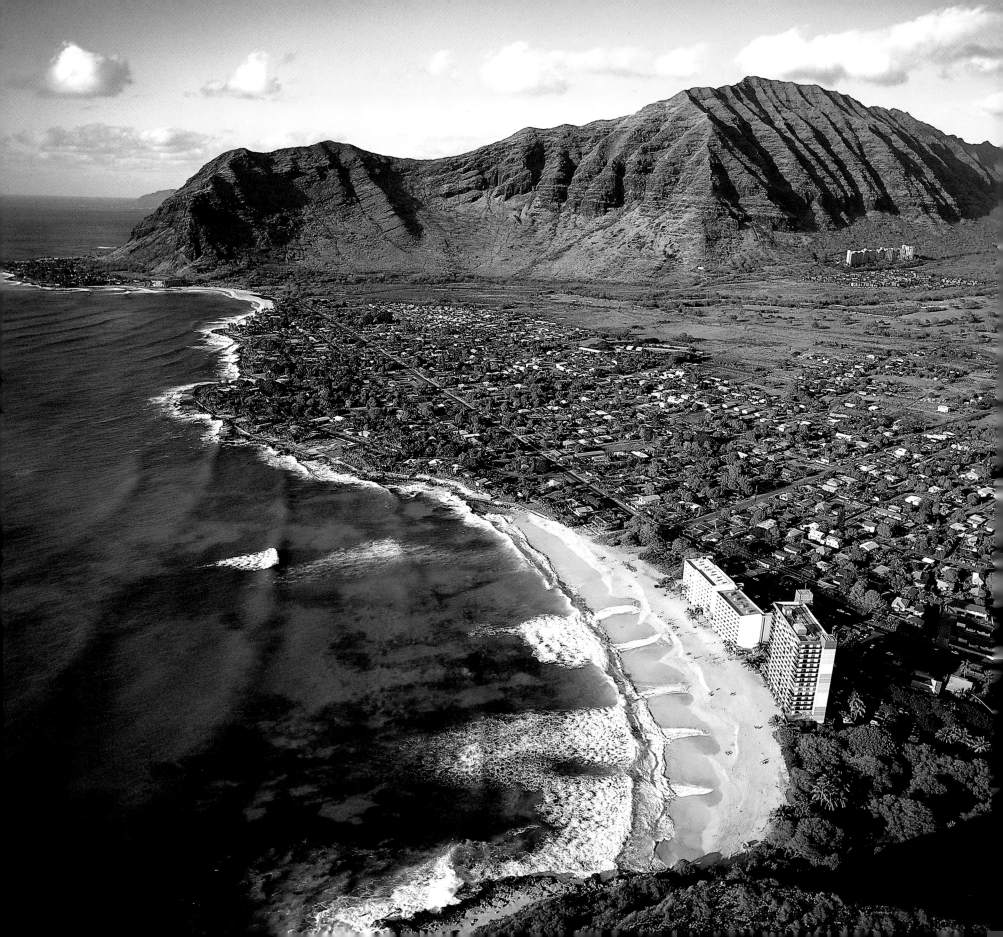

*Papaoneone ("sandy shelf")
Beach is also called Lahilahi,
Crescent, or Turtle Beach. In the
old days a trail, visible along
the shoreline to Kepuhi Point,
connected the Papaoneone
settlements with those at
Laukinui and Makaha. Rising
from the earth like toy blocks at
the base of distant Pu'u Kea'au
are the Makaha Valley Towers.*

Papakala, the venerable *kahu,* or caretaker, of Ku'ilioloa Heiau, or temple, on Kaneilio Point in Poka'i Bay, was explaining the protocol between residents and visitors in old Hawai'i to a group of Honolulu people. Facing great Mount Ka'ala, Papakala pointed to the right toward where Pu'u-ohulu slopes into the narrow coastal plain. To the left, he then noted, dramatic Mauna Lahilahi actually cut into the ocean. Any canoe entering the Wai'anae district, he explained, would have to come around one of those two points. From within the temple, a watcher could see the approaching craft and, through the beating of drums that echoed off the Wai'anae Range, alert the villages that *malihini,* or visitors, were arriving.

When the newcomers landed, their lead genealogist would step to shore first, chanting the names of the ancestors of the visitors. On the beach, he was welcomed by a resident chanter who related the ancestors of the chiefs of Wai'anae. If the genealogies contained names in common, then the newcomers would be welcomed. When no family overlapping could be found, however, the result was suspicion and possible conflict.

Named for a supernatural "Ku's long dog," killed in a battle with the half-man, half-pig demigod Kamapua'a and buried in the temple, Ku'ilioloa temple was also a shrine for travelers. Before starting a journey, they would seek a blessing at Ku'ilioloa, as did the great warrior Kamehameha before he attempted (unsuccessfully) to attack the semi-independent neighboring kingdom of Kaua'i over the horizon to the west.

Return to Ku'ilioloa Heiau in the evening, Papakala advised, and you will learn the true importance of the temple. At night, the skies are magnificently illuminated by the North Pacific stars. Here the priests who specialized in navigation and astronomy would gather, lying for hours on their backs, studying the heavens and identifying by name more than 150 celestial bodies. At Ku'ilioloa they learned the paths of the stars through the heavens and through successive generations refined open-ocean navigation.

Since Papakala guided his Honolulu visitors through the temple that he so lovingly protected, he has joined his *'aumakua* in the spirit realm. Yet this wise man's vision transformed the understanding of Wai'anae of those blessed to visit him. They return occasionally to the temple to renew their mental picture of the Wai'anae Range, to recall the lively words of a master storyteller, and to relive a bit of O'ahu's history.

RIGHT: *A remnant of the ancient shield volcano at the northwestern end of O'ahu, the Wai'anae Range is about twenty miles long and nine miles wide. Although smaller than the Ko'olau Range which extends north to south nearly the entire length of the island, the Wai'anae Mountains do include the tallest point on O'ahu, 4,020-foot Mt. Ka'ala.*

OPPOSITE: *Kolekole Pass connects the Wai'anae Coast with the U.S. Army's Schofield Barracks and the Leilehua Plateau east of the Wai'anae Range. The spectacular view of the Leeward Coast from Kolekole Pass is available, however, only to military personnel since the Army and Navy control access to both ends of the Kolekole Pass road.*

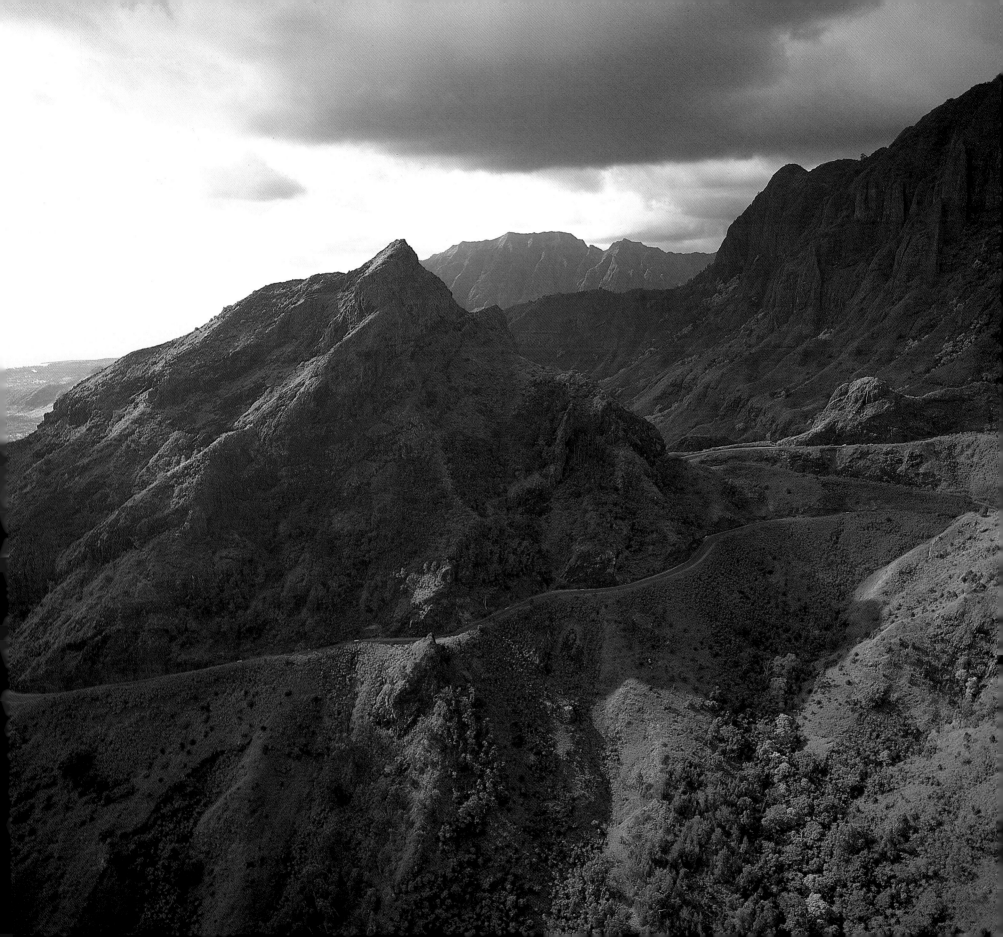

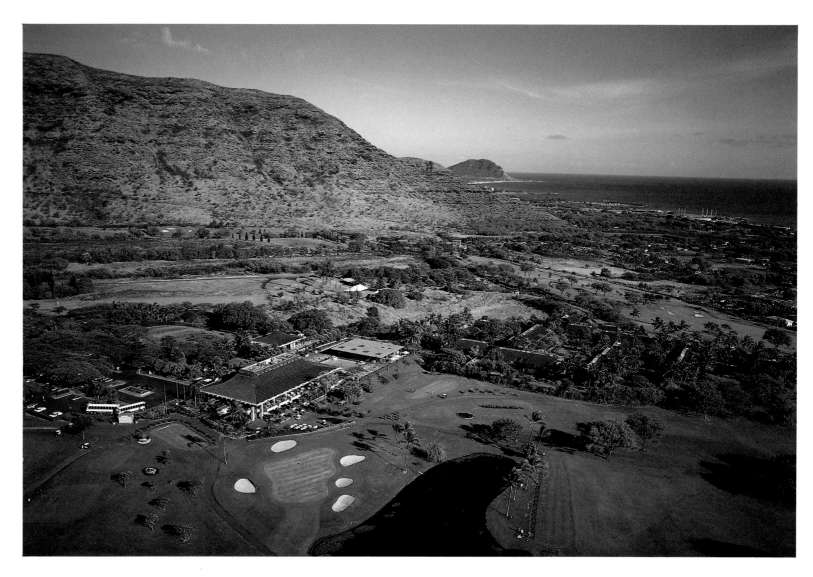

ABOVE: *Outdoor enthusiasts can enjoy the Makaha golf course designed by William P. Bell that blends stunning views of the rugged cliffs of the Wai'anae Range with the ocean at the foot of the valley.*

OPPOSITE: *With daylong sunshine, beautiful white sand beaches and great surfing waves almost guaranteed, the Makaha shoreline attracts beachgoers and surfers from around the world. But resistance by Leeward Coast residents to its development as a visitor destination has helped to preserve this rural district.*

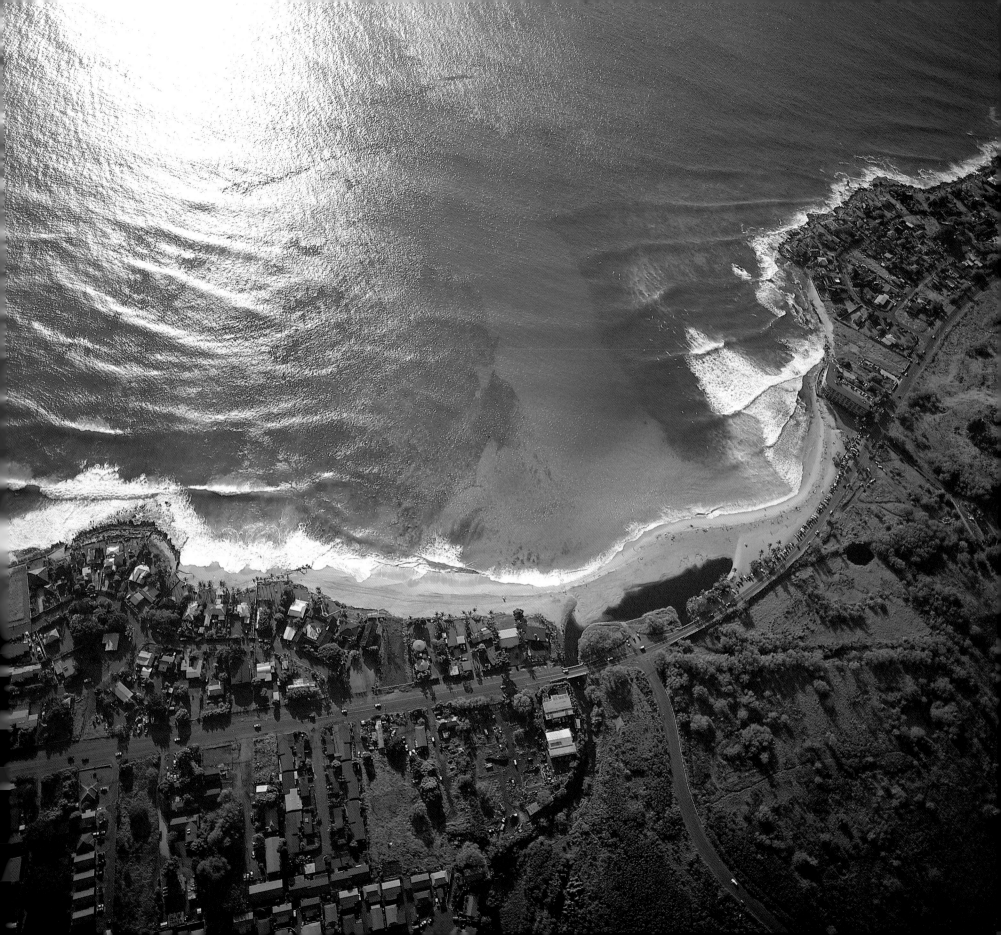

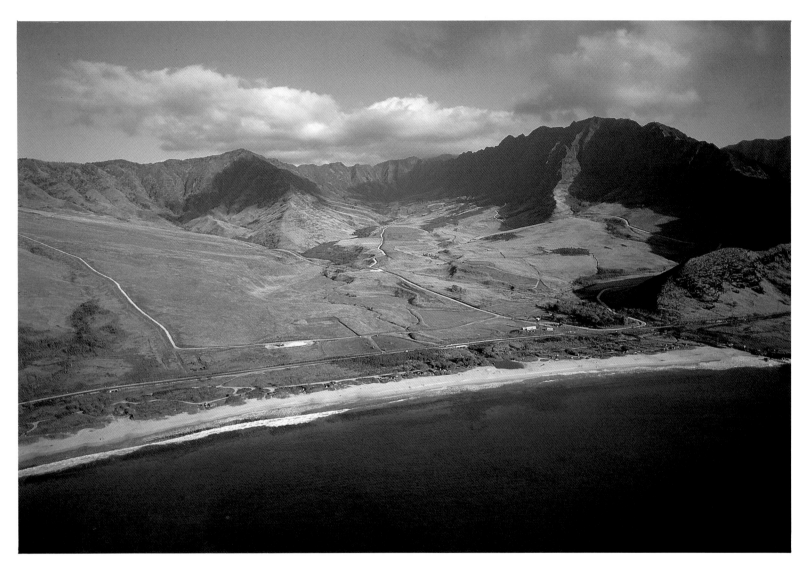

ABOVE: *Makua Valley was once a heavily populated* ahupua‘a. *It was replicated in recent years for the filming of James Michener's monumental novel* Hawaii. *Now a military bombing range, Makua Valley is virtually deserted. Only an old graveyard remains of the once thriving community that existed in this gracefully beautiful valley.*

OPPOSITE: *North of Makua Beach toward Ka‘ena Point, O‘ahu reverts to the past. Signs of civilization vanish. Houses thin out. Valleys and beaches are deserted. Finally, even the road ends. Only the hiker can enter this region of untamed beauty, said to belong at night to the spirits of the Hawaiian dead.*

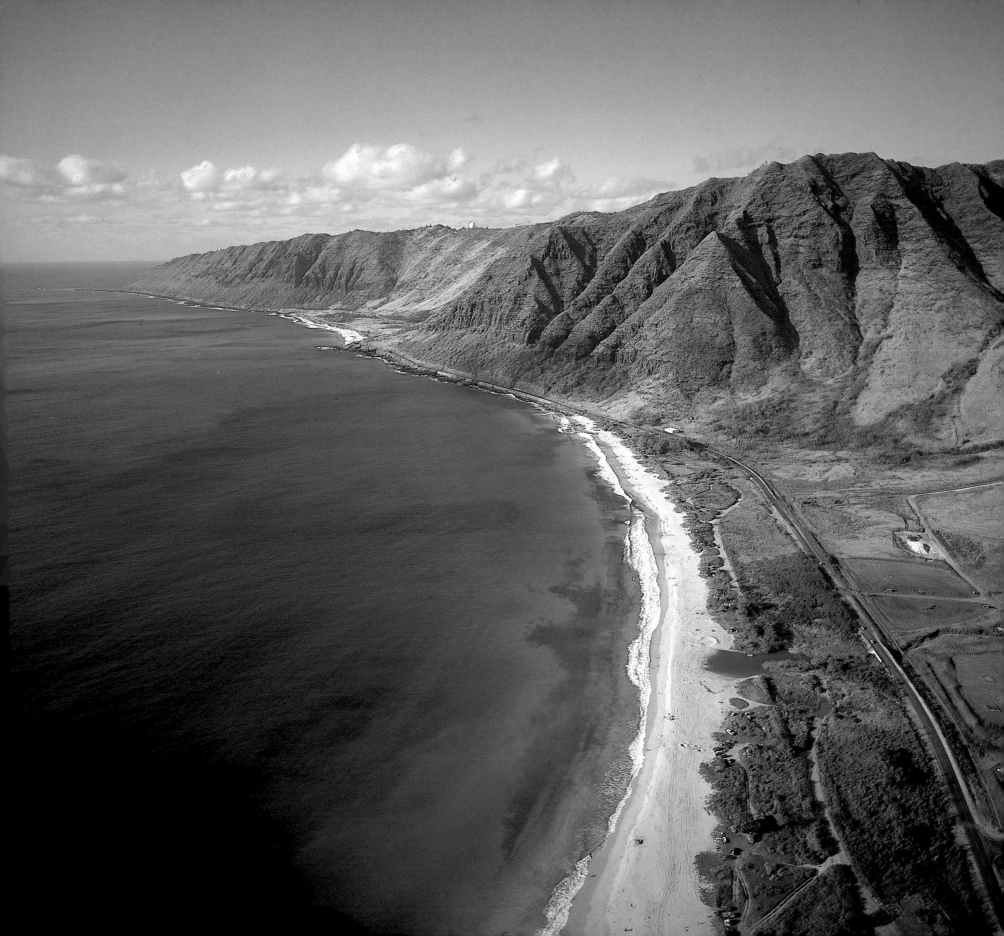

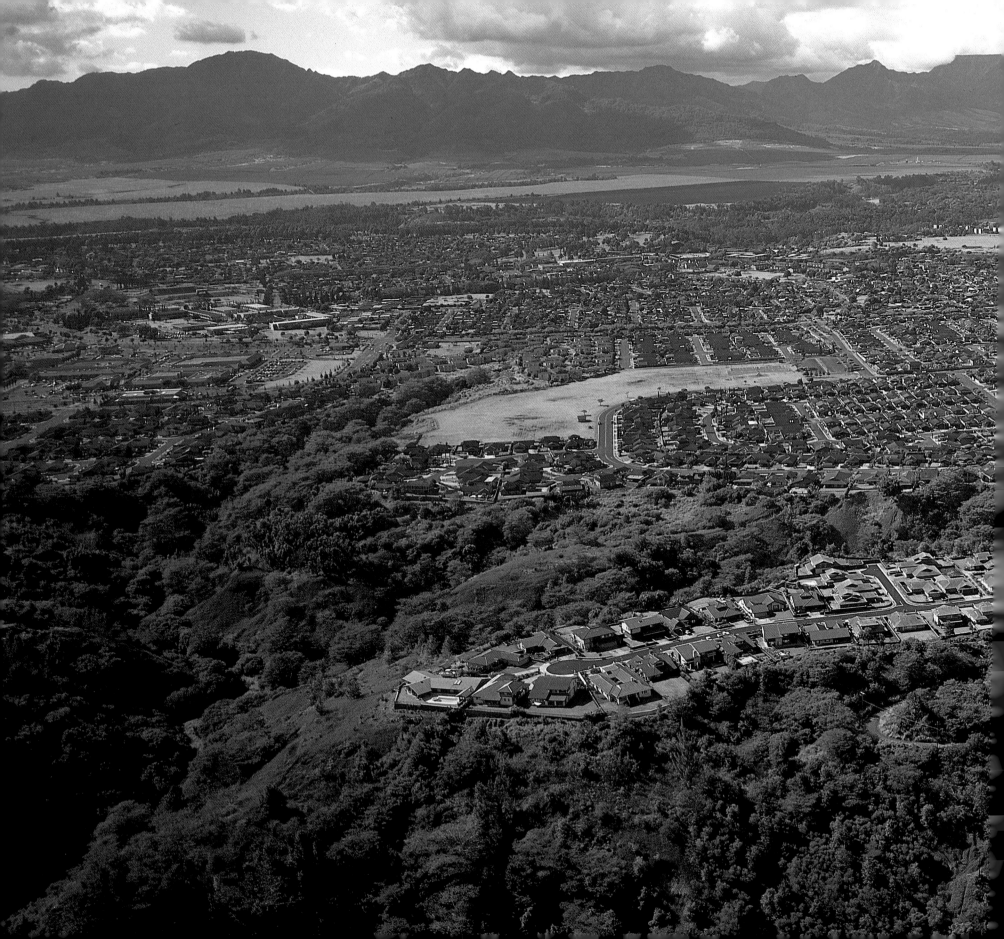

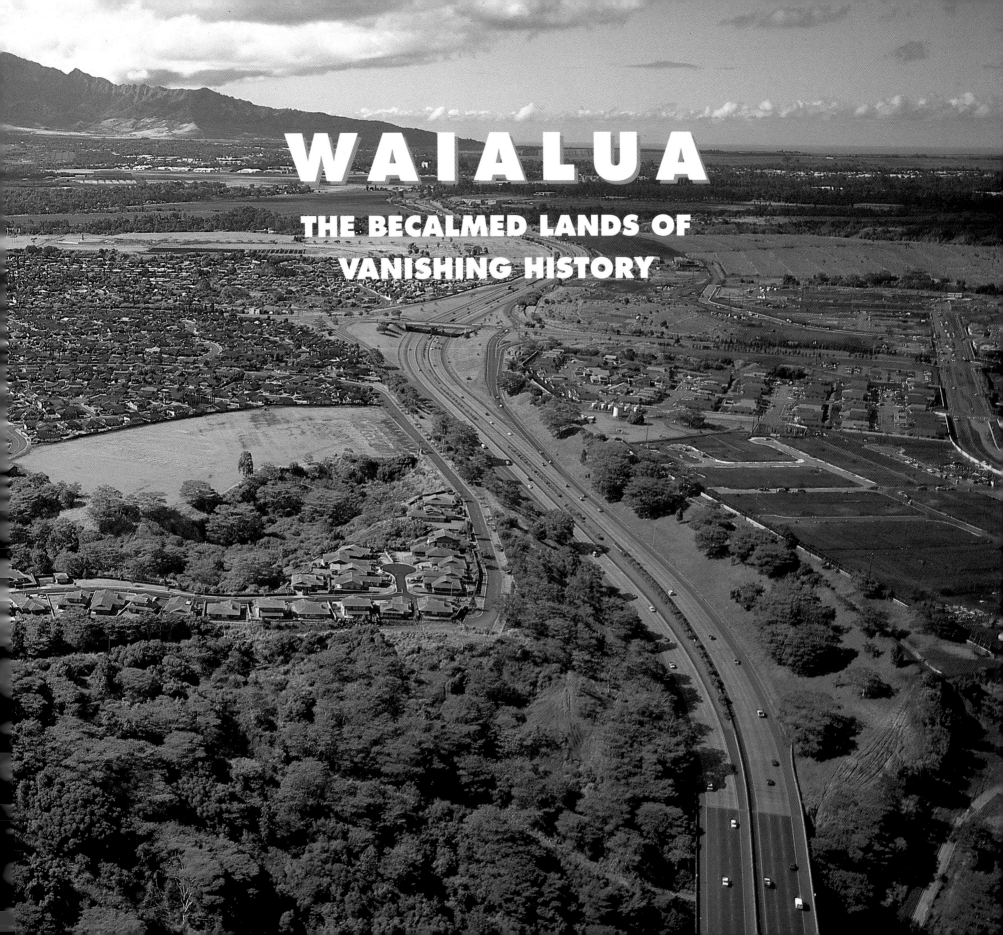

WAIALUA

THE BECALMED LANDS OF VANISHING HISTORY

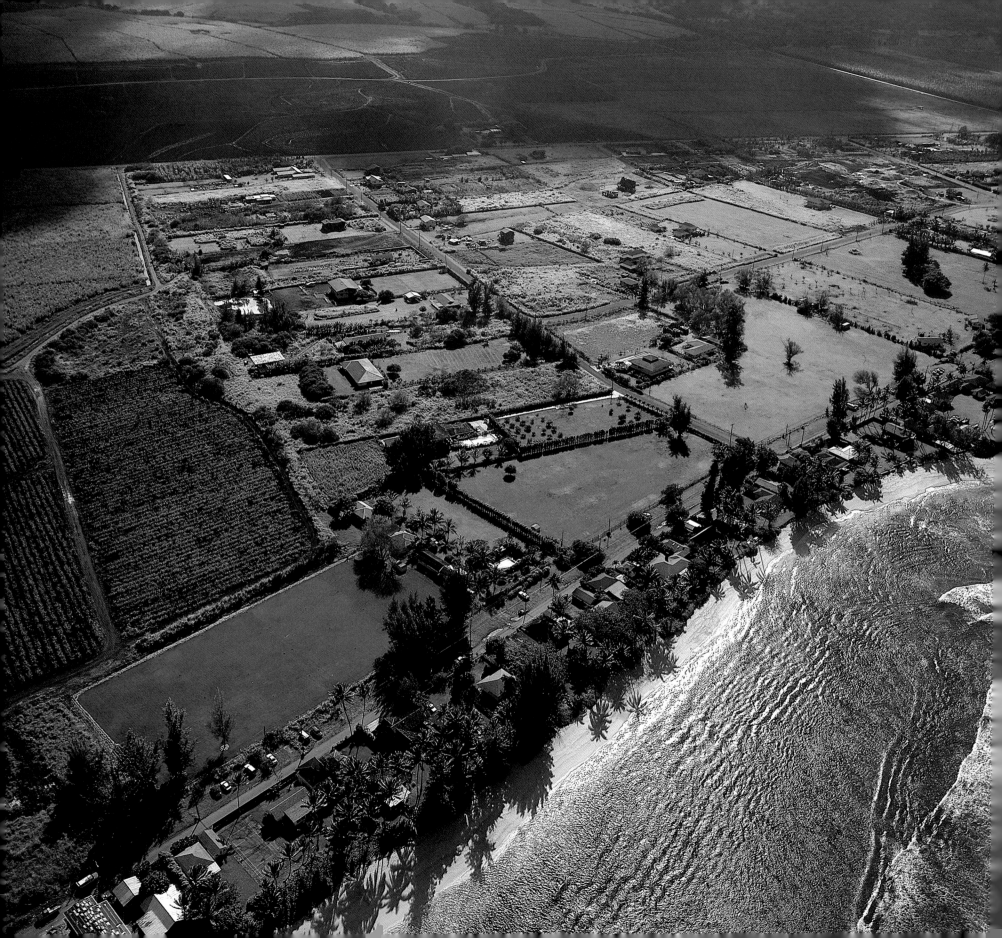

The ghost village of Kawailoa sits in the hills behind Hale'iwa, accessible only by a private plantation road that winds past a pumping station, a few abandoned vehicles and a small trash dump. Fifty or sixty years ago, when Hawai'i was on the brink of war and sugar still ruled, Kawailoa was a thriving community largely of Japanese and Filipino laborers' families and Portuguese *luna,* or bosses. There was a large plantation store, a gymnasium, public baths, an elementary school, a Catholic church, and the Honpa Hongwanji Buddhist temple. By 1986, most of these had been either torn down, collapsed through neglect, or were about to be demolished. Only a few employees of the Waialua Sugar Company remained in this slowly vanishing bit of Hawaiiana.

A van from the Waialua Community Association pulled up in front of a towering *bo* tree, the sort under which the Buddha sat to receive Enlightenment. The tree had been planted years before to shade the Hongwanji entrance. Eight senior citizens, some of them very fragile, carefully climbed out of the vehicle. All had grown up in Kawailoa. This was where they had gone to school, met their spouses, and in many cases spent their early married years. It had been at least 20 years since any had seen their old village; they had been invited now to record their memories. To revisit one's youth with a willing audience is always enticing.

The Kawailoa oldtimers, the "pleasing people of Waialua," began by posing for photos in front of the crumbling Buddhist temple. Although the detailed wooden paneling about the roof seemed well-preserved, the structure itself looked dangerous to enter. Yet so many memories were stored in this old temple that the seniors couldn't be restrained.

PREVIOUS PAGES: *"Interstate" H-2 freeway passes suburban Gentry Waipi'o, Mililani and Waipi'o Acres en route to Central O'ahu and the island's North Shore. Oahu's urban centers have spread dramatically toward 'Ewa and Wahiawa. Freeways, rare in Hawai'i, help to ease the daily congestion as suburban commuters struggle through the morning and evening traffic to and from jobs in downtown Honolulu or Waikiki.*

OPPOSITE: *The fertile lands of Mokule'ia, "isle of abundance," along six miles of O'ahu's northernmost shoreline, once supported a large population of farmers and fishermen. When sugar plantations were established, tall ironwood trees were planted as windbreaks. Mokule'ia also had several dairies including the Dillingham Ranch. Today the Dillingham airfield is used by gliders, private aircraft and sky-diving parachutists.*

103

Waialua, 'aina ku
* palua i ka la'i.*
* "Waialua, land that stands*
* doubly becalmed:*
* pleasant weather and*
* pleasant people."*

"Look, look," exclaimed one of the Japanese. "See how the newspaper was pressed into the floor." Across the floor of the temple a crazy patchwork of old Waialua community newspapers had literally burned itself into the floor boards.

"Under the *tatami* mats that covered this floor," the senior explained, "people used to put a cushion of old newspapers. All those years, sitting on the mats, we pressed them permanently into the floor. When we changed the *tatami* mats every couple of years, we laid down new papers."

Crawling on their hands and knees, the returnees discovered names of neighbors and friends. Wedding announcements, obituaries, graduations, crimes, and honors—all the rites of passage were represented.

The rest of the day was spent looking for other mementoes of Kawailoa's past. The World War II observation tower was now inside barbed wire. In the ruins of the public bath, a Filipino woman told of the night the ghostly, invisible hand of a demon scratched her thigh as she sat alone in the tub. Behind her one-time home, a Portuguese woman found the brick oven for baking bread that her husband had built right after their marriage. Although some bricks had cracked, it was in good condition.

"I could still bake bread in that oven," she boasted, fully aware that the new occupant might look unfavorably on such a proposal. The oven was now the home of a prize fighting cock.

Abandoned many years ago, the dilapidated schoolhouse was now surrounded by junked cars under a shroud of wild shrubs and weeds. The tour of Kawailoa camp concluded there with stories of great marble contests and childhood collections of milk-bottle caps. Through their stories, the old playground came to life.

Waialua seen from the air is one vast field of green sugarcane, bordered by acres of pineapple and dotted with beach houses, a sugar mill, and busy,

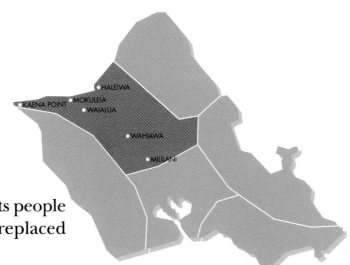

Western-looking Hale'iwa town. The soul of Waialua, though, is in its people who for years have watched as their once-steady way of life was replaced with an uncertain future.

Despite having O'ahu's richest agricultural land, Waialua has had to struggle to keep its sugar and pineapple industries alive. Yet every year more land must be converted to meet the housing needs of O'ahu's growing population. Tourism provides one answer to Waialua's economic needs. A dude ranch of a sort is open in the uplands. Weekends, Hale'iwa packs in visitors buying shave ice, T-shirts, shell braids, plant hangings and velvet paintings from roadside vendors.

Plantation communities like Kawailoa, however, are fast becoming ghost towns. Since the returnees' visit, the Buddhist temple with the newspaper-strewn floor has given way to more sugarcane. The schoolhouse, too, has been removed. The wartime observation tower, the Portuguese "honeymoon" oven with the prize gamecock, and the *bo* tree remain.

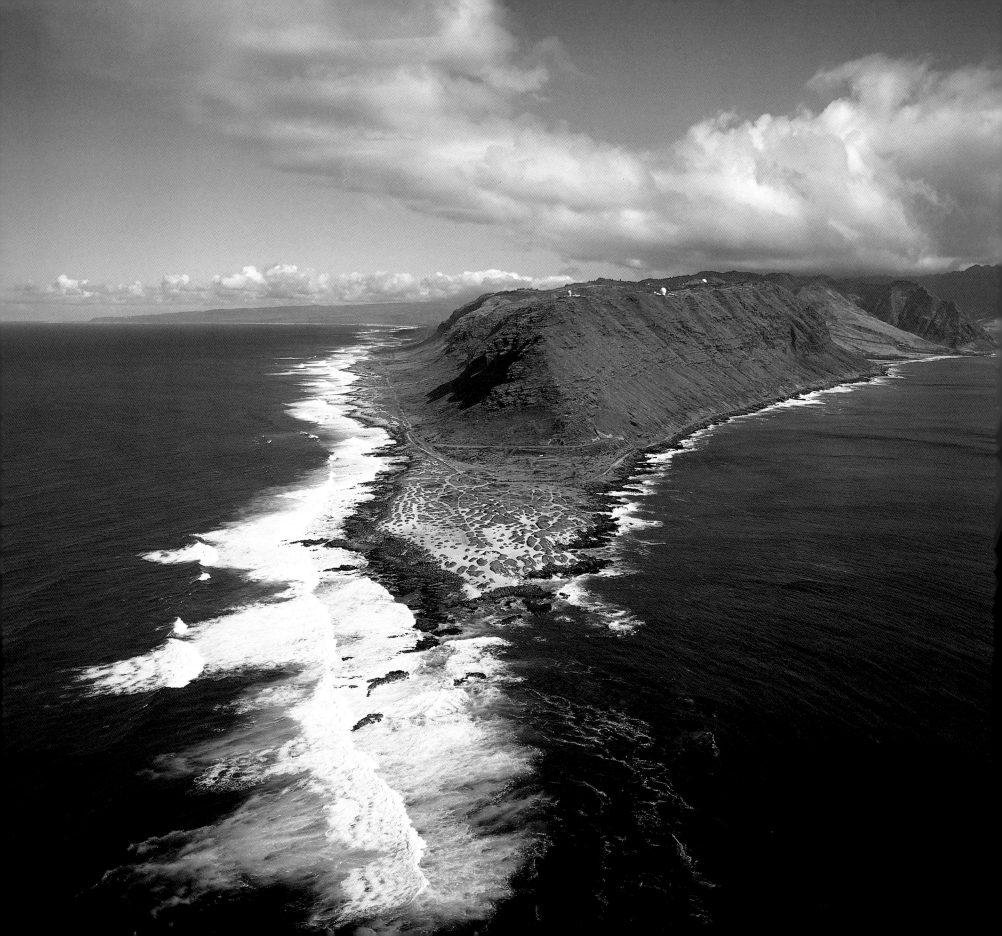

On the island of Kaua'i, in the late 1940s, a middle-aged Hawaiian woman, dying, watched as her spirit floated to the ceiling of her modest home. In the old Hawaiian fashion, on her death she was quickly placed in her coffin to be buried that night. As she watched loved ones crying and wailing about her body, she obeyed an irresistible urge to quit her home, cross the channel separating Kaua'i from O'ahu, and to walk the beach at Mokule'ia. There she saw spirits such as herself, existing in a separate reality but seemingly aware of and in touch with their families. Some were moving in a procession toward Ka'ena, the northwestern point of O'ahu. She joined the hundreds gathering on a white rock off the shore. From there the departing spirits would leap toward the horizon to be swallowed by an endless night.

As the Kaua'i woman climbed the rock and was about to join her fellow spirits into the blackness, the face of her grandmother came out of the endless night.

"Go back, baby," said her grandmother. "Go back. This is nothing. Forty thousand times forty thousand."

Forty thousand times forty thousand, she knew, was the Hawaiian way to say eternity, eternal darkness, oblivion. Frightened, she pulled back from her leap, watching as other souls hurled themselves into the void.

She suddenly found herself sitting up in her coffin in the parlor of her home. About her were terrified friends and family. The woman who had journeyed to the rock of Ka'ena only to be sent back by her grandmother had returned to life. For many years she used the miraculous healing powers she had brought back to minister to the sick of Kaua'i.

A hike to Ka'ena Point passes Leina Kauhane, or "the soul's leaping place," the rock from which ancient Hawaiians believed spirits of the dead leaped into the world of darkness. When night comes to this wildly beautiful cape on the northwestern corner of O'ahu, the souls of all those who have gone before seem to crowd around, pressing to ascend the rock and to escape into the final aerial view.

Although the old Oahu Railway and Land Co. trains rounded Ka'ena Point fifty years ago and motor cars later used its abandoned roadbed to get an unparalleled view of O'ahu, today the point is a Natural Area Reserve reachable only on foot. The white "golf balls" at the crest of the Wai'anae Range are plane and satellite-tracking stations.

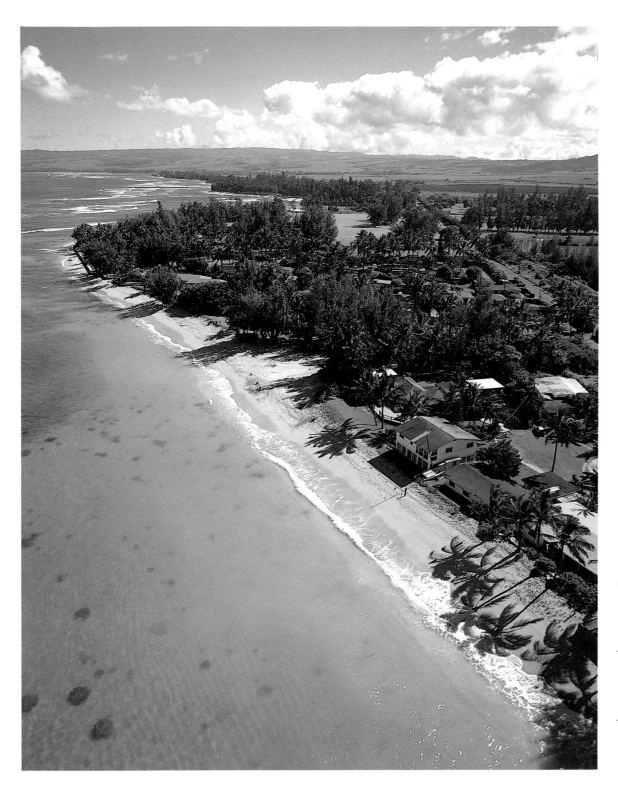

OPPOSITE: *Three Air National Guard helicopters from Wheeler Air Force Base chug across verdant sugar lands on the Waialua side of the Wai'anae Range. The extensive sugar cane fields in O'ahu's Waialua district are among the state's most fertile and Waialua Plantation remains active despite rising labor costs and foreign competition.*

LEFT: *The uncrowded beaches of Mokule'ia are favorites for family picnics and escapes from urban pressures. At the north end of the Mokule'ia coast, school groups and senior citizens frequently retreat to the YMCA's Camp Harold Erdman. Devotees of polo attend weekend matches at the Mokule'ia Polo Field.*

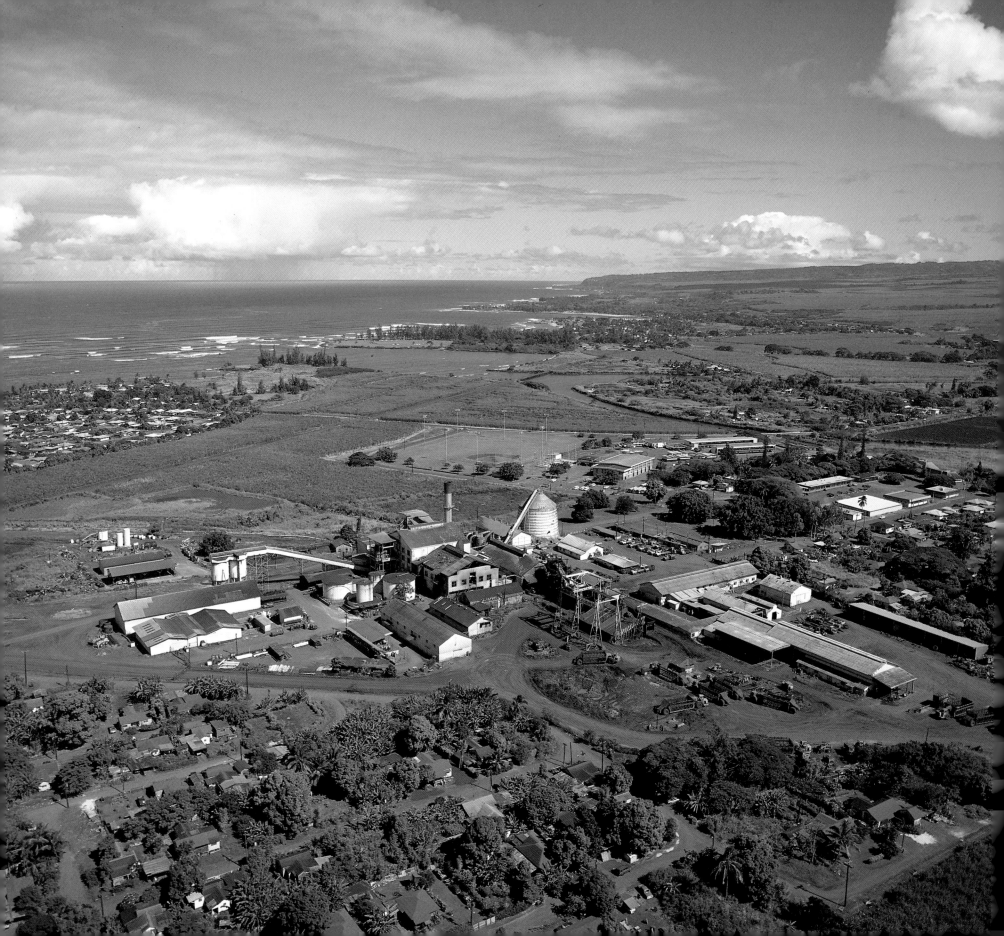

Waialua's sugar mill still stands, although it ceased sugar operations in 1996. Waialua is now best known for its coffee, which is grown at ideal altitudes on the fertile volcanic slopes formerly used to cultivate sugar cane. The old mill itself now houses the Waialua Coffee Visitors Center.

The old Oahu Railway train rounded Ka'ena Point and stopped briefly to allow passengers to take snapshots of the beautiful Wai'anae Mountains before continuing eastward toward the sugar fields of Waialua. It was 1913. The first-class passengers had paid $2.80 each for the roundtrip to the sugar plantation town of Waialua and the nearby elegant Haleiwa Hotel. They got their money's worth. O'ahu's north coast was an endless cane field rustling in the trade wind, and the Waialua Mill smokestack stood out against a blue sky.

Since the 1880s the Waialua Sugar Company had been harvesting sugar on the once-rich taro land of Waialua that in this tropical climate was always in production. Plantation laborers came from China, Japan, Korea, Okinawa, Puerto Rico, the Philippines and Portugal, usually as single men hoping to strike it rich, but occasionally as whole families, to work the fields, plant, irrigate, weed, burn, cut, gather and haul tons of cane. They lived in camps distinguished by ethnic names. Who lived in Japan Camp, Spanish Camp or Korea Camp was obvious. Camp One may have sounded less romantic, but it was no less segregated.

Within their plantation communities, new arrivals perpetuated the traditions and customs of the homelands, the Japanese pounding *mochi* for rice cakes at New Year, the Portuguese building brick ovens to bake their delicious *pao duce*, or sweet bread, and the Filipinos honoring their national hero on Jose Rizal Day. Visitors marveled that, in the Hawaiian Islands, all the people of Asia, the Pacific and Europe seemed to have gathered.

While their parents insisted on their ethnic divisions, plantation children had a harder time perpetuating old world biases when they all went to one school, played together and swam together in the "two rivers" that gave Waialua its name. All spoke the same "pidgin" English and, on Halloween, most spent the night together at an old "haunted" church near a putative "hangman's tree."

The 1913 visitors rolling past Waialua in their first-class seats enjoyed unparalleled sightseeing, but probably couldn't understand the pleasures of "small-kid time" in the sugar days of Waialua when the racial distinctions among Hawai'i's people were being blurred.

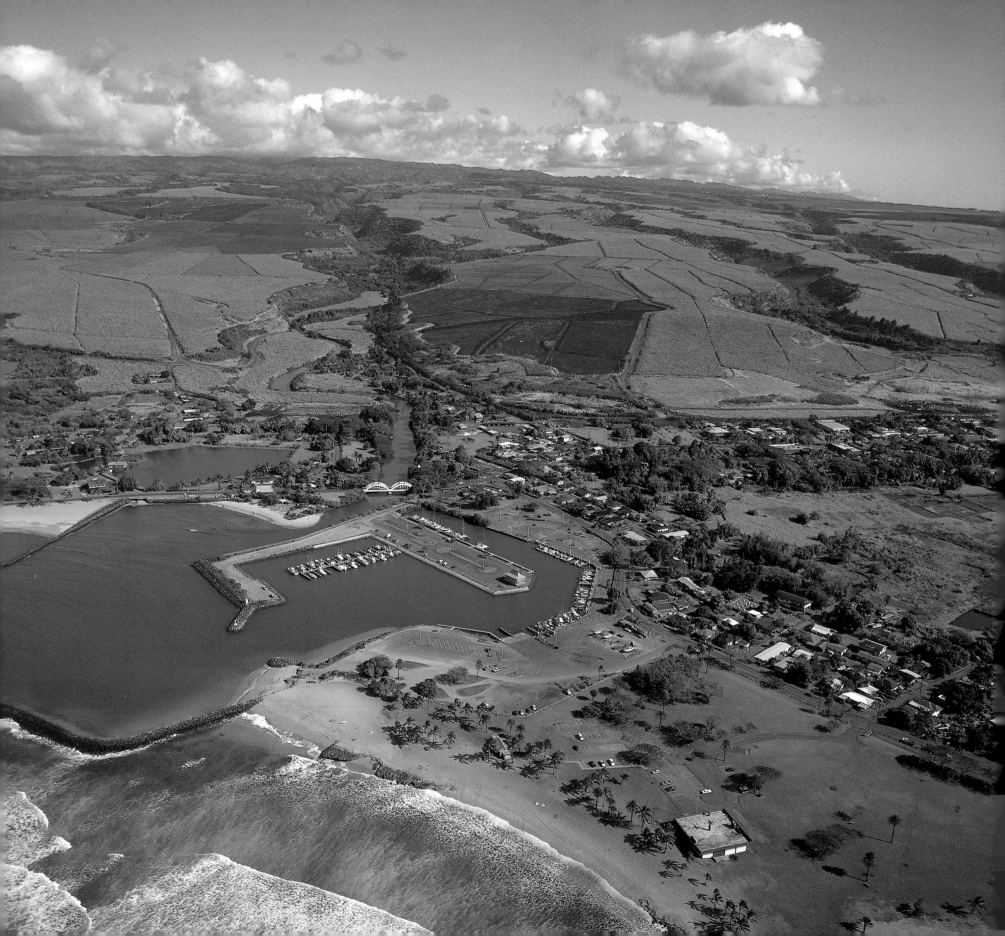

OPPOSITE: *Haleiwa, "the house of the frigate bird," is the North Shore's busiest town and boat harbor. Haleiwa on weekends is a hurly-burly of traffic, long lines at the shave-ice stands, crowded souvenir shops, and gentrified art galleries. Yet old Haleiwa lives on in rustic cottages along Anahulu pond (to the left beyond the harbor) and in the little plantation village of Kawailoa.*

LEFT: *Wahiawa, Central O'ahu's pivotal town, is a community of military personnel, older Japanese and Filipino plantation families, and young people seeking affordable housing. Kaukonahua Stream winding past Wahiawa rises in the Ko'olau Range and flows 33 miles into the ocean at Haleiwa, the longest stream in the State of Hawai'i.*

RIGHT: *The Wahiawa fields on the Leilehua Plateau are the bulk of O'ahu's remaining 11,500 acres of pineapple. Pineapples were introduced into Hawai'i in the early nineteenth century but did not become a viable commercial crop until James Drummond Dole revolutionized the way that they were grown, harvested and canned. The Wahiawa pineapple fields are still a popular visitor attraction, along with the famous Dole Pineapple Cannery in Honolulu.*

OPPOSITE: *The U.S.Army's Schofield Barracks on the Leilehua Plateau, the largest military base in the United States, was named for Lt. General John McAllister Schofield, a Civil War general who visited Hawai'i in 1872 and 1873 and returned home to proclaim the strategic value of Pearl Harbor. After American annexation of the islands in 1898, the U.S. Army occupied this property, today the home of the ready-to-go 25th ("Wolf-hound") Infantry Division (Light).*

114

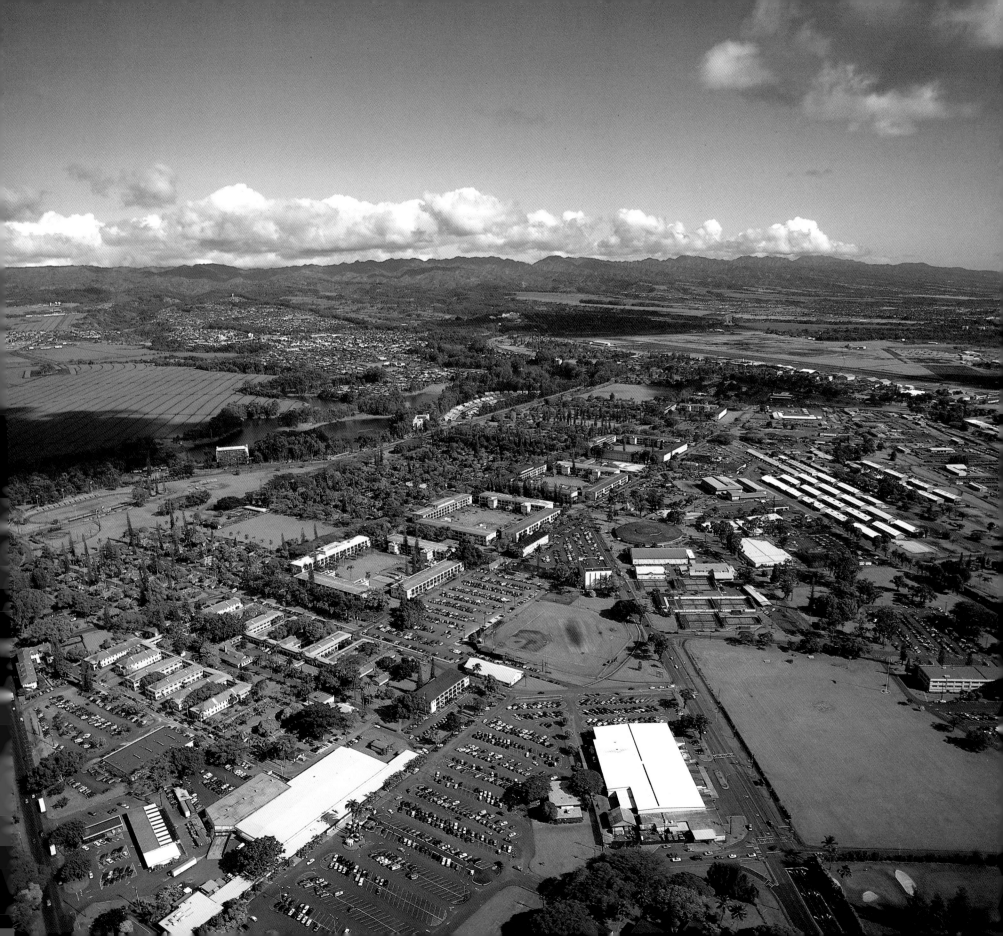

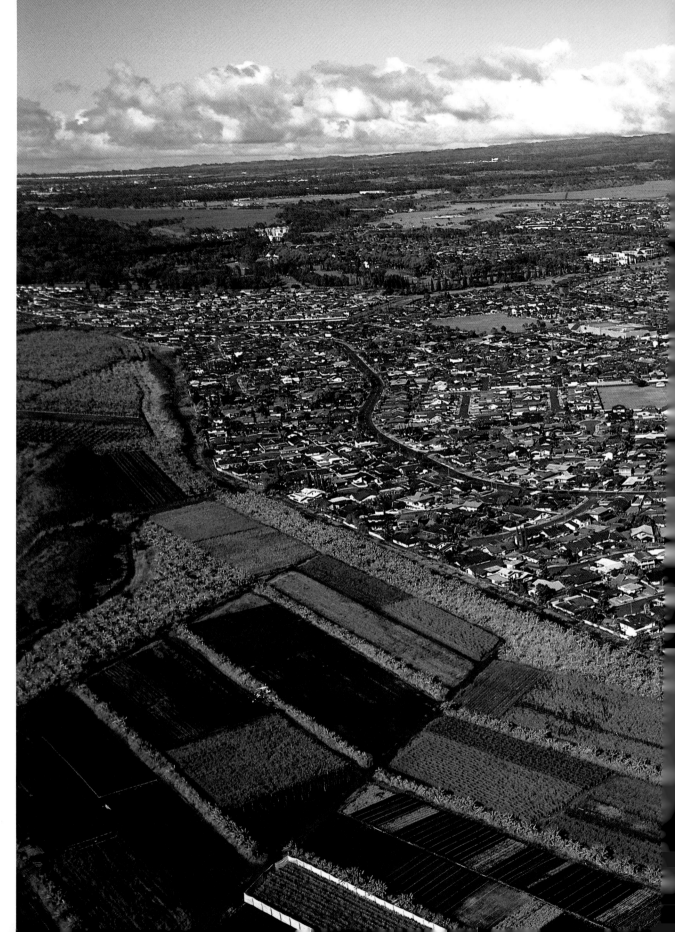

Mililani's housing development presses right up to the edge of Oʻahu's agricultural lands. Waikele ("muddy water") Stream meandering to the left, in ancient times irrigated taro terraces that fed a large Hawaiian population. Today, remnants of the old way largely have been destroyed by sugar cultivation and residential development. Hikers along Waikele Stream, however, see boulders where pohaku kʻii, or petroglyphs, recall Hawaiʻi's Polynesian heritage.

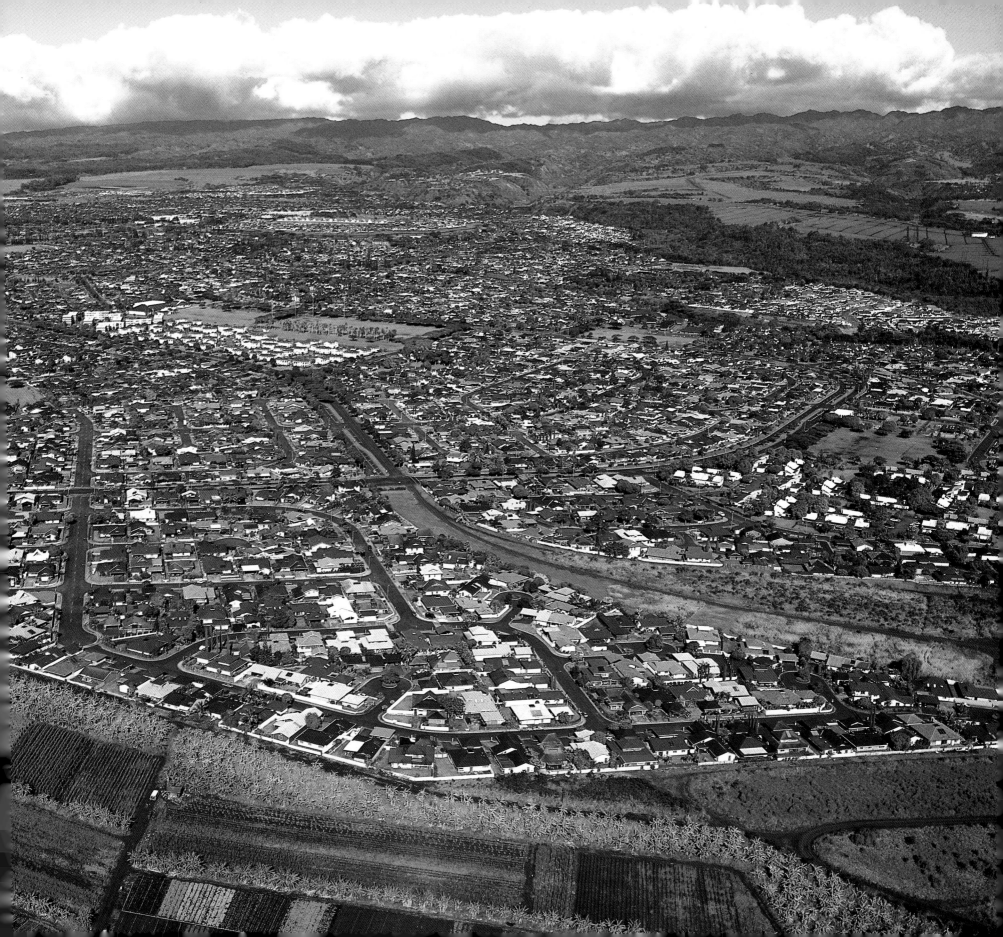

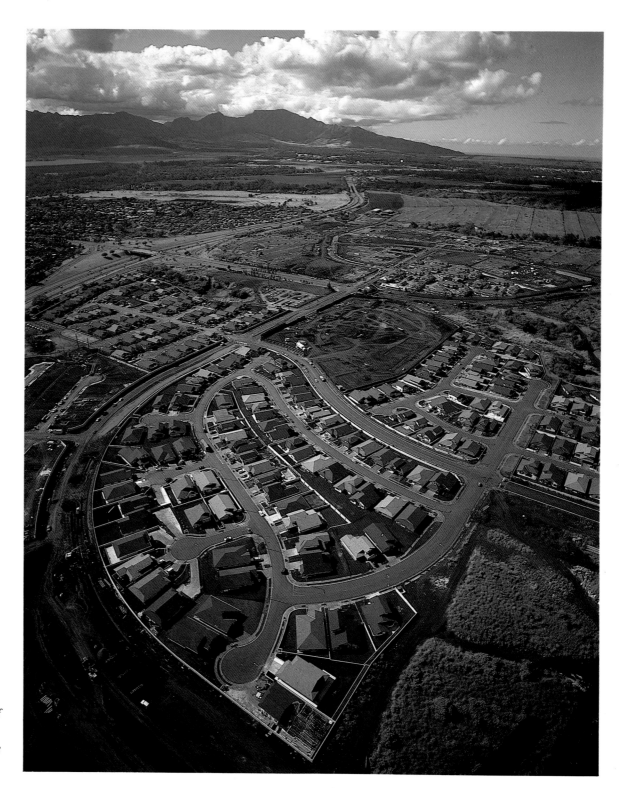

RIGHT: *Hawai'i's housing crisis has seen former sugar plantation lands converted into tracts of single-family dwellings such as this project at Mililani in Central O'ahu. The average price of a Mililani home has soared to nearly $350,000.*

OPPOSITE: *Although Honolulu's population continues to push out toward Central O'ahu, ranches remain in the Wahiawa uplands. Barely visible in this aerial view are whitewashed ranch structures set beside one of the many gulches that carve the gently sloping leeward side of the Ko'olau Range.*

118

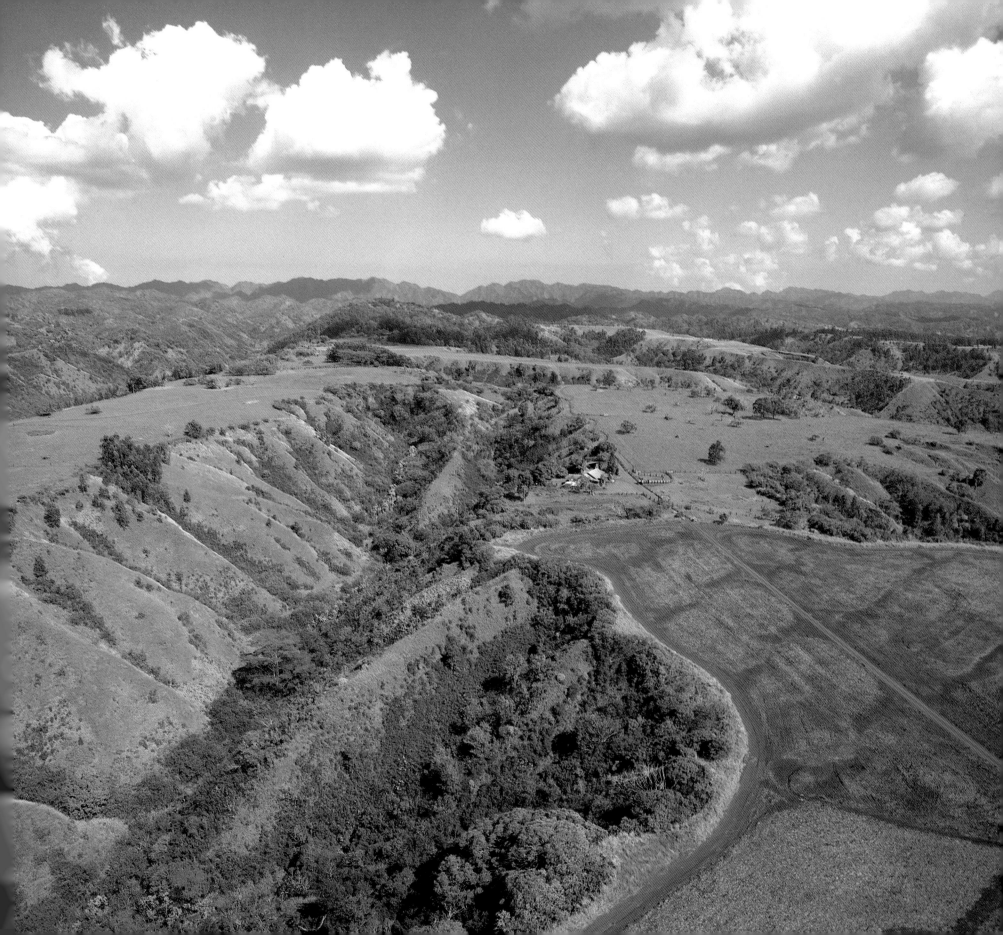

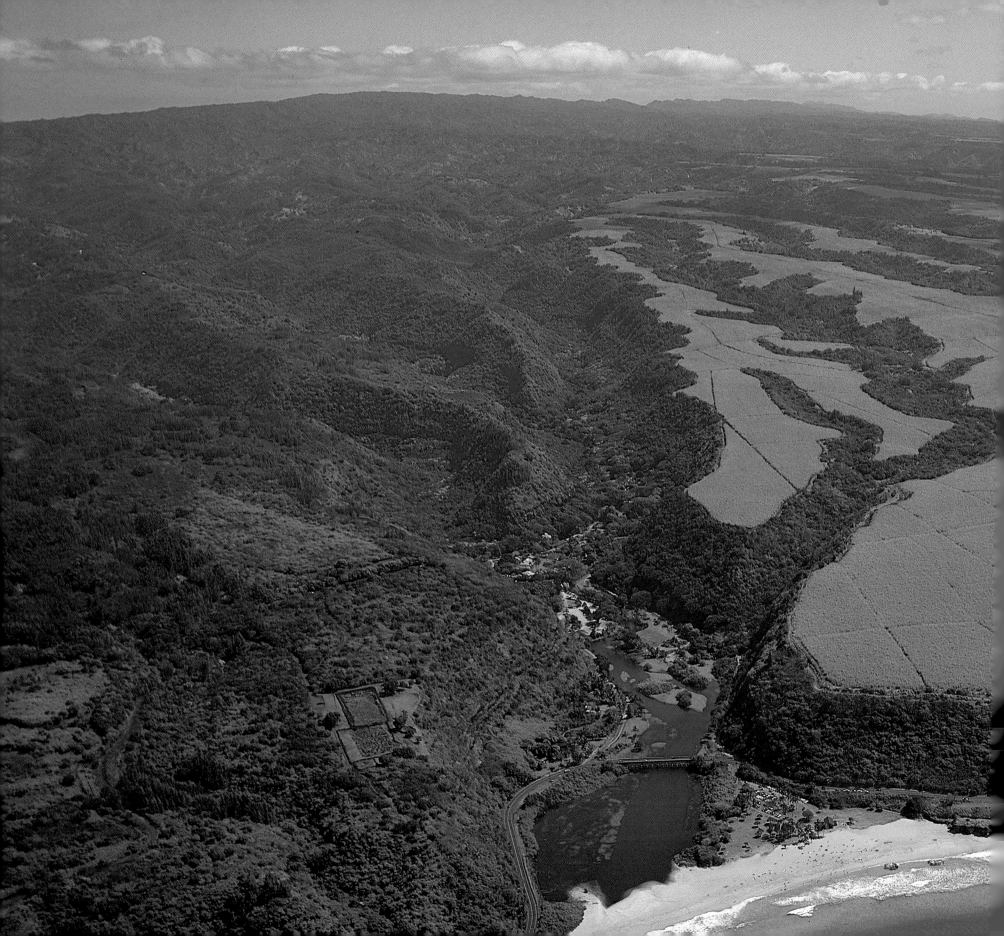

KO'OLAULOA

THE NORTH SHORE OF WILD SEAS

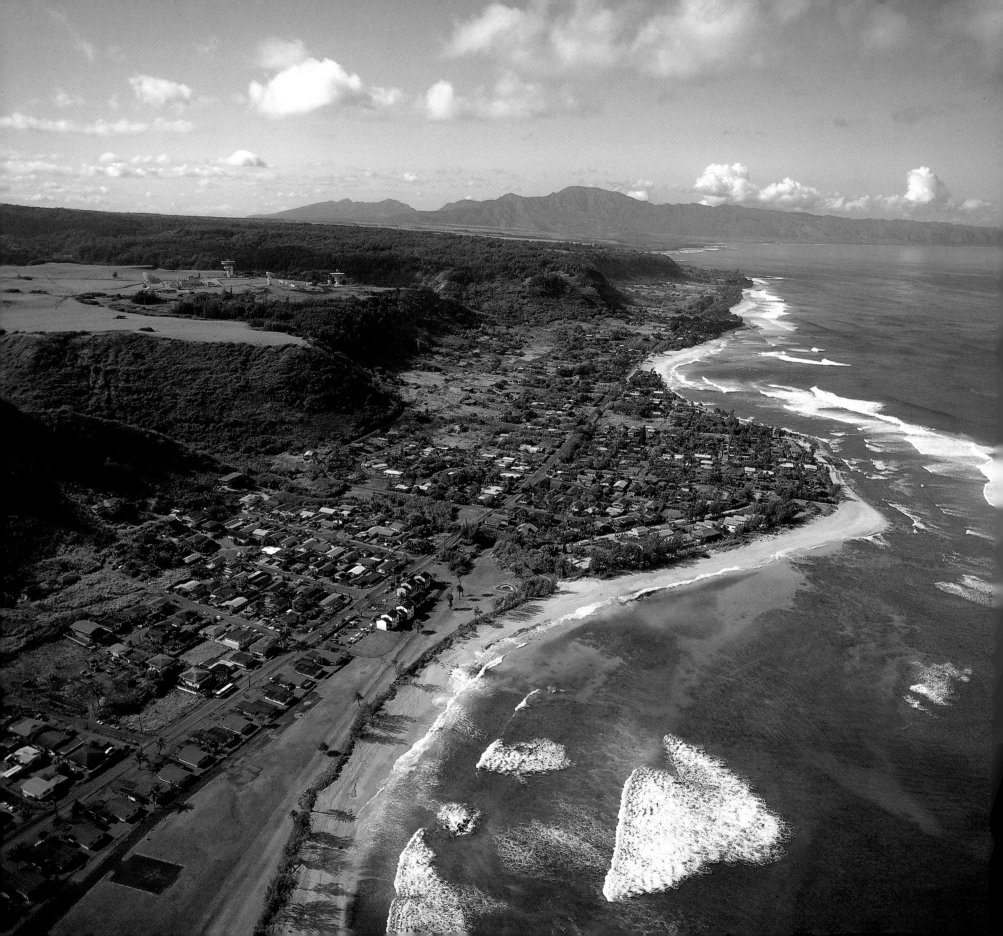

Holoholo wale, to drive aimlessly for pleasure, is a well-established activity on Oʻahu. Along the scenic island-circling Kamehameha Highway, especially through Koʻolauloa and Koʻolaupoko districts on the Windward Coast, you can stop to swim at a secluded beach, to cast a fishing line, to share a refreshing drink at a little roadside "mama-san and papa-san" store while briefly "talking story"—all these simple island pastimes are easily available for the cost of a tank of gasoline. An adventurous heart and some knowledge of Hawaiian history and folklore lets you experience what's left of old Hawaiʻi on Oʻahu.

The journey begins at Waimea Valley. Eager eyes search the rugged red cliffs for caves where in ancient times the bones of Hawaiian chiefs of highest rank often were concealed. Following the death of Kamehameha the Great at today's Kailua-Kona on the island of Hawaiʻi his high priest, *Kahuna Nui* Hewahewa, moved to Oʻahu and settled near Waimea. Since Kamehameha's grave or tomb has never been located, more than one scholar suspects that the bones of the great chief may have been taken by Hewahewa himself to Waimea Valley. For the rest of his life the *Kahuna Nui* lived near Waimea and on his death his bones were hidden in the valley. Had he come to Oʻahu to conceal and then protect the remains of his great leader?

Recognizing that those who disturb ancient burials frequently come to bad ends, the traveler ponders the mystery, then moves on.

The Kamehameha Highway between Waimea Valley and Kahuku to the north was opened in 1932 after two years of roadwork. The rock-crushing tower built by the contractor is still a landmark at Waimea Bay. Acquired by the Catholic Church as Saints Peter and Paul Mission, the old tower,

PREVIOUS PAGES: *When Captain George Vancouver's store ship* Daedalus *sailed into Waimea Bay on Oʻahu's North Shore in 1792, the area was well-cultivated and heavily populated. Many of the original sites have been preserved and interpreted by Waimea Falls Park—a large privately-owned botanical garden and cultural attraction in Waimea Valley. On Pupukea hill overlooking the bay on the left a stonewall outlines Puʻu-omahuka, Oahu's largest* heiau, *or temple.*

LEFT: *Soon after the scenic Pupukea-Paumalu Beach tract was opened in 1919 the entire westward-facing coastline became known as Sunset Beach. Today this spectacular stretch is famous for its world-class surfing sites, including Paumalu ("Sunset Beach") in the foreground, ʻEhukai Beach, Banzai Beach, The Pipeline, and Pupukea Beach as the eye travels westward.*

'A'ole no i 'ike ke kanaka i na
nani o kona wahi
i hanau 'ia ai.

"A man doesn't see all the beauties
of his birthplace."

storage bins and machine sheds are now chapel and office space.

On the hillside above nearby Sharks Cove, Pu'u-omahuka, O'ahu's largest remaining *luakini,* or human sacrifice temple, provides not only a spectacular view of Waialua and Ko'olauloa, but an insight into old Hawai'i's *hoomana ki'i,* or religion. The winding Pupukea road leads into a small parking lot, where a number of stones wrapped in ti leaves rest on the ancient walls and altar of the temple. Built in the eighteenth century—by *menehunes,* Hawai'i's legendary small people, according to local tradition— the temple still attracts rock-and-*ti*-leaf offerings. Residents declare that nightmarchers with lit torches sometimes walk along the ridge and into the Puuomahuka compound.

North of Waimea is wild-surf country. If the waves are good, half the cars of Honolulu seem to be parked along the highway as residents try to catch the action at Sunset Beach or The Pipeline. Nearby is a giant redwood carving by Peter Wolfe, who has done symbolic wooden sculptures in all 50 states. Supposed to represent a Hawaiian, this mammoth carving more resembles an American Indian and strikes the traveler as a bit out-of-place. But, along the North Shore appearing out-of-place is almost normal.

*Holoholo*ing on, the traveler wonders at the boarded-up Industrial School for Boys, the perfect haunted mansion, on the grounds of the Crawford Convalescent Home. More than one elderly resident of Honolulu has confessed to having been sent there in the 1930s for such infractions as swearing and smoking cigarettes on campus.

Rounding the north end of O'ahu, near the Turtle Bay Hilton turn- off, a Hawai'i Visitors and Convention Bureau "warrior" points to the former Opana radar station (which first detected the attacking Japanese planes on December 7, 1941) on a hill now covered with giant windmills that would have intimidated even Don Quixote.

SUNSET BEACH
KAHUKU
WAIMEA
WAIMEA BAY
HAUULA
KAHANA BAY

After offering glimpses of the monumental white Mormon Tabernacle and the neighboring Polynesian Cultural Center at Laie, the Kamehameha Highway takes us past the Hawaiian homestead lands at Hauʻula, the entrance to Kaliuwaʻa Valley's "sacred falls" where the half-man, half-pig demigod Kamapuaʻa made his home, and finally to Kahana for a picnic beside a beautiful sheltered bay. The State of Hawaiʻi has declared Kahana Valley a "living history park," where several families continue cultivation utilizing traditional Hawaiian methods.

The traveler senses that Kahana Valley must have sustained thousands in the old days. The beautiful bay rimmed with ancient fishponds, some still in use, is redolent with the spirit of an old Polynesian village. In the imagination Hawaiian *waʻa,* or canoes with distinctive tapa sails, maneuver to the shore where children frolic in the surf and villagers pick shellfish and seaweed from the reef. In the lush valley farmers share their bounty of taro, sweet potatoes and bananas with the fishermen. Ancient Kahana may have disappeared and the temples abandoned, but the legends live on along this Windward Coast.

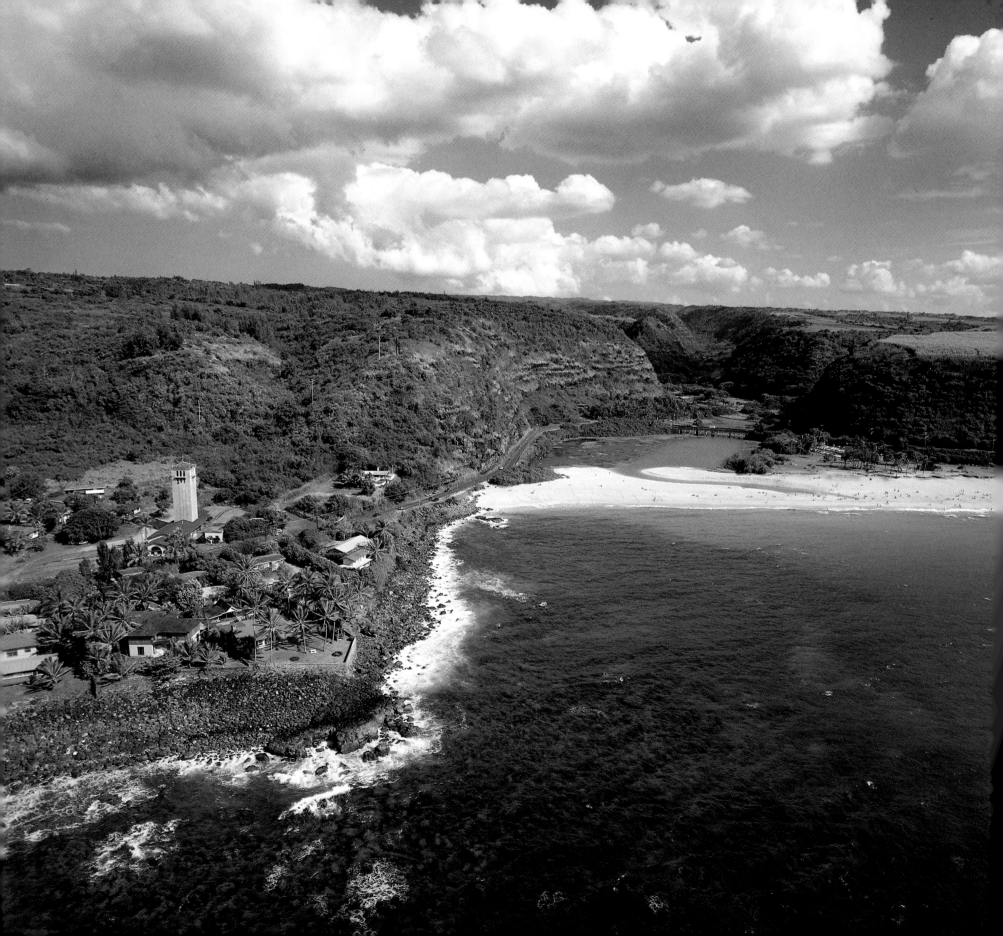

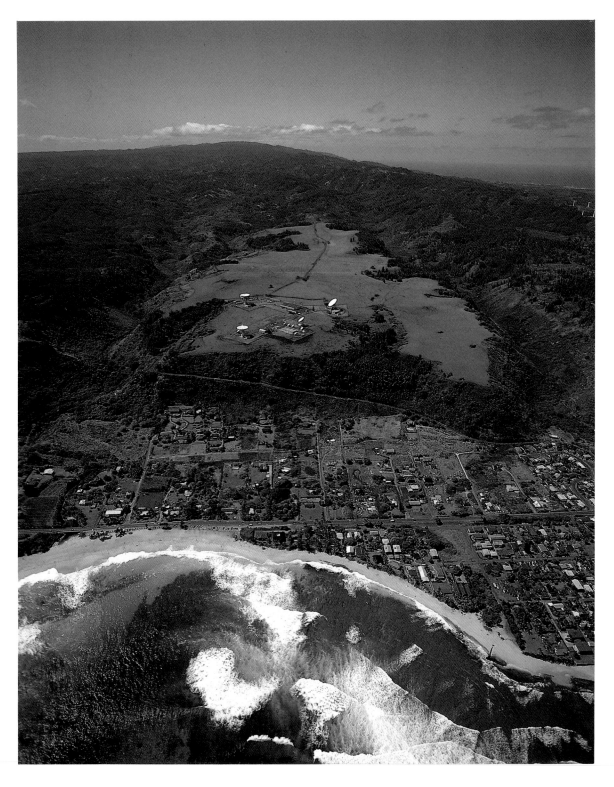

OPPOSITE: *O'ahu's Waimea (a frequent geographical name in Hawai'i; it means reddish water) is known for huge surfing waves that annually challenge world champions. The landmark Saints Peter and Paul Mission at the base of the Pupukea plateau originally was the tower of a rock-crushing plant built in 1928 when the Waimea-Kahuku stretch of island-circling Kamehameha Highway was paved.*

LEFT: *Sunset Beach's two miles of continuous sand is the longest stretch of beach on O'ahu. Famed for its huge winter surf and "laid back" local surfing lifestyle, the* mauka *area is also used for ranching as well as high-tech communication satellite tracking. The Comsat tracking station visible on the ridge overlooking Sunset Beach is currently keeping tabs on four Pacific satellites for Intelsat, an international satellite communication organization.*

127

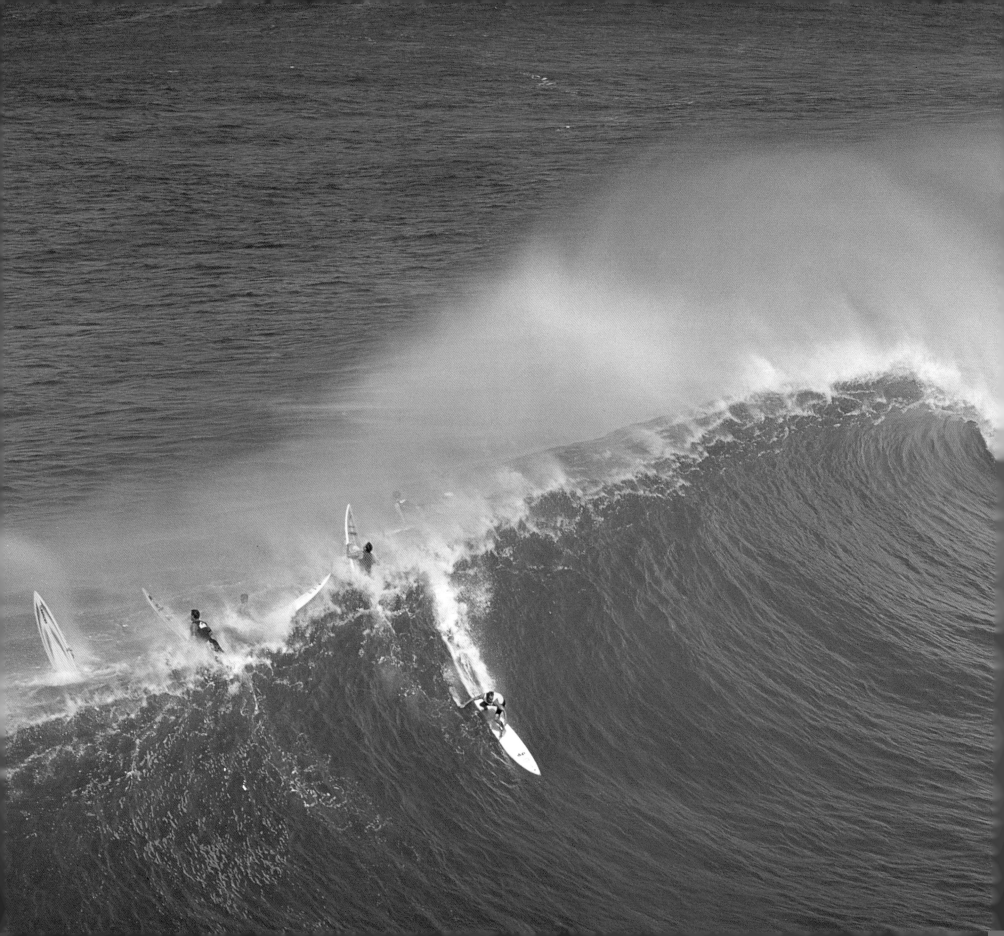

Surfing the big winter waves at Sunset Beach began in earnest in the early 1950s when Bob Simmons, famed on the North Shore as "that crazy haole surfer," used one of the new lightweight surfboards to ride the "bull-mouthed monsters." Other daring surfers followed, making "Sunset" one of those legendary O'ahu's beaches to which, when the surf is up, all of Honolulu rushes.

Na-pela-kapu-o-Namahanaikale-leonalani or, as he was commonly known, J. H. Napela, told in 1869 how the Church of Jesus Christ of Latter-Day Saints, the Mormons, had come to choose Laie on the north point of O'ahu as their Hawai'i home. One of the first Hawaiian converts to the Mormon faith, Napela said he had heard the bit of history from William Cluff, a pioneering missionary.

Cluff, he said, had paused under a cluster of *hau* trees while passing through Laie. It was high noon. A tall, dignified Caucasian approached him. As the figure came closer, Cluff realized that this was no man. Brigham Young himself, the leader of the church, who at that very moment was in Salt Lake City, was standing before him! Young silently pointed out the boundaries of Laie and then vanished. Cluff immediately returned to Utah to tell Young of the vision. Was it a divine sign that this fertile northern district of O'ahu was to become the home of the Mormon Church in Hawai'i?

Another early Mormon missionary to Hawai'i had been colorful Walter Murray Gibson, who in the early 1860s established the church on the island of Lanai. Soon after Gibson purchased most of the tiny island using Mormon funds he was excommunicated for doctrinal deviations. Scrutiny of the deeds for the Lanai property revealed that their excommunicant had used his own name on the conveyances. Walter Murray Gibson owned Lanai, a political power base that he would use to launch a stormy career as a journalist, politician and, finally, controversial member of King Kalakaua's cabinet. In the meantime, the Mormons were without a home.

In January, 1865, whether though divine inspiration or business acumen, the Mormon headquarters was re-established at Laie. By the late 1870s the colony had developed a profitable sugar plantation, an impressive tabernacle, a settlement of homes and stores, and a college. Church members had acquired the Koolau Railroad Company. Sugar boomed and a dairy farm, cattle ranch and pineapples became prosperous subsidiary businesses. Capping the growth of the colony since Lanai, in 1919 a beautiful new tabernacle was dedicated at Laie on the site of a former Hawaiian place of refuge. Access to the tabernacle is restricted to Mormons.

The site of the *hau* trees where the vision came to William Cluff now is part of the beautiful campus of Brigham Young University-Hawaii. Next door is the Polynesian Cultural Center, the Mormon church's attractive theme park and Hawai'i's most popular visitor attraction, where students from throughout the Pacific interpret the cultures of their homelands. The vision revealed by Napela probably has been fulfilled beyond even that of the spirit of Brigham Young himself.

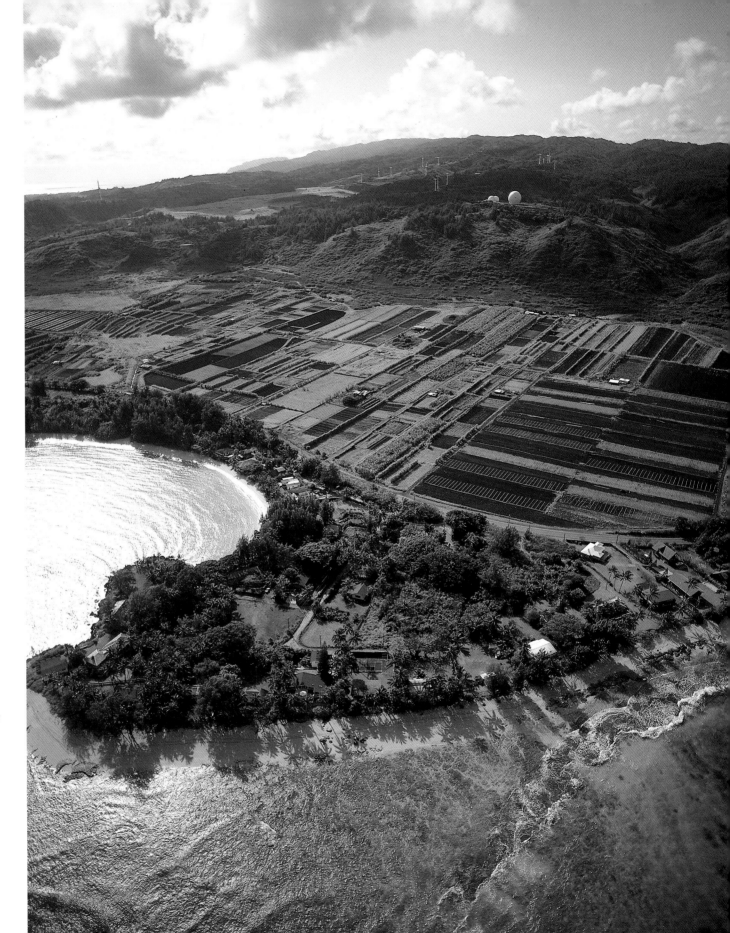

Kawela Bay in ancient times was so filled with lobsters that the great chiefs of O'ahu reserved for themselves the fishing rights to this shore. Inland from the bay Punaulua, a freshwater spring that legends say was created by the Polynesian god Kane, feeds a pond which irrigates the North Shore farms that grow a variety of cash crops, including corn and watermelons, for the Honolulu market.

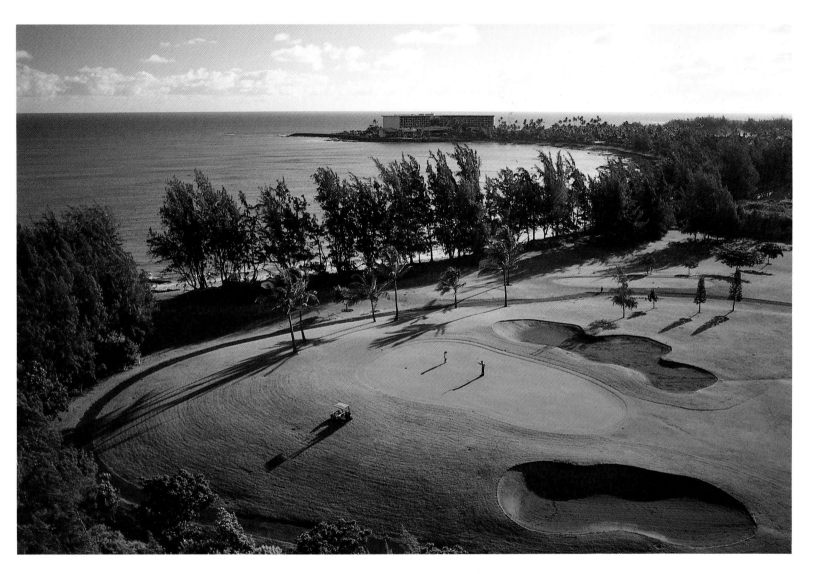

The Turtle Bay Resort's golf course covers an area long known as Kuilima, or "joining hands," in reference to the three men who once walked from mountains to sea here in such a fashion. The first-class but relatively isolated resort (forty miles from downtown Honolulu!) is a self-contained world where guests swim, sunbathe, golf, play tennis, ride or simply escape the crowds of Waikiki, as their whims dictate.

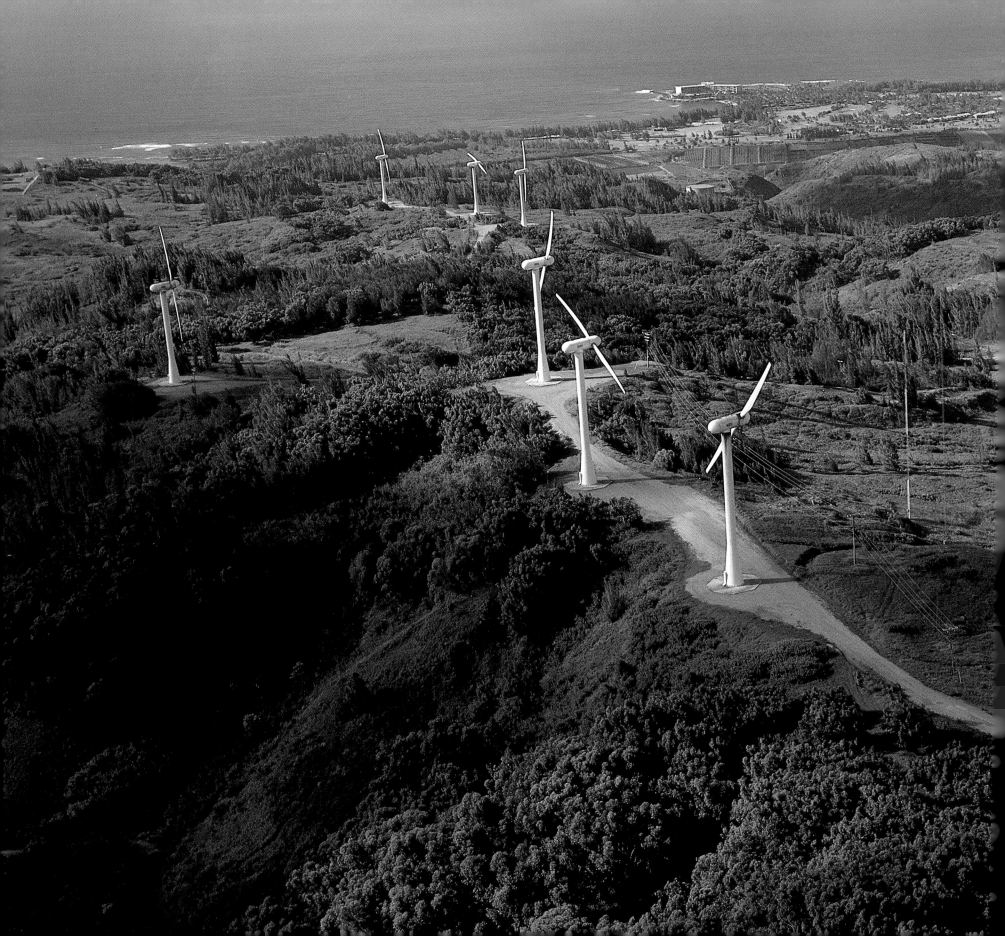

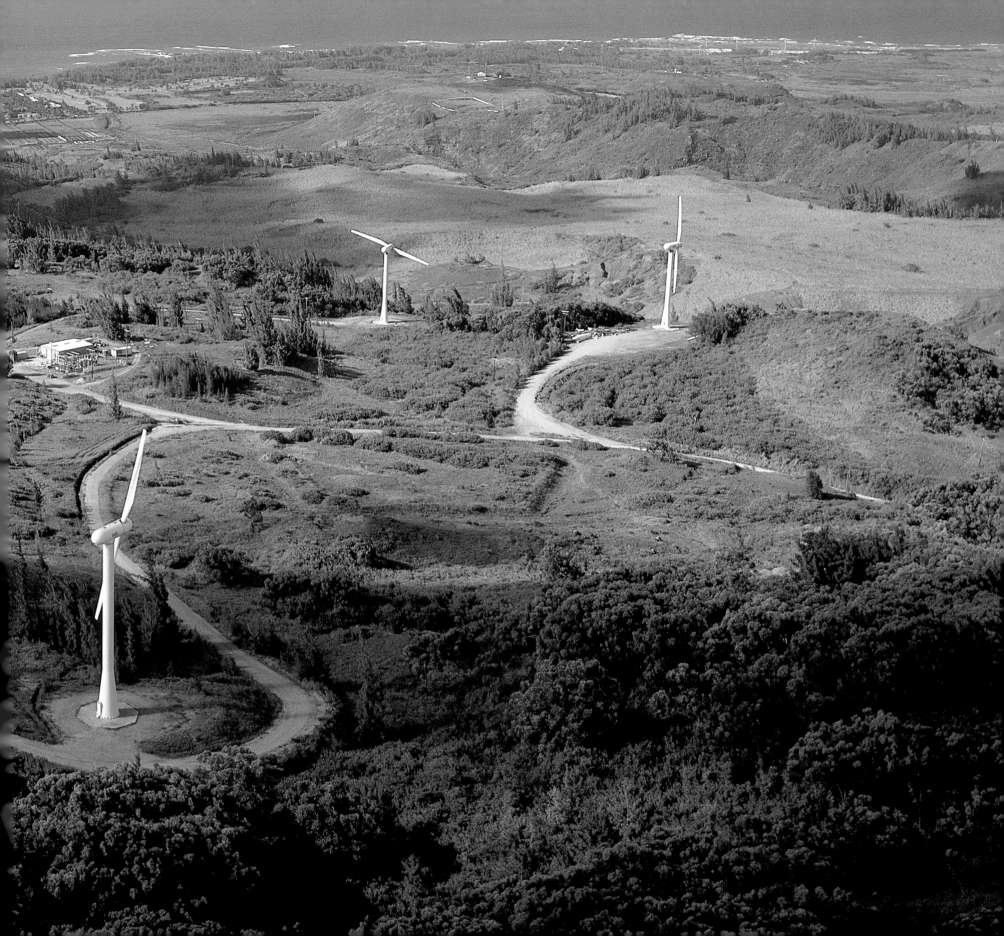

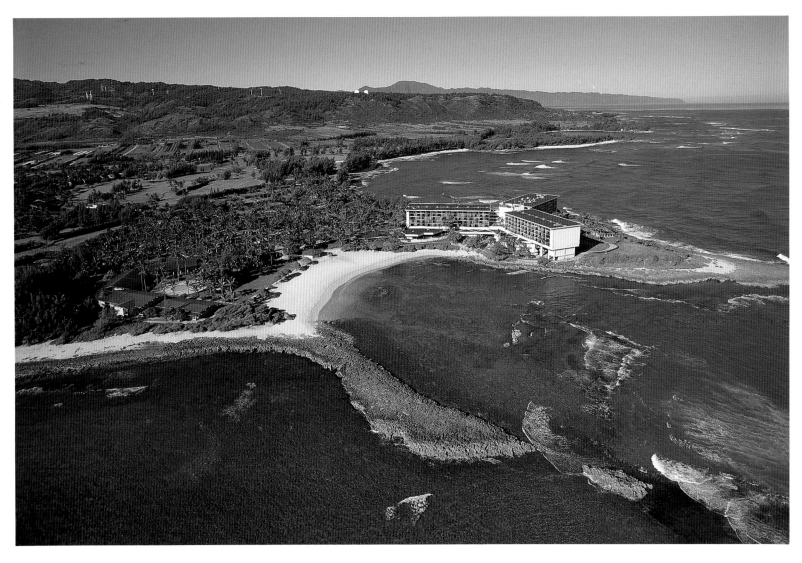

PREVIOUS PAGES: *The trade winds that pummel Oʻahu's northeastern coast 300 days a year make Kahuku a natural windmill-farm site, able to produce up to eighty megawatts of electricity.*

ABOVE: *The land on which the Turtle Bay Resort was constructed was known as Kalaeokaunu, "the point of the altar." Here Hawaiian kahuna, or priests, would make offerings to the ʻaumakua, or family patron spirits, who could calm the seas for the fishermen. To the left of the hotel, Kuilima Cove once was a secluded and protected bathing pool for royalty.*

OPPOSITE: *The ancient Hawaiian practice of cultivating fish in the ponds that once ringed all the inhabited islands has been revived as a modern industry. More than a score of prawn farms operated throughout the state in 1990. Shrimps and prawns are being raised in these Kahuku aquaculture farms.*

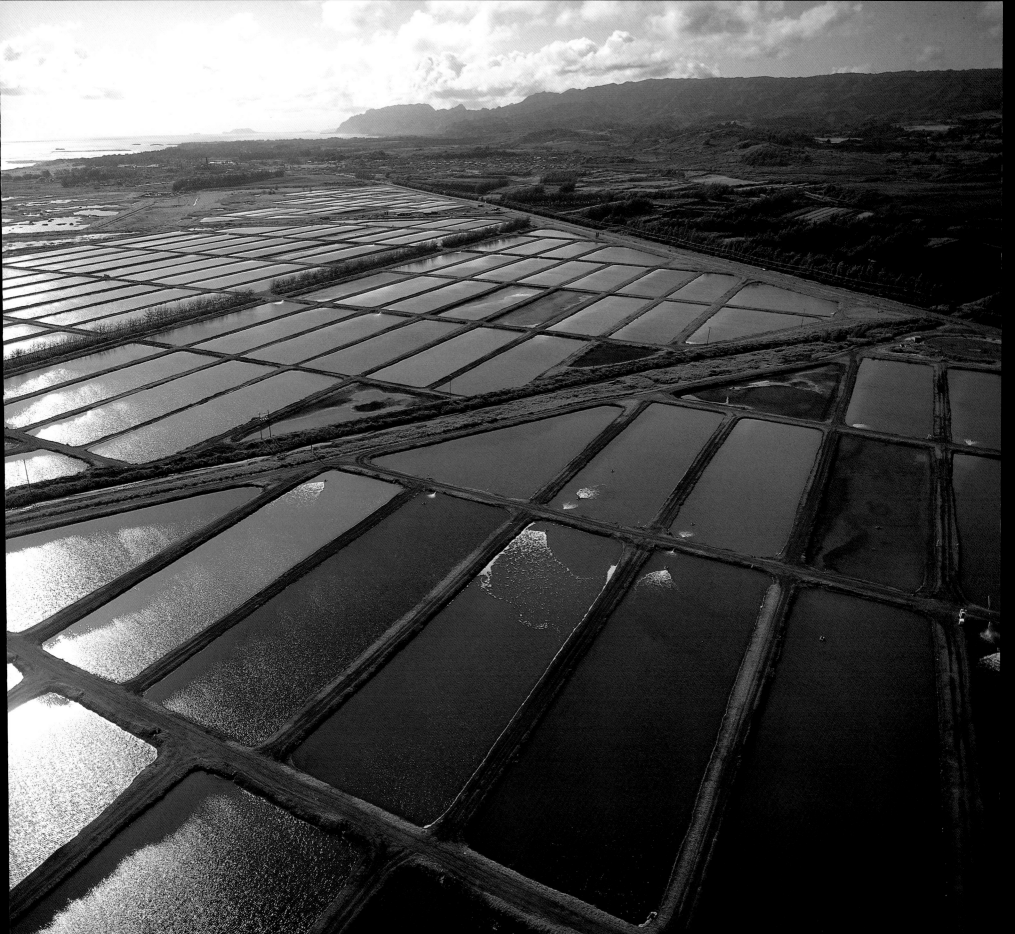

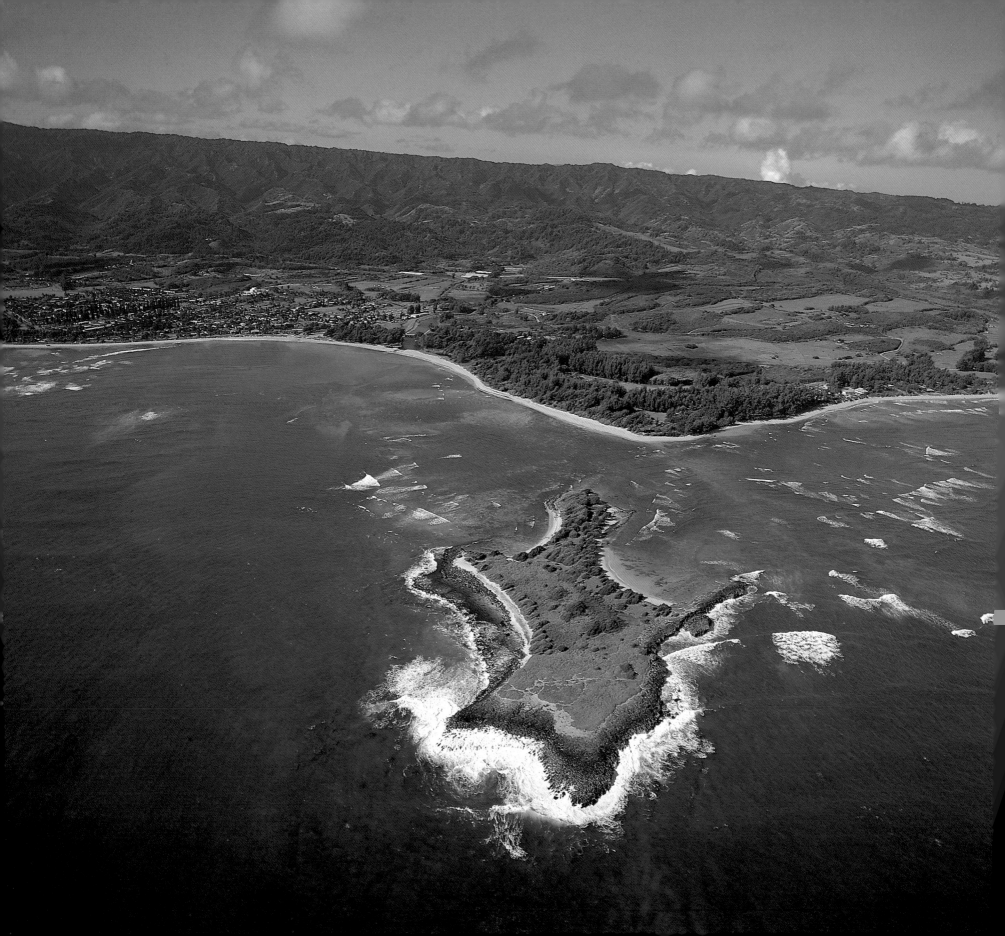

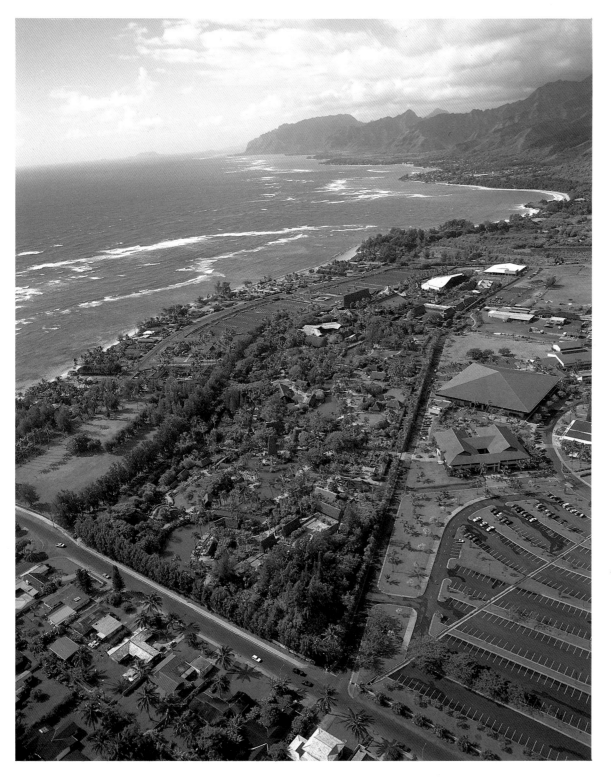

OPPOSITE: *Moku'auia, or Goat Island, is easily accessible at low tide by wading from Kalanai Point. Used in the last century by the early Mormon community of La'ie to raise goats, it was once home to a local lawyer named Kauahi and his two mistresses. When King Kamehameha V ordered him arrested for bigamy, Kauahi refused to be taken to jail, pointing out successfully that Moku'auia did not appear on any maps of the Hawaiian Kingdom and therefore was independent.*

LEFT: *Hawai'i's most popular visitor attraction, the Polynesian Cultural Center at La'ie, features an array of model Pacific village compounds, authentic craft, dance and lifestyle demonstrations, tropical lagoons, and a Polynesian stage extravaganza. Operated by the Mormon Church of Jesus Christ of Latter-Day Saints, most of its cultural demonstrators are South Pacific students at the nearby Brigham Young University-Hawaii campus.*

137

RIGHT: *The tiny village of Hau'ula was named for the red flowers of the* hau *trees that once covered this district. Fed by five streams pouring from the rainy Ko'olau mountains, Hau'ula was extensively terraced for taro cultivation. The shallow rocky reef visible offshore is Wahi-o-Pua, "place of young fish." The people of Hau'ula gathered all their fish from this once-abundant reef.*

OPPOSITE: *Ka'a'awa Beach Park (left foreground) is a thin white sandy strip named for the* 'a'awa *fish that frequent these waters. Hawaiians named most beaches along the Windward coast for their marine life. Above Ka'a'awa are Kalae'o'io ("bonefish cape") Beach and Makahonu ("eye of the turtle") Point. Distant Pu'u Kanehoalani Mountain marks the boundary between Ko'olauloa and Ko'olaupoko districts.*

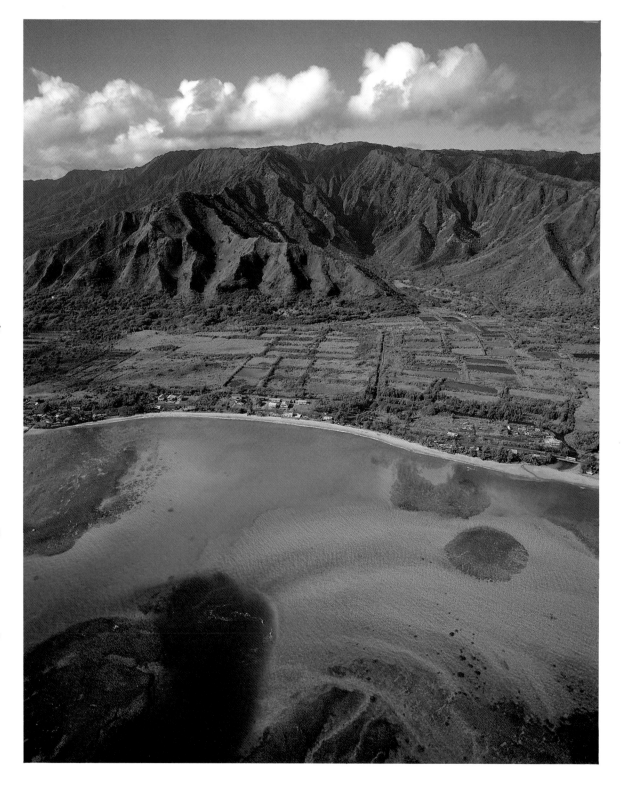

138

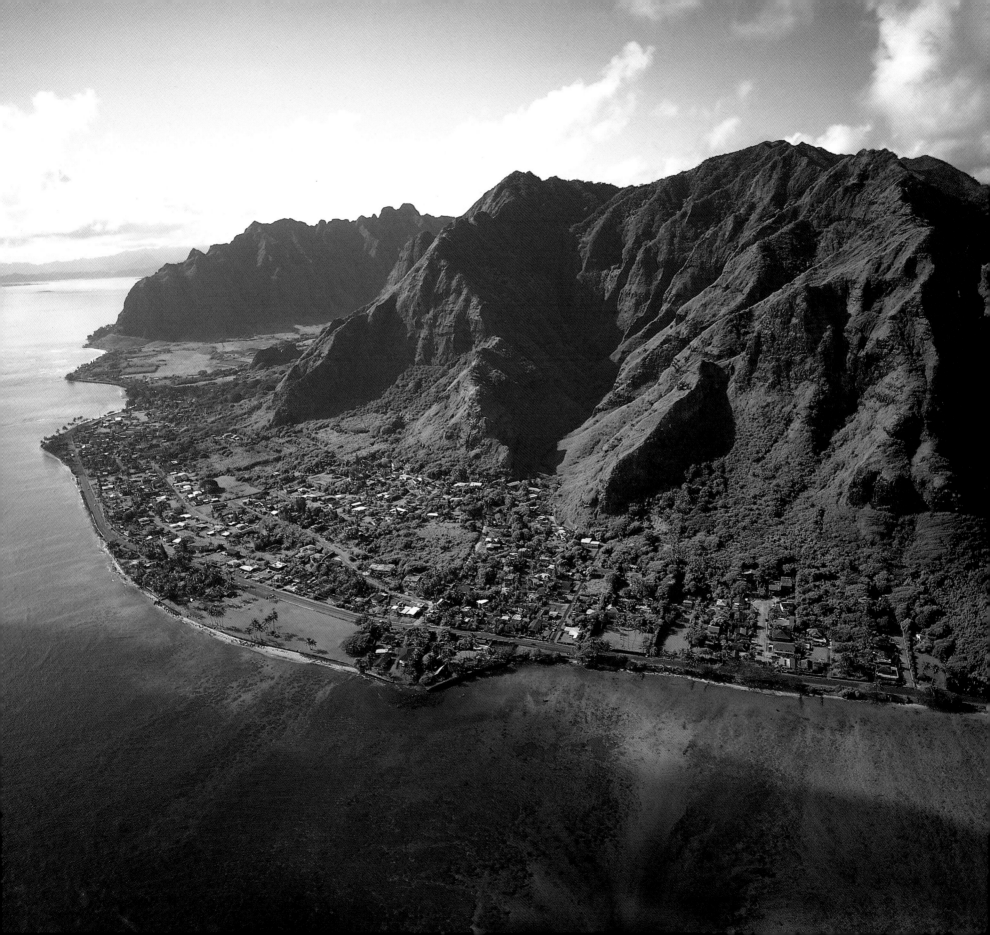

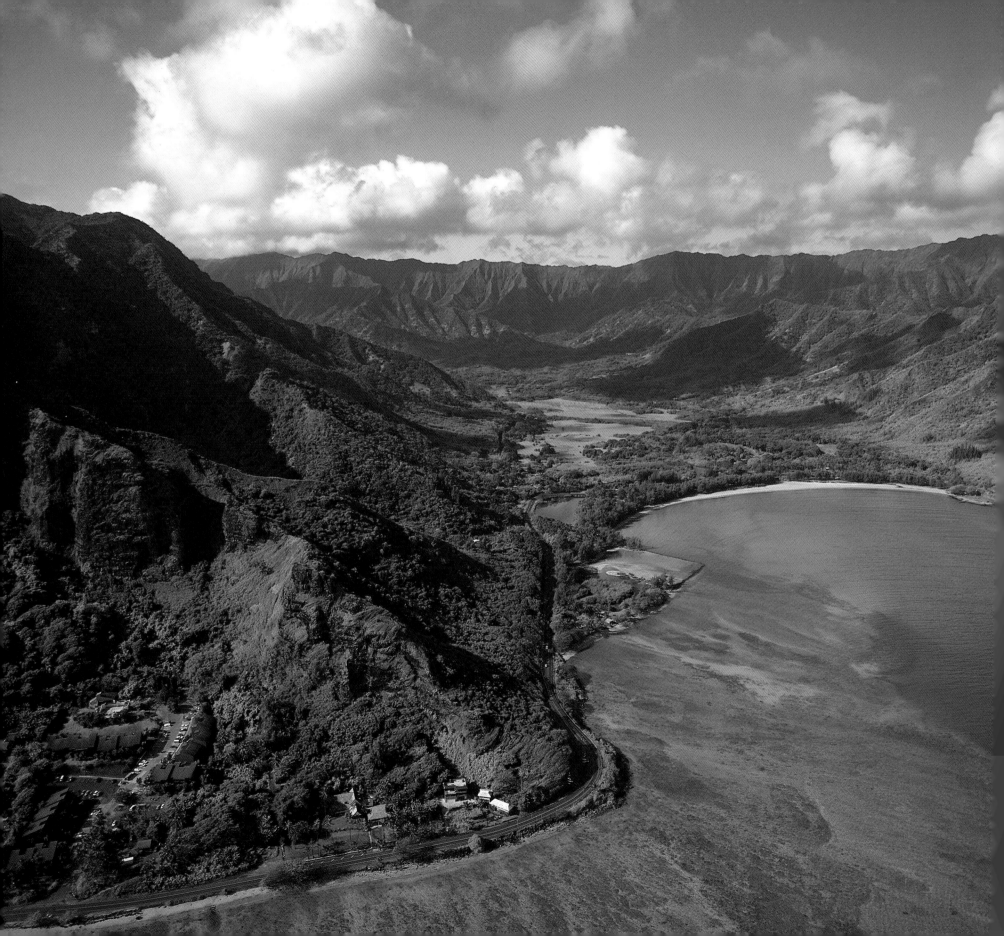

He kai 'ahiu ko Kahana, "a wild sea has Kahana," says an ancient Hawaiian poetical reference to a bay that actually is often quite placid. Once sheltering a sizable Hawaiian community, the entire Kahana Valley is today a "living history" State Park where a few Hawaiian families maintain their traditional life-styles. In the foreground before Mahie Point is the Crouching Lion Inn, originally a private residence and now a popular lodge and dining room.

Sunset Beach, The Pipeline and Banzai Beach are synonymous with the legendary Big Surf that, for most who master the surfboard, remains a fantasy rarely fulfilled. On O'ahu's North Shore in the last three decades a surfing way-of-life has sprung up that blends California's counter-culture with Australian brashness and the laid-back Hawaiian life style. The *hele nalu*, or surf riders, of the North Shore are trapped in a curious time-warp—Youth Caught in Pursuit of Endless Summer.

The surf-riders' life styles, however, are inconsequential to the skills required to master the "bull-mouthed monsters," as Jack London described them, "[that] weigh a thousand tons, and ... charge in to shore faster than a man can run." London fell in love with surfing and even tried his own hand at the sport on the gentler waves of Waikiki. The sight, from the beach, of the *hele nalu* sliding down the face of one of these "monsters" has never been so grandiloquently described as by this literary bohemian who almost made Hawai'i his home.

"And suddenly, out there where a big smoker lifts skyward, rising like a sea-god from out of the welter of spume and churning white, on the giddy, toppling, overhanging and downfalling, precarious crest appears the dark head of a man. Swiftly he rises through the rushing white.... Where but a moment before was only the wide desolation and invincible roar, is now a man. Erect, full statured, not struggling frantically in that wild movement, not buried and crushed and buffeted by those might monsters, but standing above them all, calm and superb, poised on the giddy summit, his feet buried in the churning foam, the salt smoke rising to his knees, and all the rest of him in the free air and flashing sunlight, and he is flying through the air, flying forward, flying fast as the surge on which he stands."

All along Kamehameha Highway, jammed with double-parked cars and tour buses, a gaping crowd watches these "winged Apollos" defy every normal instinct of self-preservation to ride The Big Surf.

Hawaiians created this quintessential water sport and identified more than 1,700 surfing sites. Missionary-traveler William Ellis, visiting the islands from Tahiti in 1823, said it best when he simply noted that seeing "fifty or a hundred persons riding on an immense billow, half immersed in spray and foam ... is one of the most novel and interesting sports a foreigner can witness in the islands."

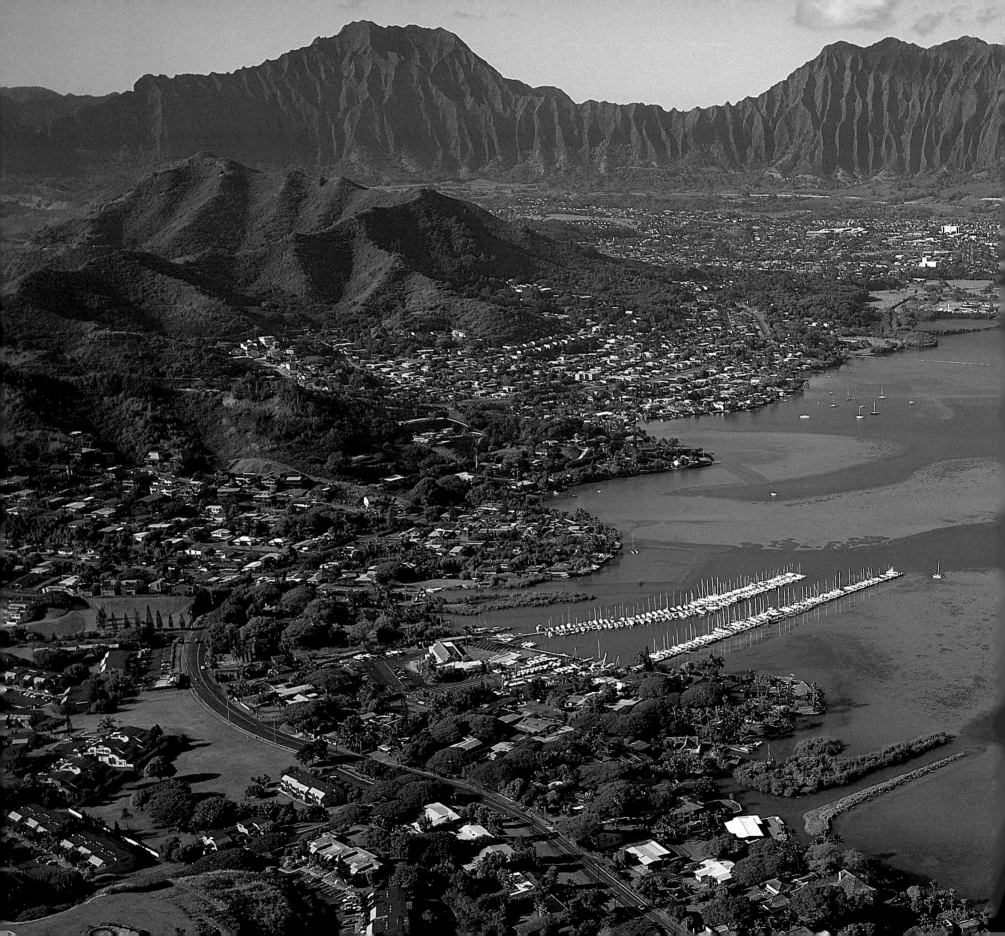

KO'OLAUPOKO

WHERE LEGENDS STILL LIVE

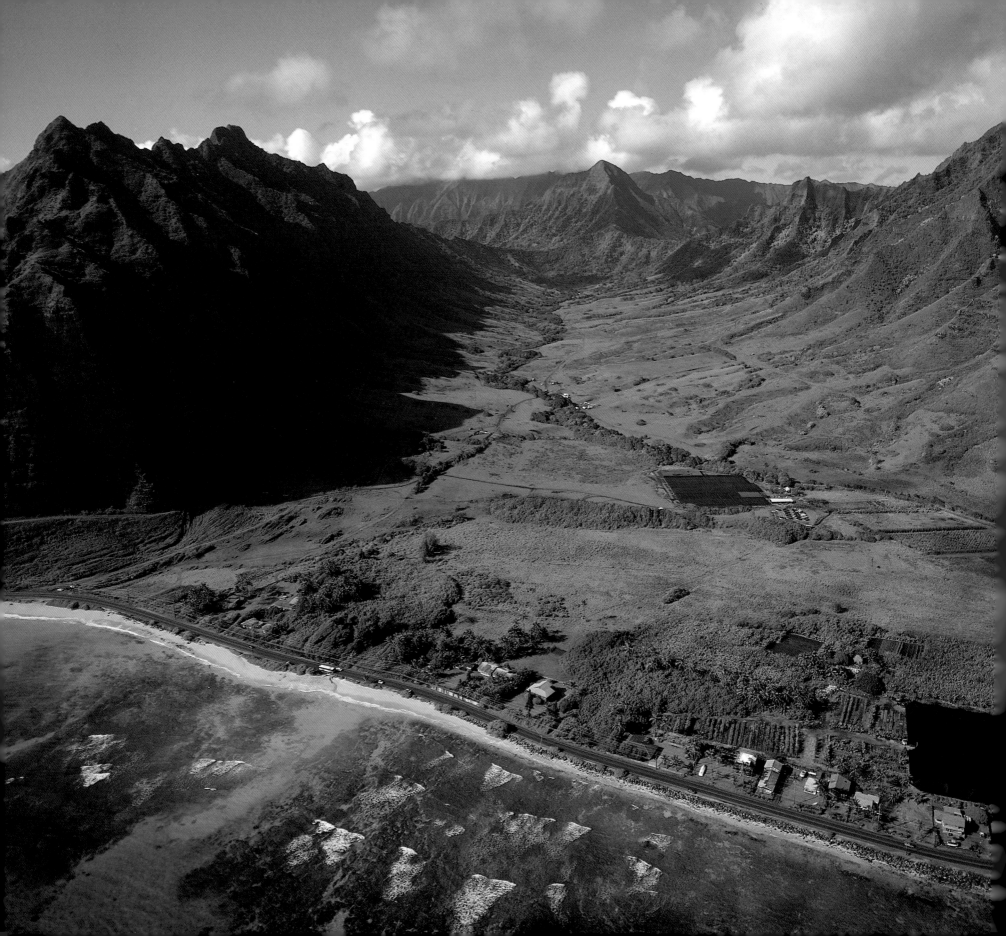

PREVIOUS PAGES: *In ancient times Kane'ohe, in the shadow of the Ko'olau Range, its beautiful sheltered bay ringed by productive fishponds and abundant coral reefs, was O'ahu's largest population center. Despite its steady expansion into a middle-class suburb and the construction of cross-island expressways, Kane'ohe retains a faintly bucolic island atmosphere.*

LEFT: *Kanehoalani Mountain reaches the beach at Kalae'o'io Point (right), separating the two traditional moku'aina, or land divisions, of Ko'olauloa and Ko'olaupoko. In Ka'a'awa valley, where cattle graze, historic taro terraces reveal the location of a once significant village. Somewhere on the Ka'a'awa face of Kanehoalani there is said to be the entrance to an ancient burial cave.*

Puha ka honu, ua awakea, says the old wisdom. "When the turtle comes up to breathe, it is daylight."

So the traveler along the Kamehameha Highway awakens from a Kahana reverie to continue a *holoholo,* or pleasurable, wandering journey into the Ko'olaupoko district where legends are not wholly dismissed. Marking the boundary between Ko'olauloa and Ko'olaupoko, towering 1,900-foot Pu'u Kanehoalani poses its own interesting mysteries. On the Ka'a'awa side of the mountain near Kalae'o'io point was the entrance to a burial cave called Pohukaina. An extensive lava tube believed by Hawaiians to underlie the full interior of O'ahu, Pohukaina was said to contain the most sacred bones of ancient chiefs.

Kalae'o'io Point refers to the legendary Hawaiian nightmarchers. Spirits of the dead, the nightmarchers walk certain paths only on the night of *Pokane* when there is no moon. Few who have seen the marchers have lived to tell the tale, but they can be heard as they approach. One of their retainers calls out *"o'io"*—"clear the path. Do not look upon us or disturb our procession." If the marchers include *hula* dancers, drums and chanting may be heard. Witnesses claim that they have seen torches floating in the night, carried by invisible chiefs.

When Pu'u Kanehoalani is viewed from the Ko'olauloa side, the outline of the mountain is that of a helmeted Hawaiian warrior looking up to the sky.

On the Kualoa side of Pu'u Kanehoalani is an old sugar mill smokestack, supported by wooden braces and covered by shrubs and weeds. The Mill of Tragedy was part of Kualoa's first sugar plantation, started by

Na pali hauliuli o ke Koʻolau

*"The dark hills of Koʻolau, they
are always dark
and beautiful with
trees and shrubs."*

Dr. Gerrit P. Judd, initially a missionary doctor, later a minister of the Hawaiian Kingdom under King Kamehameha III, and by the 1850s the owner of much of Kualoa. The sugar mill opened in 1863 but, due to low sugar yields, closed eight years later. On August 20, 1868 Dr. Judd's grandson Willie Wilder, roaming about in the mill, slipped and fell into a vat of boiling cane juice. Young Willie died the next day and the eerie "Mill of Tragedy" became another Koʻolaupoko legend.

Past Mokoliʻi ("Chinaman's Hat"), the Kamehameha Highway makes a turn near the ancient 124-acre Moliʻi fishpond. The familiarity of the ancient people with aquiculture was so outstanding that many fishponds such as Moliʻi have been restored. The University of Hawaiʻi has been experimenting with aquaculture techniques at Kualoa, using Moliʻi for fish cultivation. At nearby Heʻeia on Kaneʻohe Bay, another fishpond is to be restored by aquacultural entrepreneurs.

Another kind of local food production continued until just a few years ago. *Poi* factories used to be found everywhere when the demand for glutenous taro pounded into a paste was extremely high. With the introduction of Asian diets at the turn of the century, however, and the popularity of Chinese and Japanese rice farming in Kaneʻohe, rice eventually replaced *poi* as Hawaiʻi's dinner staple. One old-fashioned wooden *poi* factory sat beside the highway between Waikane and Waiahole. Today it is an art and handicraft shop.

For the open-minded, *poi* is a taste that, once acquired, may be difficult to lose.

"The forefinger is thrust into the mess and stirred quickly round several times and drawn as quickly out," observed Mark Twain of a feast of *poi*, "thickly coated, just as if it were poulticed. The head is thrown back, the finger inserted in the mouth and the delicacy stripped off and swallowed,

the eye closing gently, meanwhile, in a languid sort of ecstasy."

The Kamehameha Highway ends in Oʻahu's largest bedroom communities, Kaneʻohe and Kailua. The tour of the Windward side would not be complete without continuing through Waimanalo and past Bellows Air Force Station to Makapuʻu. In the early evening, after the bodysurfers and sunbathers have gone home, end the day by listening to the surf break against Oʻahu's southeastern point and by gazing out at peaceful Rabbit Island and its companion, Kaohikaipu islet. The stars or a full moon provide the perfect backdrop. The lighthouse on the cliff begins methodically swinging its beam of light. Then from the cliffs behind Sea Life Park a yellowish ball of fire may lift off from the mountain, swirl through the sky to illuminate the clouds, then, followed by a bluish tail, vanish as suddenly as it had appeared.

"*Akualele,*" the Hawaiians explain. "*Hinotama,*" add the Japanese. "A fireball," suggests the *haole.*

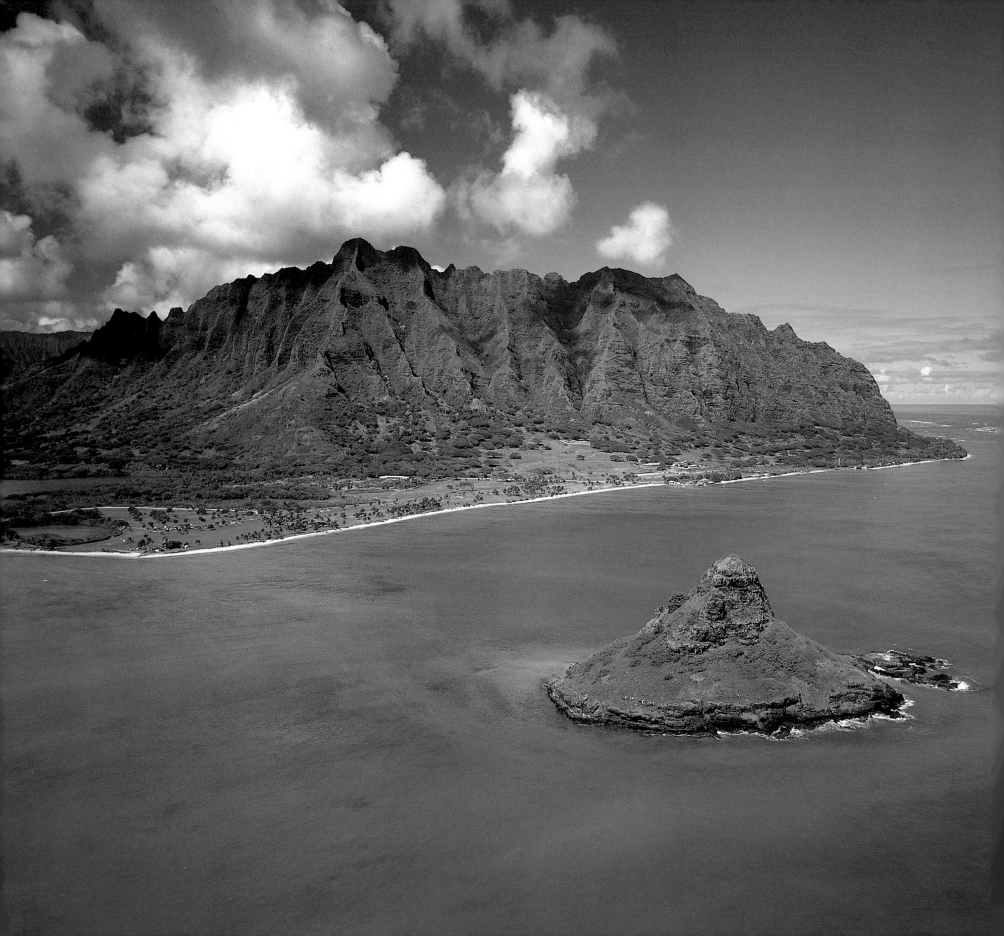

Mokoli'i islet, commonly called "Chinaman's Hat," floats offshore of O'ahu's most sacred place, Kualoa Beach on Kane'ohe Bay. In ancient times, children of royalty were brought here for their education. A place of refuge also existed at Kualoa. Later the land was purchased by missionary Dr. Gerrit P. Judd who planted sugar and built a mill, portions of which still remain along Kamehameha Highway. Kualoa Ranch operates one of O'ahu's two major cattle "spreads."

To the thousands who weekly snap its photograph, the islet off Kualoa beach is "Chinaman's Hat," a fitting name for the conical volcanic remnant but not what the Hawaiians called it. In ancient times, Kualoa was a *pu'uhonua*, or place of refuge, where *kapu* violators could hope to receive sanctification and purification. Its fertile fields and mullet-filled ponds had been the favorite resting place of *ali'i* such as Kahahana, the eighteenth century Maui chief who, after Kahekili had conquered O'ahu, was selected to rule the island. Canoes passing Kualoa regularly lowered their masts, keeping them down out of deference to royalty. The sacred drums of Kapahuula and Kaahuulapunawai were kept there also. And at Kualoa the most precious treasure in ancient Hawai'i was found—the whale "ivory" from which the *lei palaoa*, or whale-bone pendant, was carved. This precious tongue-shape symbol of royalty was worn by high chiefs on a necklace of human hair. The *mana*, or divine power, of Kualoa is great.

In ancient times the shores of Kualoa attracted not only the *ali'i*, but the gods as well. For in their many forms the immortals frequently moved among the mortals, performing extraordinary deeds, protecting the frail, destroying the arrogant, or simply seeking amusement. Thus Pele the fire goddess in one of her dreams fell in love with the handsome chief Lohiau from Kaua'i. On waking back at home on the Big Island, Pele sent her youngest sister Hi'iaka to Kaua'i to find Lohiau and escort him back to her home at Kilauea crater.

On the arduous return journey to Pele's waiting arms, Hi'iaka and Lohiau dallied at Kualoa. While enjoying the cooling waters, the two were confronted by Mokoli'i, a great *mo'o*, or supernatural lizard. The creature reared itself up, seeking to terrify these strangers to the land he inhabited. For this was no domestic gecko, but a dragon with a twenty-foot-long body and reptilian head with flaring nostrils. Despising *mo'o*, Hi'iaka unflinchingly opened her *pa'u*, or skirt, and pulled out a great lightning bolt. With a swing of her terrifying weapon, she killed Mokoli'i. Cutting up his body, she threw the tip of his tail offshore.

Lohiau and Hi'iaka left Kualoa to face more adventures and perils on their return to an increasingly jealous Pele. As for Mokoli'i, his tail turned to stone and is today's "Chinaman's Hat."

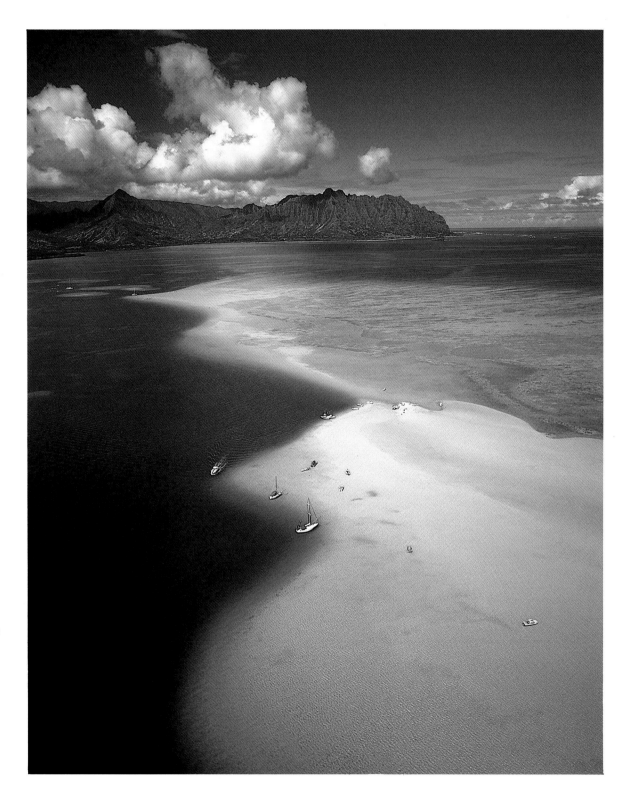

RIGHT: *A growing sandbar in Kaneʻohe Bay makes a safe anchorage for pleasure craft. Wading from their boats to dry sand, these adventurers have found a secluded beach on which to enjoy sunbathing, a cold beer, a picnic and a swim while soaking in the incredible beauty of the scenery stretching from Kualoa Point to the Nuʻuanu Pali peaks.*

OPPOSITE: *Windsurfers are tiny specks among the sandbars of Kaneʻohe Bay. Ocean-oriented recreation activities such as windsurfing, parasailing, jet skiing, scuba diving and boating have become major elements in Hawaiʻi's tourism industry.*

150

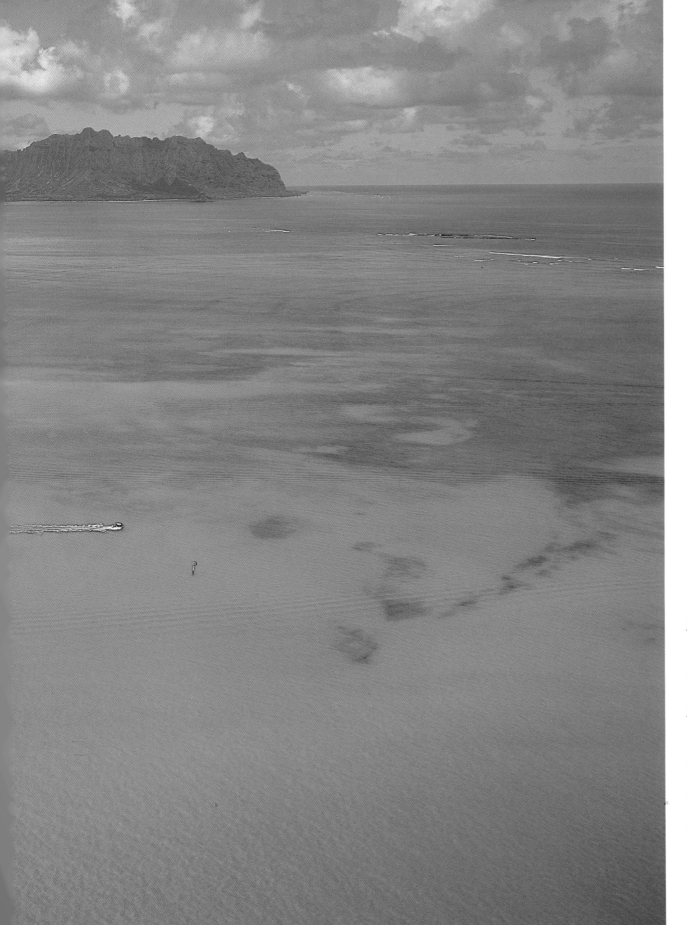

Kane'ohe Bay is a deep lagoon protected by the only true barrier reef in Hawai'i. The bay's eight-mile shoreline, however, has been dredged, filled and protected with retaining walls in many places for residential development and the construction of piers. Extensive soil runoff for a time threatened to smother the once-spectacular reefs with silt, but is being brought under control in the wake of citizen protests.

153

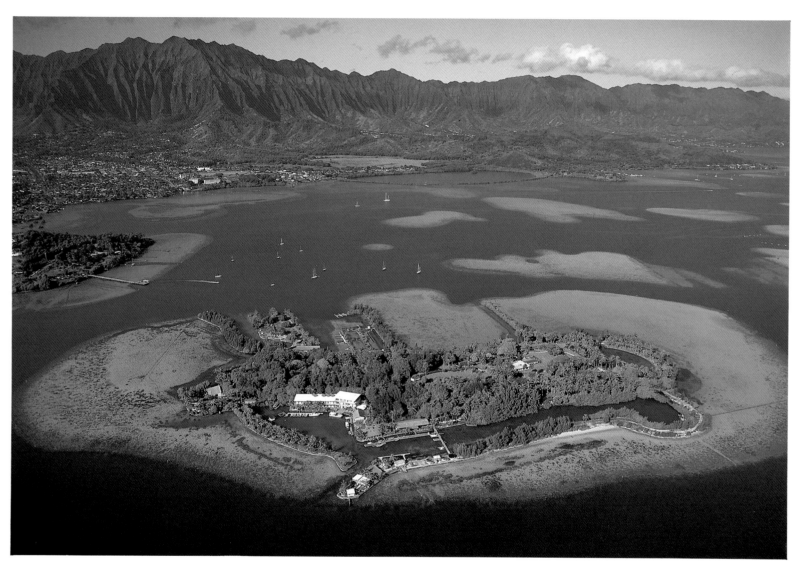

Moku-o-Loe islet ("Coconut Island") in Kaneʻohe Bay was for many years the property of Honolulu multimillionaire Christian R. Holmes who, in the 1930s built palatial accommodations there that during World War II became a R & R spot for weary "brass." Today the island is used by the Hawaiʻi Institute of Marine Biology, part of the University of Hawaiʻi system.

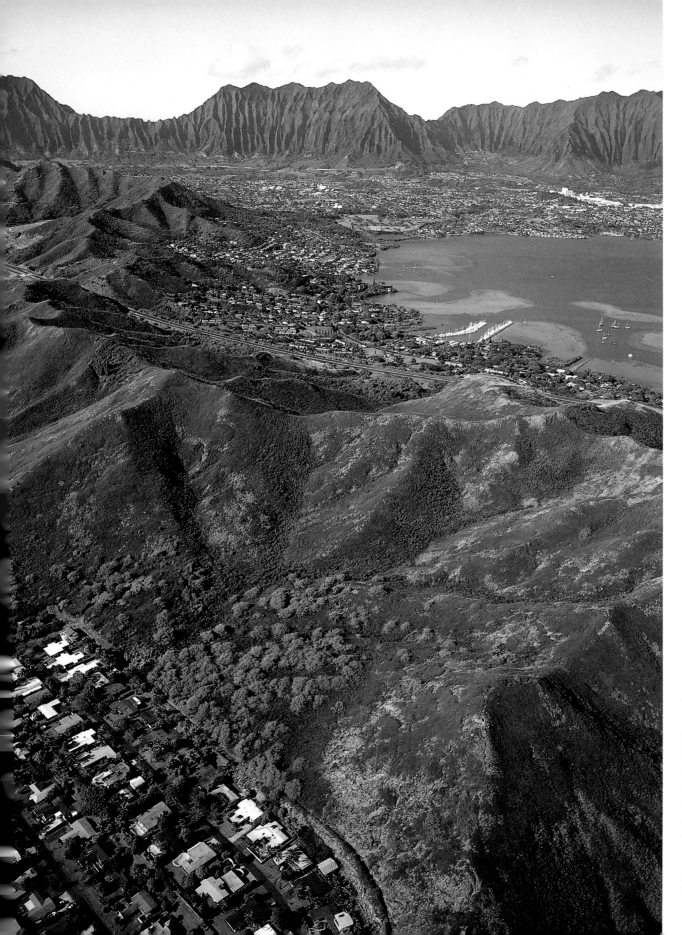

Kalaheo Hillside subdivision climbs the Oneawa hills that separate Kailua and Kane'ohe. Homes on the Kane'ohe side of the hills have sweeping views of the bay and the fluted Ko'olau Range. Kailua and Kane'ohe together house about 65,000 of O'ahu's 850,000-plus residents.

155

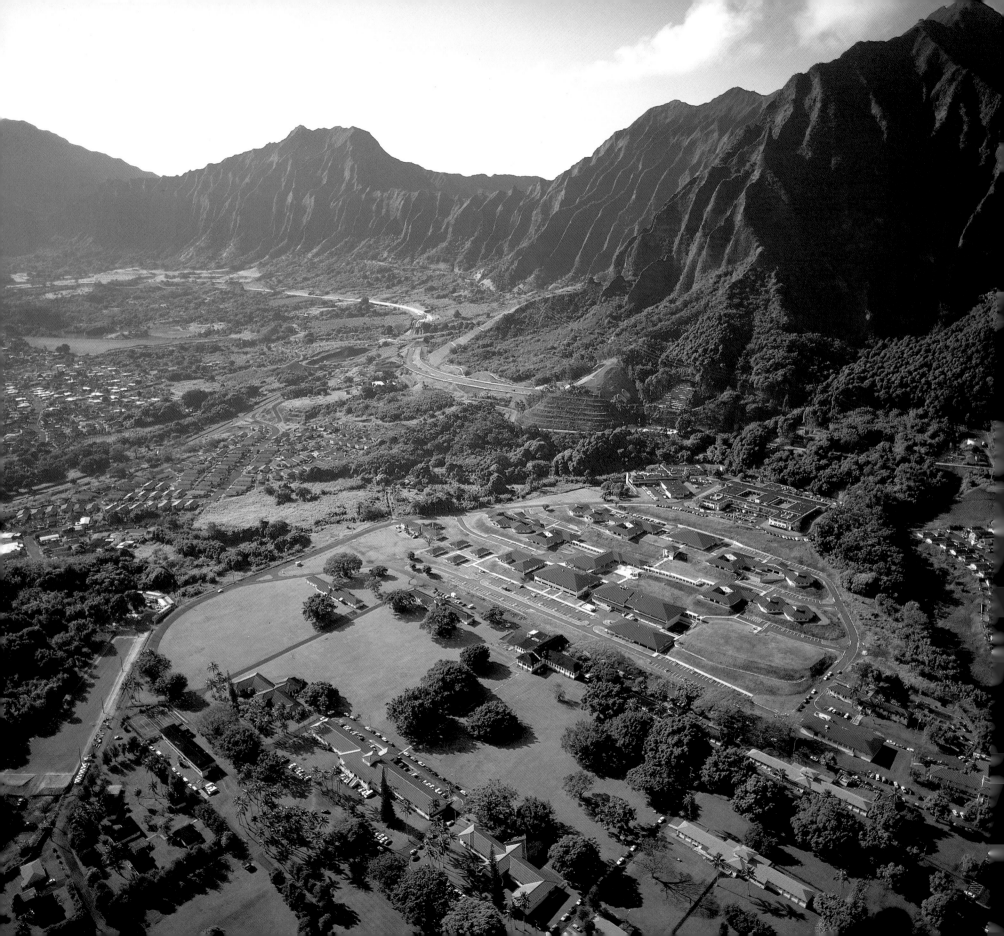

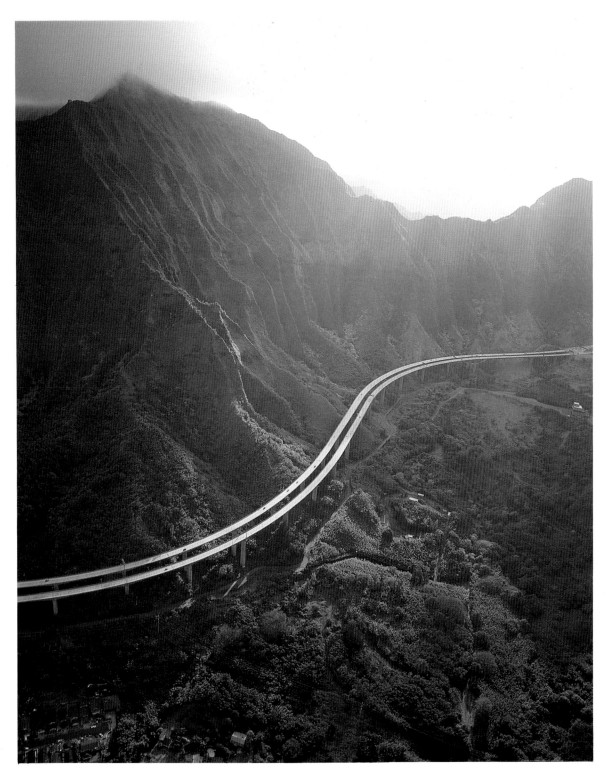

OPPOSITE: *The red-tiled roofs of the Windward Community College and the Hawai'i State Hospital contrast vividly with the luxurious greenery of Pu'u Keahi-a-Kahoe, "the fire of Kahoe hill."*

LEFT: *The H-3 freeway tunnel is the fourth major bore through the Ko'olau Range, following the Pali Tunnel, the Wilson Tunnel and the Waiahole Ditch Tunnel, an irrigation link between the rainy Windward side of the island and the thirsty sugar plantations of 'Ewa and Central O'ahu. The new tunnel and freeway have come under heavy attack for suspected desecration of ancient Hawaiian sites and damage to the environment.*

157

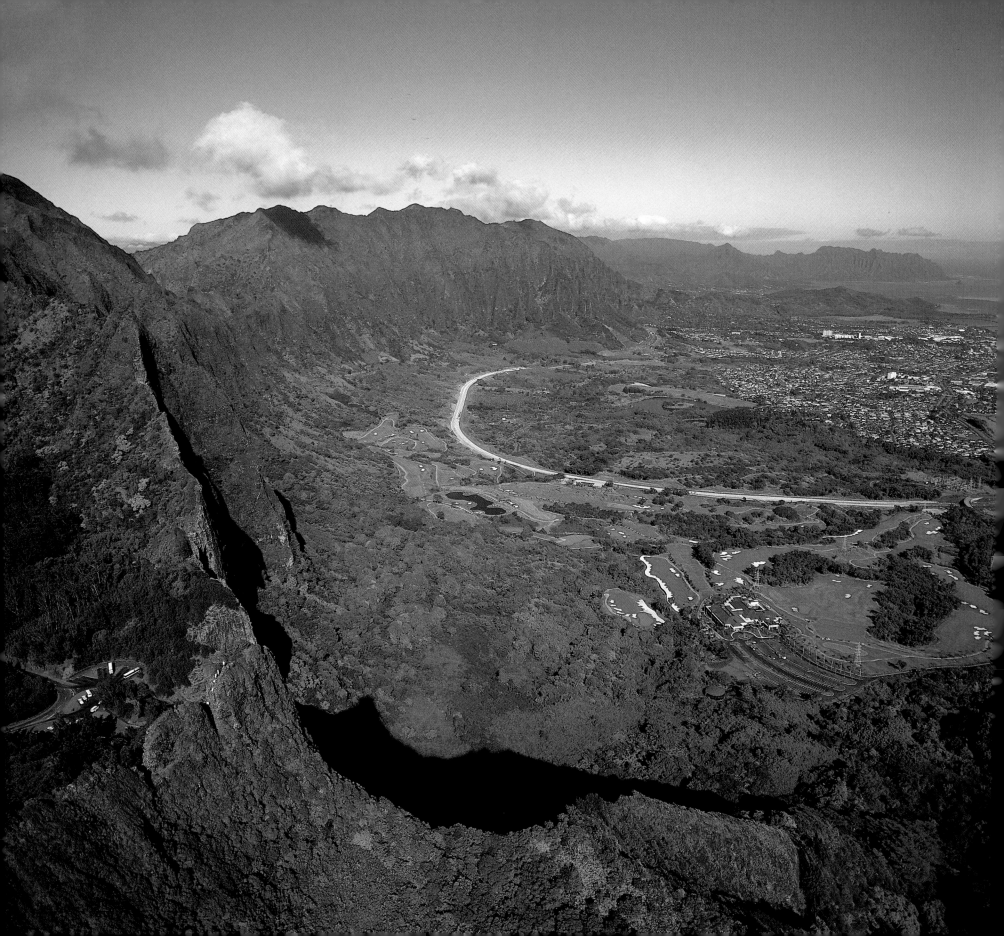

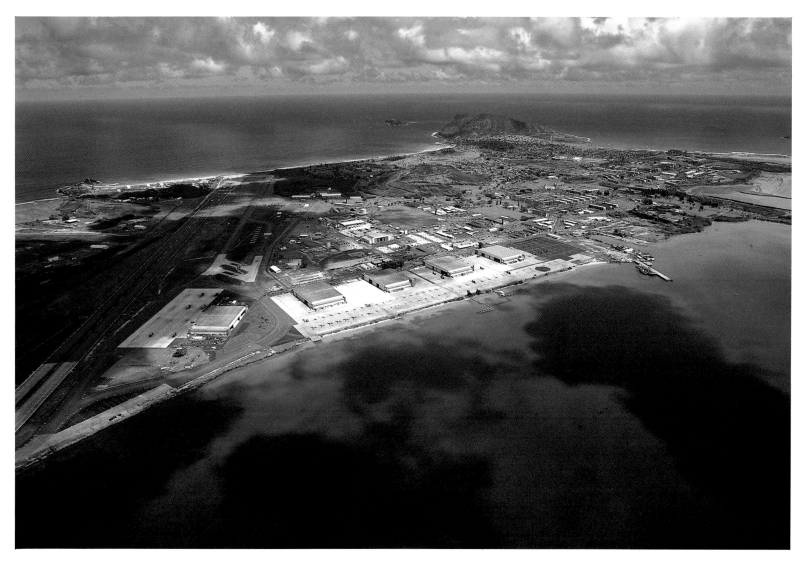

OPPOSITE: *History abounds at the Nuʻuanu Pali precipice, a windy pass through the Koʻolau mountains. In 1795 Kamehameha the Great, fighting to add Oʻahu to his dominions, defeated his rivals at the Pali edge. Some of the defending warriors leaped to* their deaths rather than let themselves be taken prisoner by the great invading chief from Hawaiʻi Island. Early travelers between Kailua and Honolulu literally had to climb up and down the face of the mountain. A carriage road was constructed in the 1860s. The Nuʻuanu Pali Lookout's parking area and popular scenic outlook are* *visible. This stunning vista of Koʻolaupoko includes new golf course construction and the H-3 freeway that will connect Kaneʻohe with Pearl Harbor and Leeward Oʻahu.*

ABOVE: *The Kaneʻohe Marine Corps Air Station is on "sacred" Mokapu Peninsula, where King Kamehameha the Great met with his chiefs following his conquest of Oʻahu. The fish in the extensive fishponds that once ringed the peninsula were* kapu, *or sacred.*

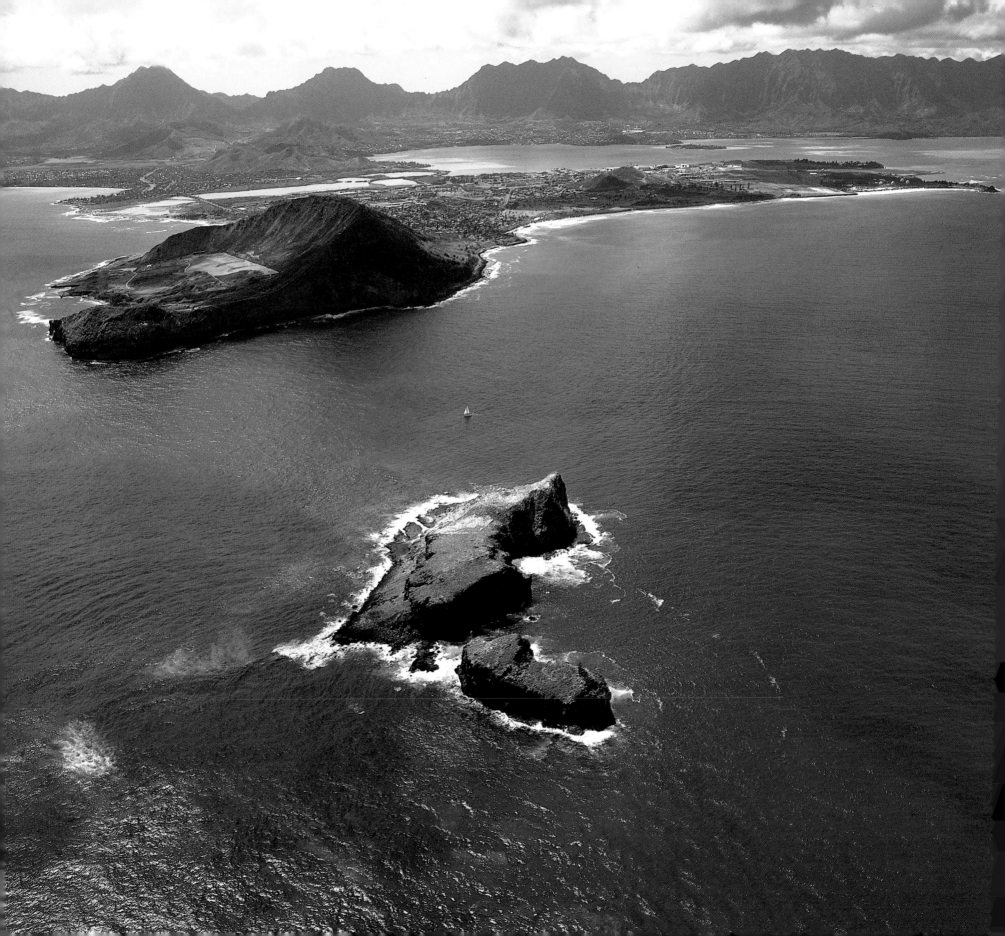

The group of Japanese fishermen that evening had no way of knowing the sacredness of Mokapu peninsula. No sign warned them away from ground where conquering Kamehameha the Great had met with the chiefs of O'ahu after the final battle at Nu'uanu Pali.. No tour guide told the fishermen how legends spoke of Mokapu's being the place where the first male and female humans were created by the gods Kane, Kanaloa, Lono and Ku.

No, this crew of fishermen, all recent immigrants, could have had no prior knowledge that summer night in 1922 concerning the full meaning of Mokapu or *moku kapu*— sacred land. They had come to fish, not to learn ancient Hawaiian lore. As the fishermen spread out along the shoreline to cast their lines and nets, a "picture bride" who had accompanied her husband that night remained at camp to prepare rice over a campfire. Around 11:30 p.m. she noticed a few lights burning in the distant darkness, accompanied by voices speaking Hawaiian. "Ah," she thought with comfort, "I'm not alone." Then a large Hawaiian fisherman came up from the beach, striding past her toward the lights. In the full glow of her lantern, she saw to her horror that he had no feet! His legs vanished at the kneecap! As he neared the lights, the apparition, voices and "fireballs" all vanished.

"*Obake* (ghost)! *Obake!*" she screamed. Her husband came from the beach to see what was amiss. When she described the man without feet and the campfires that disappeared, he investigated and found an old Hawaiian graveyard. The couple summoned the other fishermen to retreat from their midnight fishing grounds, but discovered one man was missing. They later found him unconscious on the beach at the far point of Mokapu, his shirt ripped from his body, his face and chest turned green.

"I had been fishing when I heard everyone calling *obake*," he recalled later. "I got scared and pulled in my nets to discover that I had caught a big fish. When I dragged it to shore, I saw that it was no fish but a Hawaiian woman. She leaped out of the net, jumped on my back and made me carry her down the beach. Then she ripped my shirt off, threw me to the beach and began to lick my face and chest. Most horribly, her green tongue kept coming out of her mouth until it was four feet long! I passed out and I guess that's how you found me."

A beautiful woman with a four-foot tongue emerging from the waters of Mokapu? Did the fishermen encounter a Hawaiian *mo'o wahine*, or supernatural female lizard, known in ancient tales for their transformation abilities and their remarkable tongues? Had the newcomers stepped into an ancient Hawaiian legend of a cunning female *mo'o* that inhabits the Windward Coast and seduces men?

Ulupa'u Crater, created by the goddess Pele at the tip of Mokapu peninsula, and Moku Manu ("Bird Island") lie between Kane'ohe Bay (right) and Kailua Bay. Terns and other sea birds nest on Moku Manu which is also home to a famous "Bird lady of Kailua" who cares for injured birds and resides in a gray house cut from stone on this 16-acre islet.

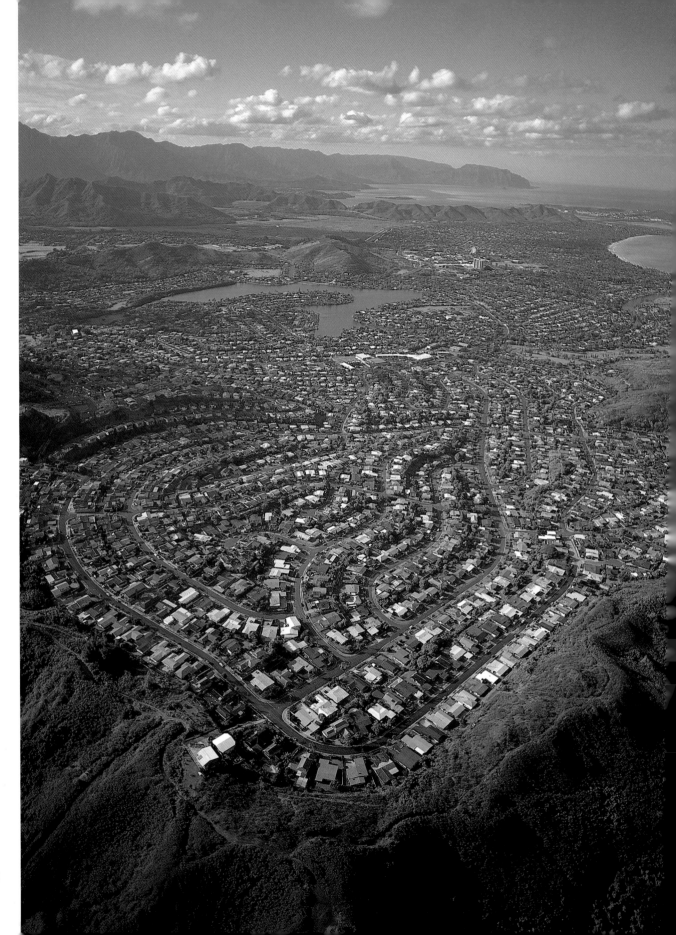

Kailua and Kaneʻohe became bedroom suburbs for Honolulu in the 1960s when the Pali and Likelike Highways were cut through the Koʻolau Range. Housing developments such as Keolu Hills and Enchanted Lake have dramatically transformed what were once rice and banana farms.

162

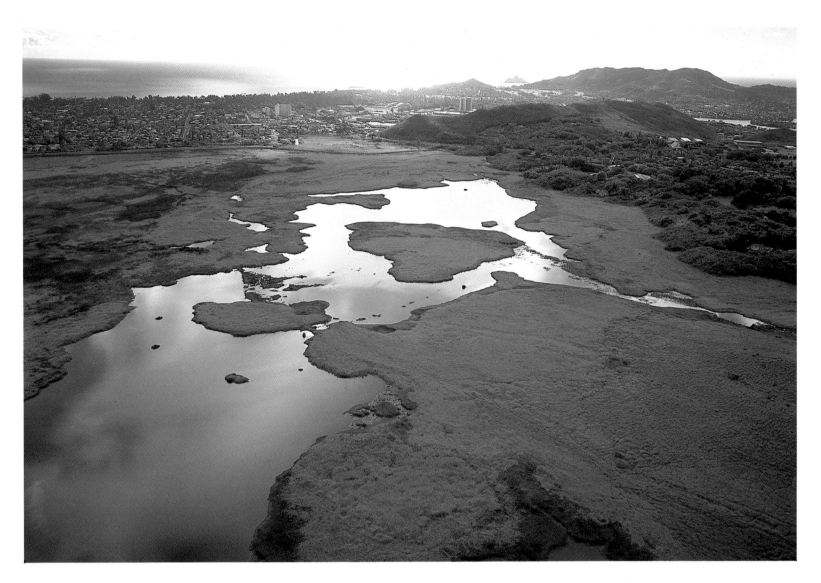

Kawainui ("big water") Swamp behind Kailua town once included the largest inland fishpond on O'ahu, famous for its milkfish and goby fish. One hundred years ago a traveler to Kailua reported that rice fields worked by Chinese surrounded the large "nesting ground for wild duck, plover, and the famous Hawaiian goose."

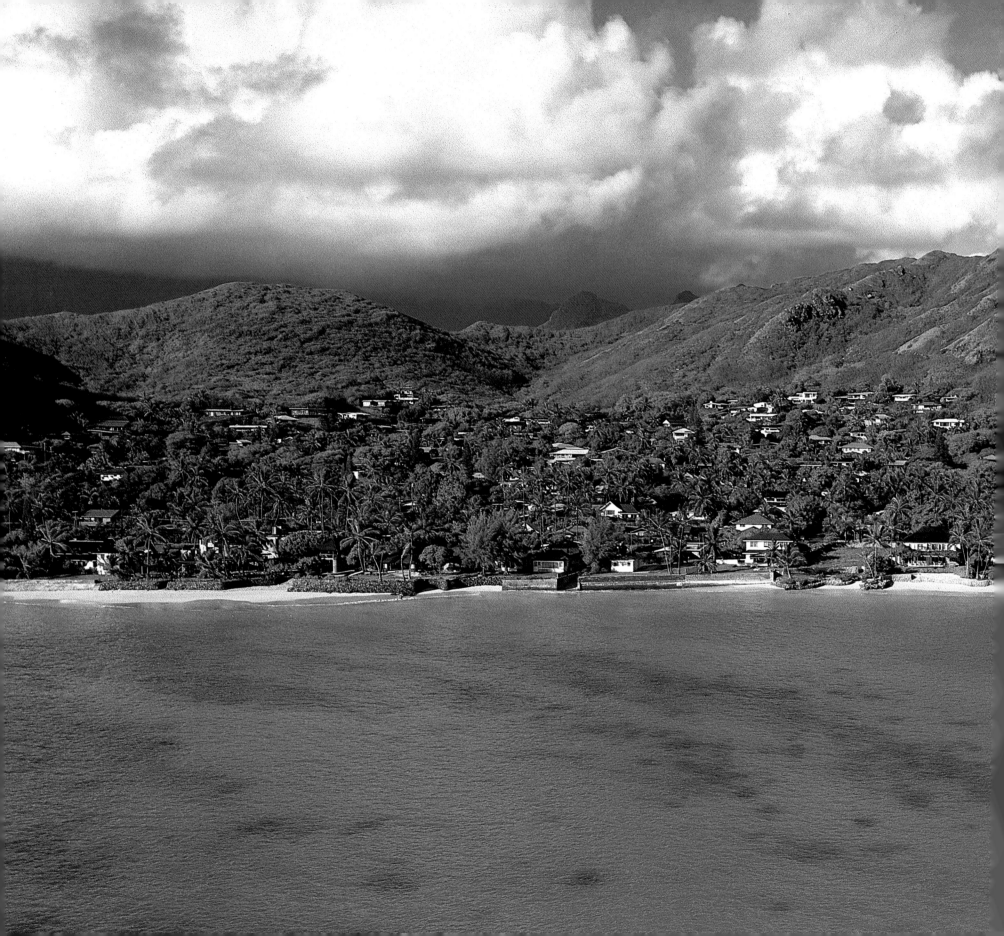

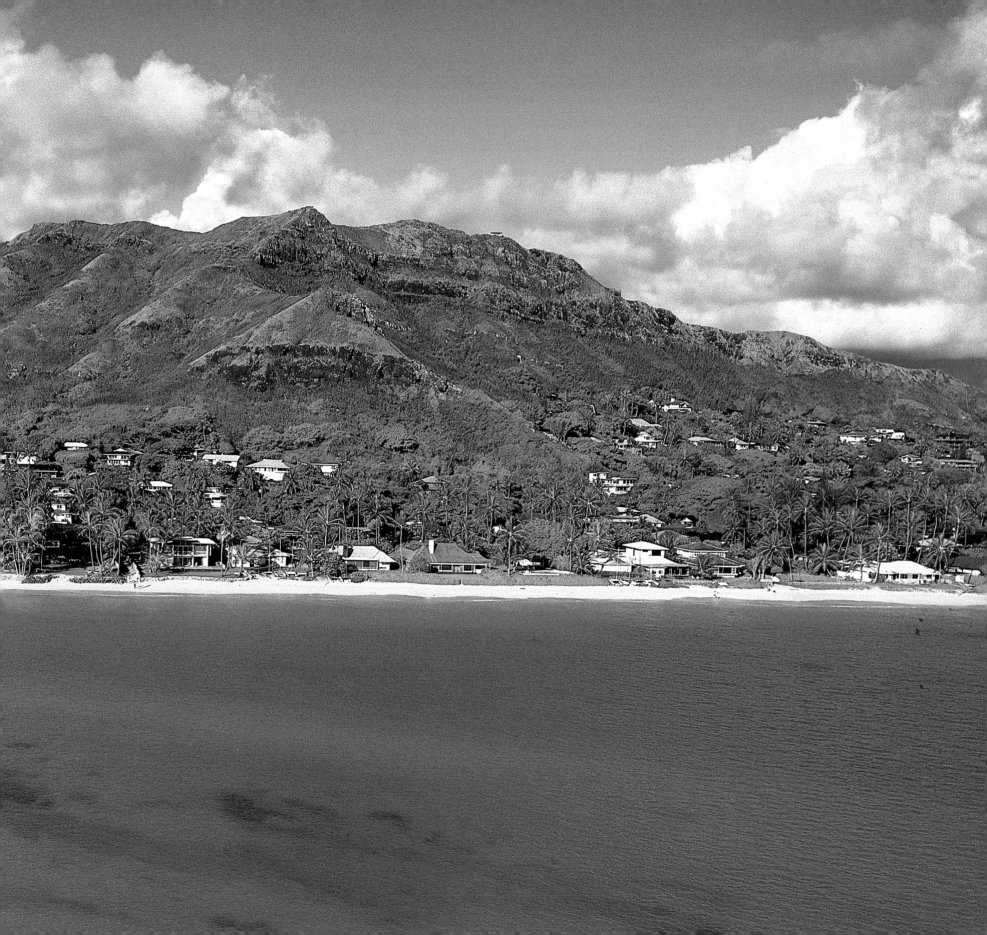

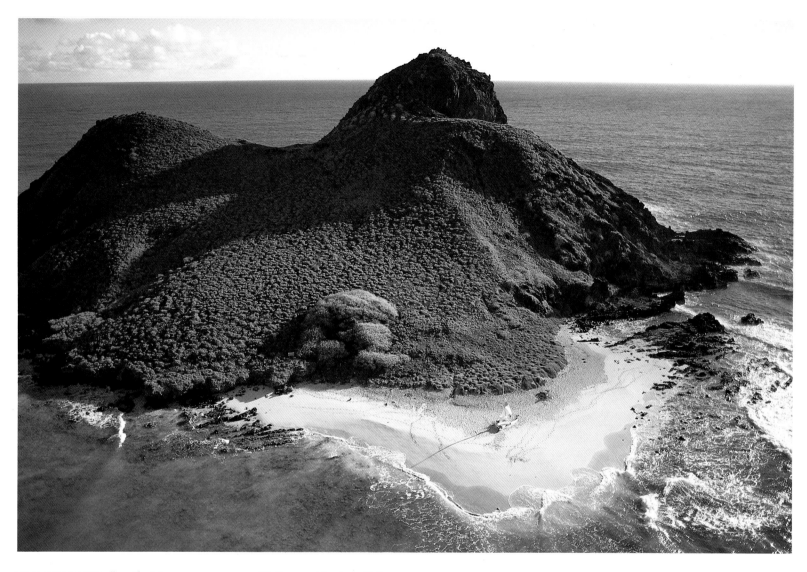

PREVIOUS PAGES: *Lanikai is a Windward beach community opened in 1924 at the foot of the Keolu hills. The developers thought they had given the area a Hawaiian name meaning "heavenly sea." They failed the language exam, however; Lanikai means "sea heaven."*

ABOVE: *Kailua residents call the larger of the two Mokulua Islands Moku Nui, "big island;" the other is Moku Iki, "small island." The state restricts access to the bird sanctuary islands, requiring recreation-use permits even for boat landings and picnics.*

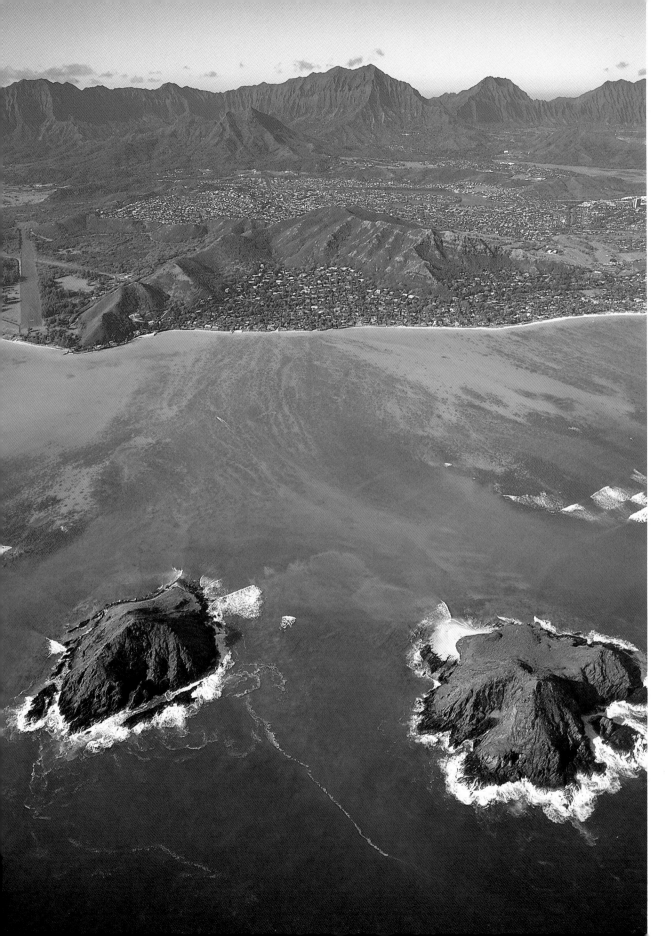

Ancient Hawaiian adze quarries have been found on the twin Mokulua Islands off Lanikai in Kailua. Stone adzes were the Hawaiians' principle tools for shaping wood before the introduction of iron by early Western navigators. These islets and a reef stretching to the beach were believed to have been constructed by Hawai'i's legendary small people, the menehune, *who never finished their work.*

The Kawailoa Girls Home and the adjacent Hawai'i Youth Correctional Facilities are on the verdant Kailua plains beneath Mt. Olomana. Kukuipilau, an old temple on the present school grounds, used to be connected to a spring called Kawailoa. The temple name was derived from the inedible nuts of the candlenut trees that grew in this area.

169

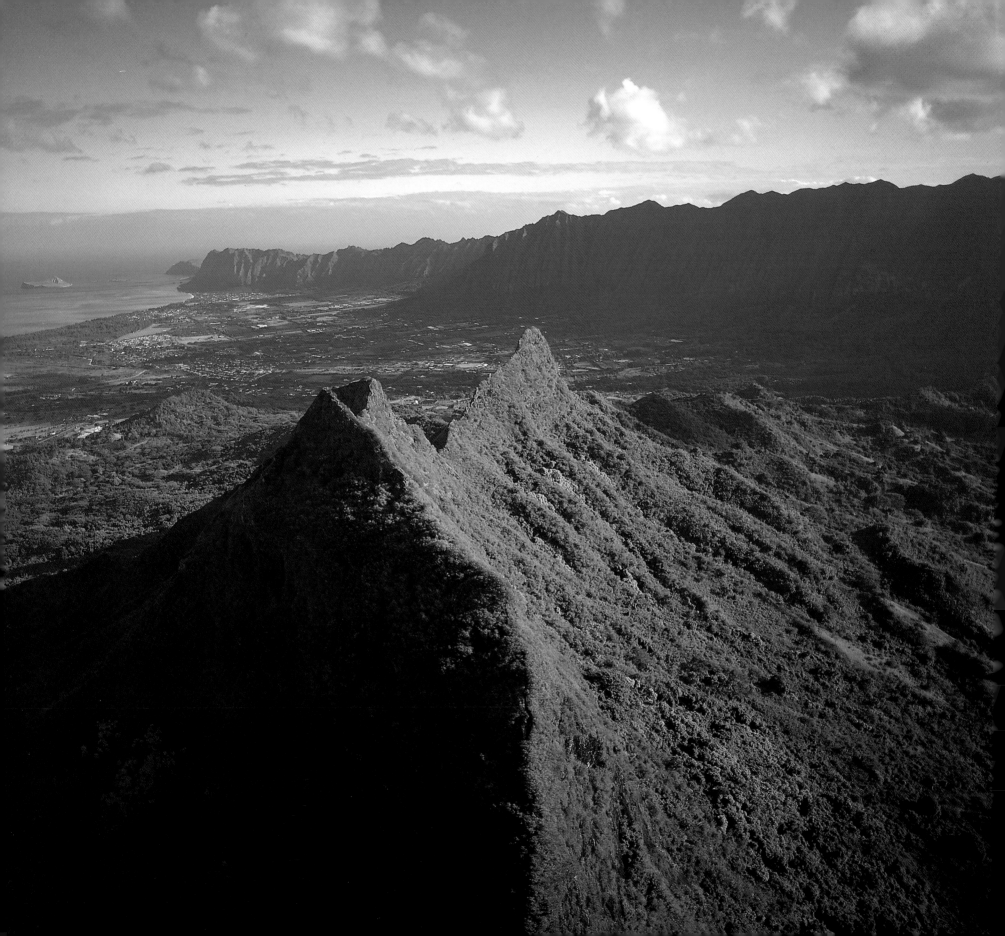

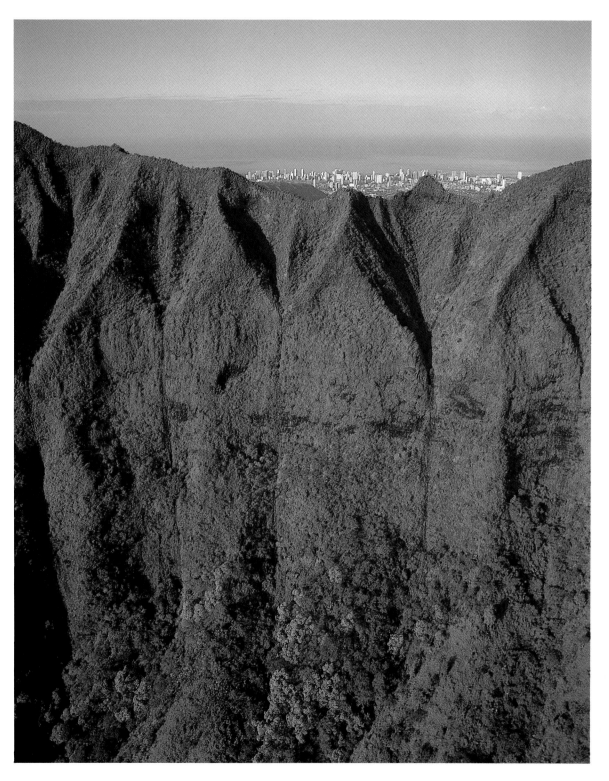

OPPOSITE: *When a young prince from Kaua'i named Kauhi descended the Nu'uanu Pali on his way to Kailua he was confronted by Olomana, a towering giant who attempted to rob him. Fearless Kauhi struck the giant in the neck with his spear, cleaving Olomana in half. Mount Olomana at 1,643 feet is a portion of the giant's shoulder that took the blow.*

LEFT: *The steep Ko'olau mountains behind Waimanalo some three million years ago were part of the great shield volcano that formed the island of O'ahu. As the Ko'olau volcano became extinct, say the experts, the northern crater wall slumped into the sea in a titanic landslide. Wind, rain and erosion then began to sculpt the distinctive fluted cliffs. The city of Honolulu is faintly visible beyond the peaks.*

171

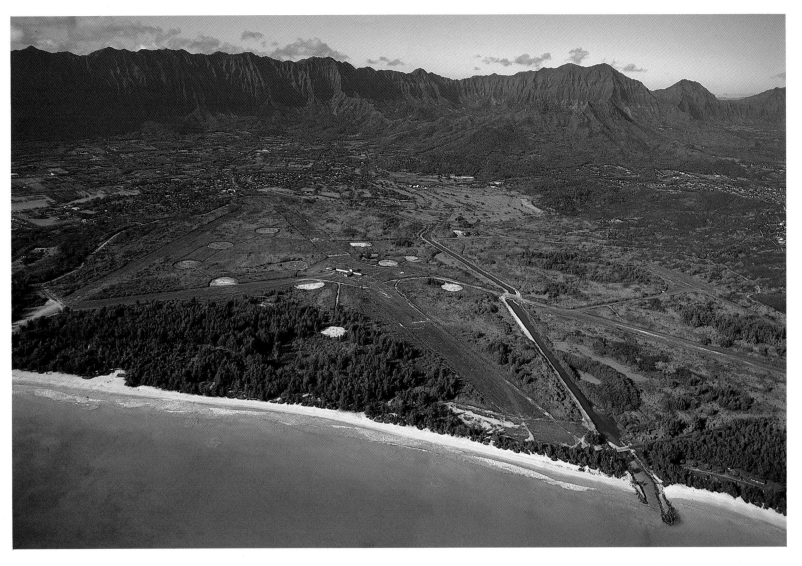

ABOVE: *Bellows Field Beach Park was opened to the public in 1964. The station was once a landing strip and training field. A confused Japanese midget-submarine skipper grounded his craft on the reef at Bellows Field and won a place in history as the first P.O.W. of the war. The sub was eventually salvaged.*

OPPOSITE: *Legends abound concerning the old Windward O'ahu village of Ko'onapou near Waimanalo. Ko'onapou fishing village (called Kaupo Beach today) grew around a mystic named Kapoi whose supernatural healing powers drew people to the village. When he was accused of adultery, however, smallpox swept the area, killing Kapoi and his followers. The water of his spring turned forever brackish.*

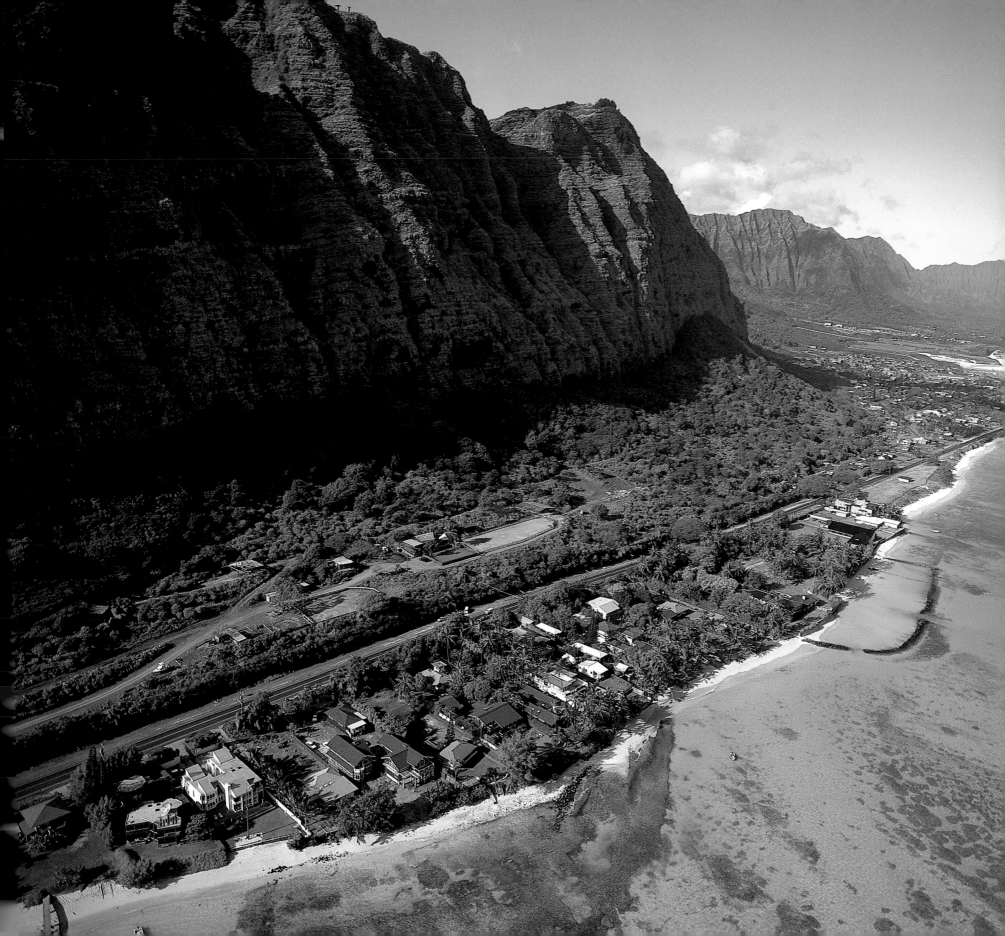

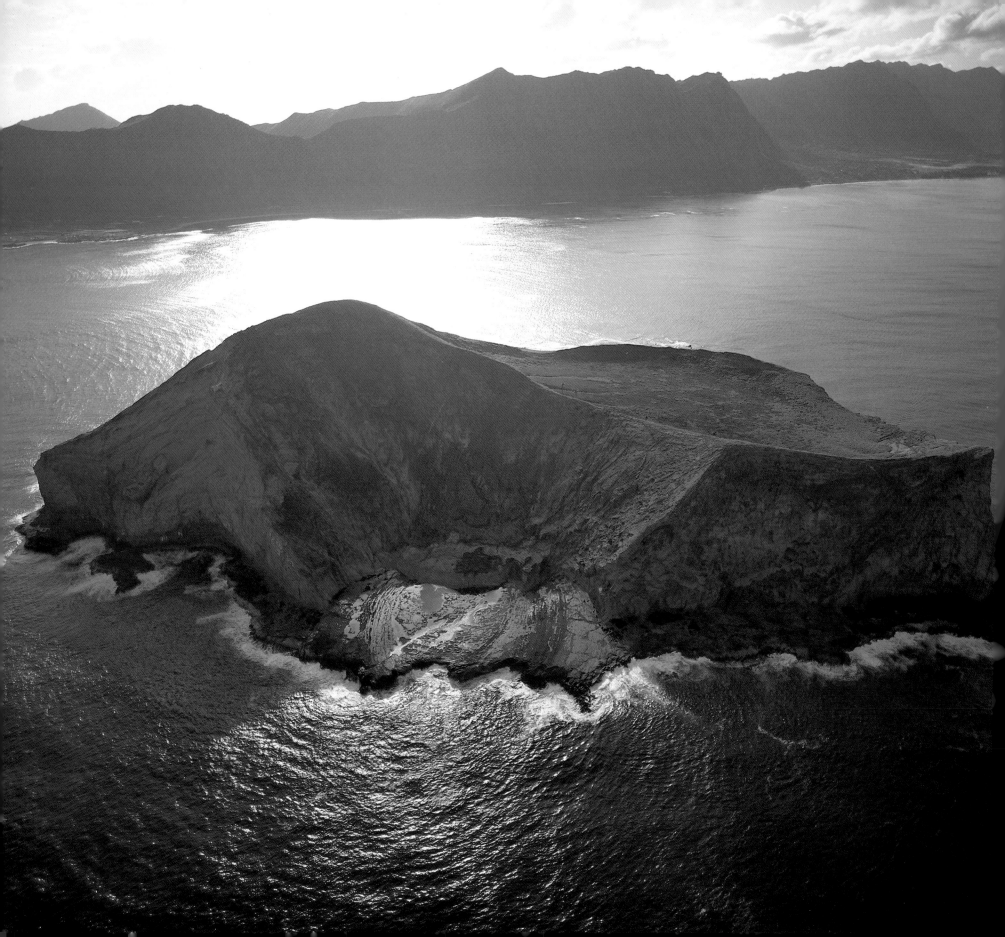

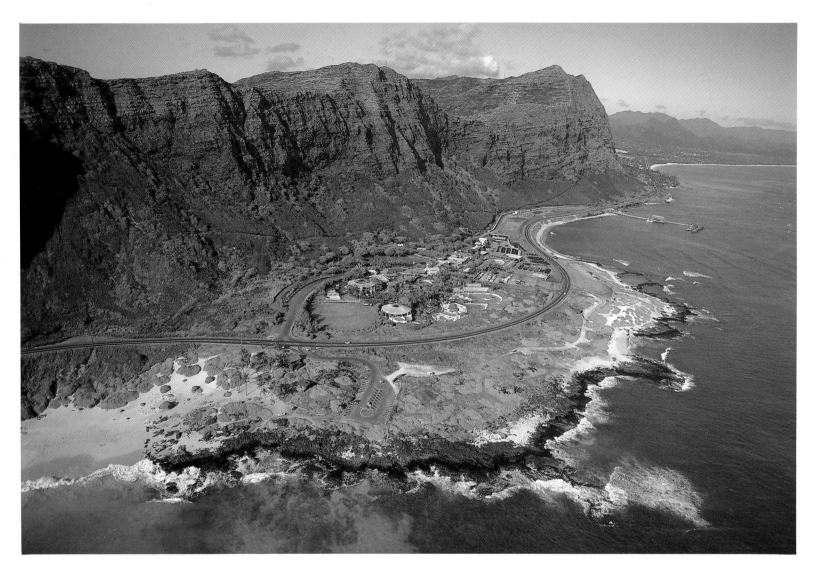

OPPOSITE: *Rabbit Island, the distinctive islet in Makapu'u Bay, earned its name when the owner of Waimanalo Ranch raised rabbits there as a hobby. On January 8, 1895 a cache of weapons buried on the island was used in an unsuccessful attempt to restore deposed Queen Lili'uokalani to her throne.*

ABOVE: *Makapu'u, "bulging eyes," is one of O'ahu's favorite bodysurfing beaches. A large black stone with eight eyelike protrusions, believed to be a supernatural woman, used to be in a nearby cave, giving this dramatically beautiful beach its name. Sea Life Park is at the base of the cliffs.*

FOLLOWING PAGES: *When it opened in 1908, the Makapu'u lighthouse on the rugged southeastern point of O'ahu was said to have the world's largest lens. Thirteen feet high and nine feet in diameter, it sent out a beam of light that could be seen by ships 28 miles away. Offshore are picturesque Rabbit Island and Kaohikaipu islet.*

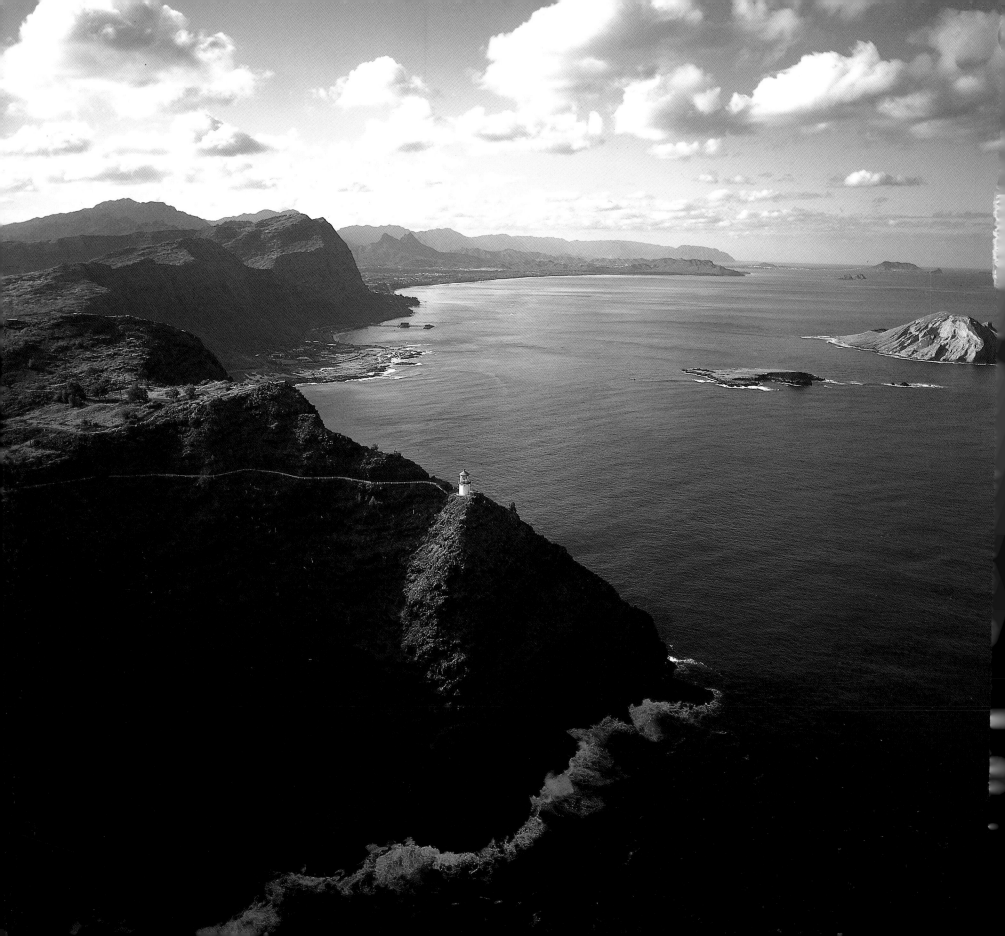